the complete guide to digital

color

creative use of color in the digital arts

the complete guide to digital
color
creative use of color in the digital arts

chris linford

HDi

HARPER
DESIGN
international

An Imprint of HarperCollins*Publishers*

contents

introduction

THE COMPLETE GUIDE TO DIGITAL COLOR:
CREATIVE USE OF COLOR IN THE DIGITAL ARTS
Copyright © 2004 by Axis Publishing Ltd.

First published throughout the World in English
in 2004 by
Harper Design International
An imprint of HarperCollins*Publishers*
10 East 53rd Street
New York, NY 10022
www.harpercollins.com

Created and conceived by
Axis Publishing Limited
8c Accommodation Road
London NW11 8ED
UK
www.axispublishing.co.uk
Creative Director: Siân Keogh
Art Director: Clare Reynolds
Editorial Director: Anne Yelland
Managing Editor: Conor Kilgallon
Design: Axis Design Editions
Production: Toby Reynolds, Jo Ryan

HarperCollins books may be purchased for
educational, business, or sales promotional use.
For information, please write: Special Markets
Department, HarperCollins*Publishers* Inc.,
10 East 53rd Street, New York, NY 10022

First edition
Printed and bound in Thailand
1 2 3 4 5 6 7 / 10 09 08 07 06 05 04

Library of Congress Cataloging-in-Publication Data
Linford, Chris.
 The complete guide to digital color : creative use
of color in the digital arts / by Chris Linford.
 p. cm.
 ISBN 0-06-072793-4 (pbk. with flaps)
 1. Image processing--Digital techniques. 2. Color.
I. Title.
 TA1637.L58 2004
 741.6--dc22 2004012222

1

the science of color

2

using color

3

color communication

4 digital input **116**

5 color management **152**

■ introduction

Color is a highly subjective topic and one of the most debated subjects in the world of graphic design. It is also an exciting area of study, since working with color produces immediate results.

Translating the science of color into practical results is not always easy. Clients want the color reproduction featured on or in their products to look as good as possible but are often not aware of the limitations that color has when applied to different media. In addition, designers want their work to be reproduced as accurately as possible to maintain the visual appearance of the work that they have created. It is normally the printer, who comes at the end of the production cycle, that suffers the wrath of both clients and designers when the final product does

not appear quite as expected. However, often it is not the printer's fault; unsatisfactory color specification is one of the main problems in the design industry. Few, up until now, have had the skill and knowledge to manage color usage efficiently to guarantee a satisfactory product. The aim of this book is to arm you with that skill and knowledge, which will put you in a position to understand both the potential and limitations of color, regardless of the situation. With this understanding, you will be able to accurately inform clients of the limitations that they can reasonably expect, and be able to identify where problems might originate.

This book has been designed to enable you to work more effectively with color no matter what type of

work you produce or computer platform you work on, with the focus always on practical usage rather than theory. It takes you back to the beginning of color science, in the seventeenth century, where much of the science that we still use today was discovered. This brief history is important because it will provide a solid foundation for your knowledge of the subject, and will enable you to see how many of the "old" principles we still use today with digital devices. You will also be introduced to the way that our eyes and brains see color and how you can use this to enhance your work, investigating the psychological aspects of color, how our immediate environment affects our interpretation of color, and how this interpretation changes from one culture to another.

Color science within the field of modern digital imaging is also important and you will be shown how color can be communicated verbally and mathematically. From this you will be able to see how color is defined and used for images designed for screen display and printing, and be able to identify what colors will be available on a range of digital outputs. You will also learn how to create digital color, using digital technology to input, control, and manage images and files. Lastly, the book will show you how to manage color on a digital system across a range of products, regardless of whether you are using a Mac or a PC. Together, this is an invaluable and detailed resource for anyone needing to control digital color.

the science of color

The science of color goes back to the seventeenth century and this chapter introduces the fundamental theories that we still use today to generate, and communicate, color. It also introduces the physiology of how we see color, how this is communicated to the brain to give a "pleasing" image, and how we can use this information to help us select and utilize color effectively.

■ light and color

The science of color dates from the seventeenth century when Sir Isaac Newton conducted experiments into color vision. His discoveries still underpin much of today's research.

right Sir Isaac Newton, who was responsible for "discovering" the principles of light and color.

In the seventeenth and eighteenth centuries, all the research and discoveries regarding light and color were based on observation and experimentation. Sir Isaac Newton (1642–1727) played a key role in this with his investigations into optics during the "plague years" of 1665–1666, when the Black Death struck London.

Newton discovered that pure (or white) light is made up of all the available colors that we find in the visible spectrum, and that they can be separated using optical prisms. This led to the discovery that light is colorless when the whole visible spectrum is transmitted equally, but when there is an imbalance, individual colors become visible. Newton was the first to recognize that a

below The electromagnetic spectrum shows the visible and invisible electromagnetic wavelengths.

THE ELECTROMAGNETIC SPECTRUM

.00001 nm	.001 nm	1 nm	10 nm	
COSMIC RAYS	**GAMMA RAYS**	**X-RAYS**	**ULTRAVIOLET**	**VISIBLE SPECTRUM**

400 **WAVELENGTH IN NANOMETERS** 500

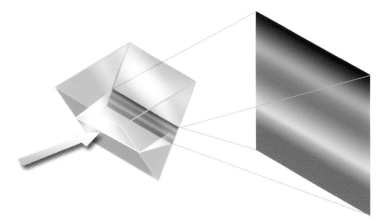

prism can separate wavelengths of light into colors, basing his experiments on discoveries by Robert Boyle (1627–1691) and his assistant Robert Hooke (1635–1703), and influenced by the theories of the scientific and mathematical philosopher René Descartes (1596–1650).

Light is produced when electrons move from a high-energy source, such as the sun, to a lower one, such as outer space. Light energy is emitted, or radiated, in the form of waves of electromagnetism, and the length of the wave dictates the hue we perceive. These wavelengths are measured in nanometers (nm). The eye can only "see" a small range of the whole electromagnetic bandwidth, between 400 nm and 700 nm, which Newton named the "visible spectrum." The closest "colors" outside the visible spectrum are ultraviolet at one end and infrared at the other. It is easy to observe our reaction to this type of light through the

tanning of the skin from ultraviolet light and heat from infrared. The spectrum does not have hard boundaries; instead, the colors seem to "merge" in and out of each other, causing a great deal of debate about how many colors make up the visible spectrum. It was especially difficult when this was done visually using prisms or rainbows. Today, we have powerful computers to help us, but it is still not an exact science. Newton identified that there were seven

colors in the spectrum: red, orange, yellow, green, blue, indigo, and violet (these are memorized at school as "Mr. ROY G. BIV" or "Richard Of York Gave Battle In Vain"). Three of these colors, red, green, and blue, are known as "primary colors."

From these basic experiments in the seventeenth century by Newton, Boyle, and Hooke, came the necessity for science to develop devices that enable us to measure electromagnetic light and color.

top Separating the wavelengths of white light through a prism was how Newton discovered that white light contains all color properties.

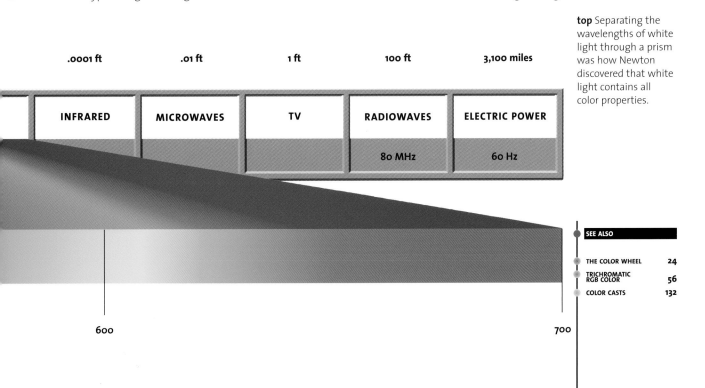

.0001 ft	.01 ft	1 ft	100 ft	3,100 miles
INFRARED	MICROWAVES	TV	RADIOWAVES	ELECTRIC POWER
			80 MHz	60 Hz

600

700

how we see color

Our eyes see color, but it is our brains that interpret what we see, often with mixed results. Modern digital systems attempt to take the interpretive nature of color into account.

The eye sees color only once light has reflected off an object. Any colors that have not been absorbed by the object are reflected into the eye. A leaf is green because when it is exposed to white light all the other hues of the spectrum are absorbed and only the green is emitted. An opaque white will reflect all wavelengths of light equally, while black does not reflect any.

Newton conducted many experiments to discover how the eye sees light to create color images in the brain. He drew on his experience of optics to study the eye's lens, and his knowledge of physiology to find the light-sensitive areas of the eye and how the brain interprets the data sent to it. Many of these experiments were extremely unpleasant and mainly performed on himself. One involved sticking a blunt needle used in the weaving industry into his eye, between the tear duct and the eyeball. He then moved the needle about, noting at what point the colors became visible. This must have been

THE EYE AND COLOR VISION

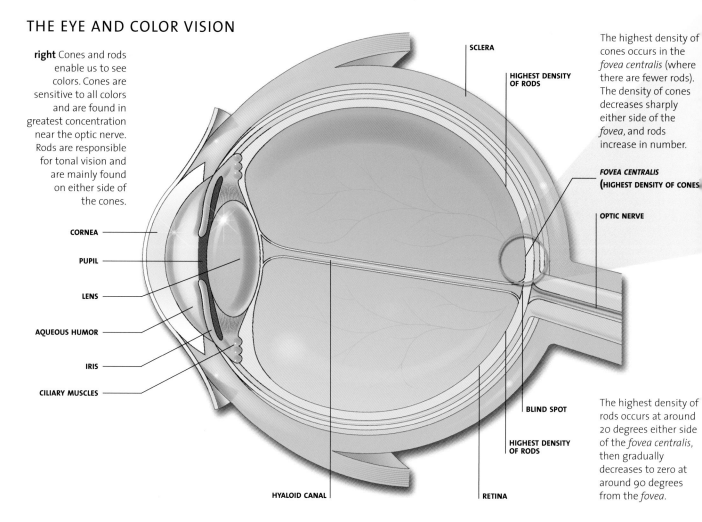

right Cones and rods enable us to see colors. Cones are sensitive to all colors and are found in greatest concentration near the optic nerve. Rods are responsible for tonal vision and are mainly found on either side of the cones.

CORNEA

PUPIL

LENS

AQUEOUS HUMOR

IRIS

CILIARY MUSCLES

HYALOID CANAL

SCLERA

HIGHEST DENSITY OF RODS

The highest density of cones occurs in the *fovea centralis* (where there are fewer rods). The density of cones decreases sharply either side of the *fovea*, and rods increase in number.

FOVEA CENTRALIS (HIGHEST DENSITY OF CONES)

OPTIC NERVE

BLIND SPOT

HIGHEST DENSITY OF RODS

RETINA

The highest density of rods occurs at around 20 degrees either side of the *fovea centralis*, then gradually decreases to zero at around 90 degrees from the *fovea*.

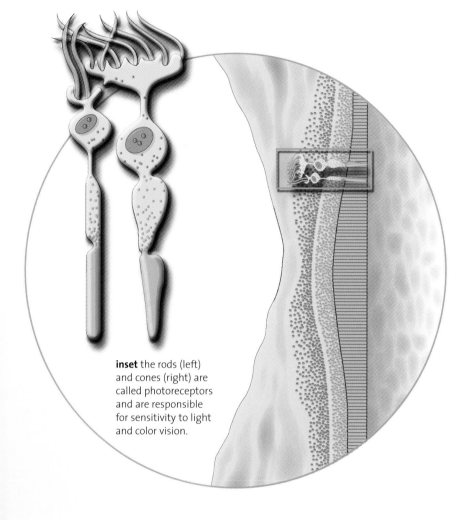

inset the rods (left) and cones (right) are called photoreceptors and are responsible for sensitivity to light and color vision.

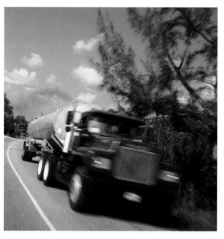

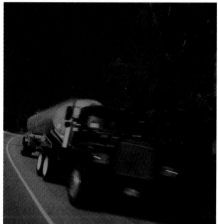

top and above Cones, which are responsible for color vision, need high levels of light. At night, when light levels are low, we can only see in black and white, using rods.

very painful but showed that color cannot be seen in all parts of the eye. He also discovered that certain colors, especially blue, are easier to perceive than others.

rods and cones

The human eye has an inner layer called the retina, which contains neurons (nerve cells) that transmit vision signals to the brain via the optic nerve. These are connected to two types of light-sensitive cells called rods and cones, so-called because of their respective shapes. There are estimated to be 125 million rods and seven million cones in the average eye. Rods provide vision at lower light levels and can discriminate between light and dark shades, shapes, and movement. Cones are used for color vision and sharpness of vision (visual acuity). In bright daylight, we see in color using our "photopic" vision, but in very low levels of light we tend to see very little color, using "scotopic" vision (at night, we see in black and white). This demonstrates that the cones are less sensitive to light.

The distribution of cones is uneven, with the largest percentage located in the *fovea centralis*, where there is a cone density of 232,500 per square inch (38,500 per

how we see color continued

square centimeter). This raises one of the major problems with color vision; because cones are mainly concentrated in only a small area of the eye, most of the color we see is actually imagined. If we saw exactly the color and tone that our eyes capture, then we would see color only in the center of our field of vision, as demonstrated in the image below.

Clearly, this is not how things appear to us. This is because our brain interprets what we see based on our prior experience or expectations. The eye also constantly scans the field of vision to gain data subconsciously. If we think the color should be red, then we will see red until we turn our head, allowing the cones to correct it. Only when you look at something with the central area of your eye, where the cones are located, can you be sure of the color. This was well known by 1900 and was considered to be a result of the bleaching of the photosensitive substance in the eye—"rhodopsin" in the rods and "iodopsin" in the cones.

By 1957, it was accepted that the three types of cone have peak sensitivities at three different wavelengths—blue, green, and red. Retinas observed in cadavers later indicated that three different pigments were found in different cells, which means each cell is only sensitive to a narrow range of wavelengths. This information forms the basis of the technology behind image-capture in Charged Coupled Device (CCD) cells used in modern digital scanning devices (see pp. 120–121).

right We have fewer cones than rods, which means we see more tone than color. This is an artist's impression of what we would see if our brain did not interpret the image.

left Green leaves absorb red and blue hues and only reflect green. The reflection is what we see.

right In these diagrams you can see how the colors cyan, magenta, and yellow are created by combinations of absorbed and reflected light.

CYAN

MAGENTA

YELLOW

WHITE

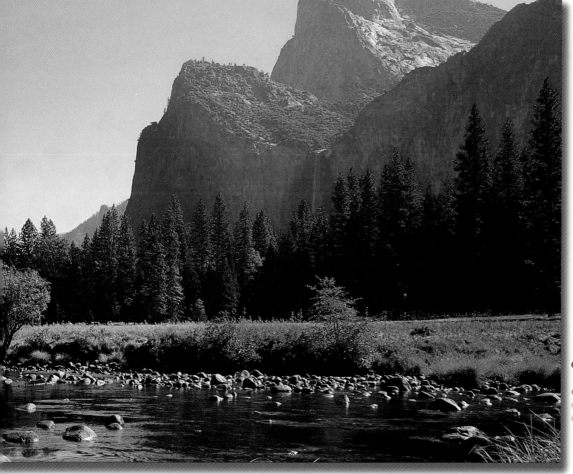

defects of vision

Many people have color errors in their vision, but are not aware of them until they are tested. The error is on the X chromosome and women have fewer problems than men.

Color blindness was first reported in the West in 1772, in a paper called "History and Present State of Discoveries Relating to Vision, Light, and Color" by the eminent scientist Joseph Priestley (1733–1804), in which the color vision problems of his colleague, John Dalton (1766–1844), were discussed. Dalton reported that he could not distinguish between certain colors and this developed into the conventional classification of color blindness by Johannes von Kries (1853–1928).

Dalton went on to write another paper called "Color Discoloration of Pigment in the Eye" (1794), where he proposed that the vision error lay in the coloring of the liquid within the eye itself. This theory was later disproved but the term "Daltonism" is still used today to refer to color blindness.

inheritance

Dalton identified that there was an hereditary nature to color blindness. The X and Y chromosomes are responsible for determining the sex of a baby, but only the X chromosome is responsible for color vision. The gene for color blindness is normally given the symbol "c," with normal color vision being given the symbol "C" (see box, opposite). The X chromosome carries the genes C/c that are responsible for color vision, and the Y chromosome does not. Because females have two X chromosomes, it is less likely that they

above Normal color perception.

TRICHROMATS

Protanomaly

Deuteranomaly

Trichromats have three types of cone cell. Most people with normal color vision are trichromats. However, in "anomalous" trichromats, sensitivity to red or green is shifted slightly, affecting their ability to distinguish between certain colors.

above Subjects with deuteranomaly are less sensitive to green.

left Protanomalous subjects are less sensitive to red.

will inherit two Xc chromosomes, so it is a lot less likely that women will be color blind. Only one XC chromosome is required for perfect color vision. Since men only have one X chromosome they are more likely to inherit an error. Because of the X chromosome, the ability of a person to see color can result in the variations in vision illustrated below.

Interestingly, women are more sensitive to all ranges of the electromagnetic spectrum, including audio perception, yet few companies use exclusively women for qualitative analysis during the development of their products.

MONOCHROMATS

left Monochromats only see in monotone (one color). This is extremely rare in humans but common in some animals.

below Color blindness is carried on the X chromosome, making men more prone to color defects.

XCXC	Normal female
XCXc	Normal female carrying the recessive gene for color blindness
XcXc	Color-blind female
XCY	Normal male
XcY	Color-blind male

DICHROMATS

Protanopia

Deuteranopia

Tritanopia

Dichromats are deficient in one of the primaries and this is probably the most detectable of deficiencies. They have a serious problem distinguishing between certain colors.

left Protanopic subjects are insensitive to red.

above Deuteranopic subjects are insensitive to green.

above Tritanopic subjects are insensitive to blue, which is an extremely rare condition.

color testing

(Shinobu) Ishihara's charts are a common way of testing color vision. However, other methods are used for specialized tasks. Many industries test for color vision errors.

There are three common ways to test subjects for color blindness, and these are incorporated into early medical tests given to children to identify problems. These tests are known as (Fithiof) Holmgren's skeins, Ishihara's charts, and the lantern method.

The Holmgren's skeins method involves giving the subject a piece of wool for which a match must be found from an assortment of other colored skeins of wool.

Ishihara's charts (below and opposite) use colored circles to create the shapes of numbers on a background of similar circles in a different color. These colors are deliberately chosen to highlight different vision defects.

The lantern method has the subject identify the color of small illuminations of various sizes. This method is used for workers such as engine drivers who look at illuminated signals all day.

PLATE 1

This is the easiest to see, as there is good hue and tonal difference. Almost everyone can see the number 12.

PLATE 2

This plate puts a green number 5 against a red background. Those with a red/green deficiency will see this as the number 2.

PLATE 3

The number 29 is interpreted as the number 70 by those with red/green deficiency, and cannot be seen at all by those who are totally color blind.

PLATE 4

The number 74 is seen as the number 21 by those with a red/green deficiency. Again, it cannot be seen at all by those who are totally color blind.

PLATE 5

The number 45 cannot be seen at all by those with any type of color deficiency and simply appears as a pattern of dots.

PLATE 1

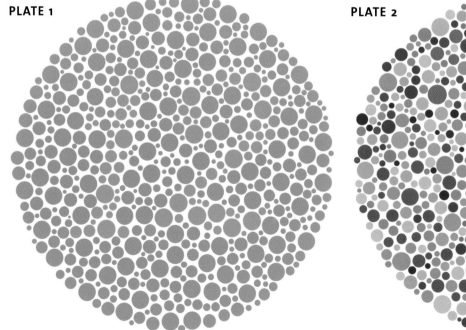

PLATE 2

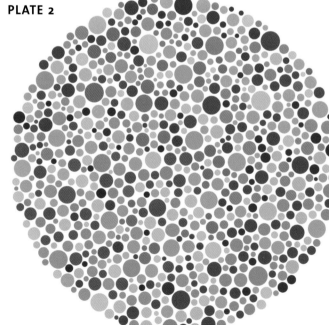

PLATE 3

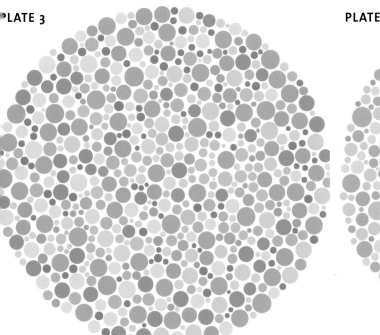

PLATE 4

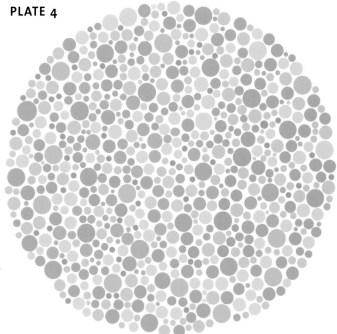

PLATE 5

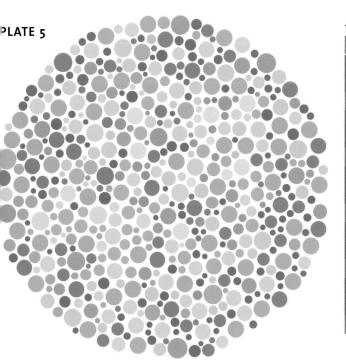

TEST RESULTS CHART

PLATE	NORMAL	RED/GREEN DEFICIENCY	TOTAL COLOR BLINDNESS
1	12	12	None
2	5	2	None
3	29	70	None
4	74	21	None
5	45	None	None

additive and subtractive color

Color reaches our eyes either directly or indirectly (reflected). Understanding and managing the difference between the two is the key to successful color management.

The way color is created with direct light (additive color) is different than how it is created with reflected light (subtractive color). Managing this difference helps solve the basic problem with computer screen to print applications.

additive color

Additive color is created when different frequencies of direct light are mixed or added together to create colors, and follows the same principles as our eyes'

visual system. Any color that we can see with our eyes can be replicated using this system. From Sir Isaac Newton's experiments, three primary colors of light were established, namely red, green, and blue. Primary colors are those that cannot be created by combining any other colors. The primary colors of light are called "additive color" because the more light you add, the brighter the object becomes, so when all three colors are combined they create bright white (see below).

Secondary colors, where two primaries are mixed, are brighter than each primary because, as we have mentioned, more light is used to create them; also, this means that secondary colors use two color sources whereas a primary color only uses one. However, too much light can result in less color saturation, owing to bleaching as the item emits more light, so a careful balance is required. One hundred percent brightness (maximum light) creates white and zero brightness (minimum light) creates black. The whole visible spectrum can be found between these two extremes.

The additive trichromatic color theory of light has been developed and used particularly by the computer and television industries by projecting red, green, and blue lights against the screens of computer monitors and televisions, using a cathode ray tube.

By having different intensities of light in different areas you can mix additive color like you can paint, giving rise to the term "additive mixing." By mixing primary colors together it is possible to achieve the secondary colors of cyan, magenta, and yellow (see left), which are used in the subtractive color system (see opposite) in the printing industry.

Of all the systems of creating color those that use additive principles offer the greatest range of achievable color, or color "gamut," because of the luminosity that can be achieved by having the image projected through a screen using light.

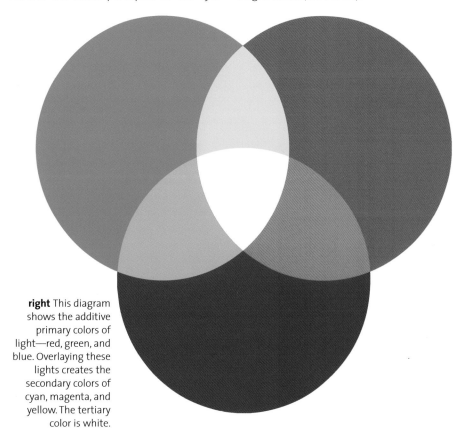

right This diagram shows the additive primary colors of light—red, green, and blue. Overlaying these lights creates the secondary colors of cyan, magenta, and yellow. The tertiary color is white.

subtractive color

The subtractive color system is based on the way that artists and painters use colored inks and paints on paper or canvas, and is the opposite of additive color. The name originates from the fact that the greater the amount of color used, the darker it becomes, in effect, subtracting color. For example, if you mix all colors together you get a type of black or dark brown, depending on the quality of your paint. The opposite color to this is white, depending on the brightness of the paper (the "substrate"). The subtractive system needs the substrate to reflect light. The greater the reflectivity of the substrate, the greater the color gamut, which is why glossy paper offers more color potential than mat paper.

The primary colors of red, blue, and yellow are the brightest colors because these use less pigment. When you mix two colors together, whether in the form of paint, ink, or dye, you create the secondary colors of orange, purple, and green, which are darker. The more color you add, the darker it becomes, as more light is subtracted, or absorbed, into the pigment of the paint or ink and the substrate. Subtractive color is viewed by reflecting light from the pigment (and the substrate), and this gives a smaller color gamut than the additive system.

special colors and printing

When using subtractive color systems, it is not possible to add luminance to the image as you can when using additive methods

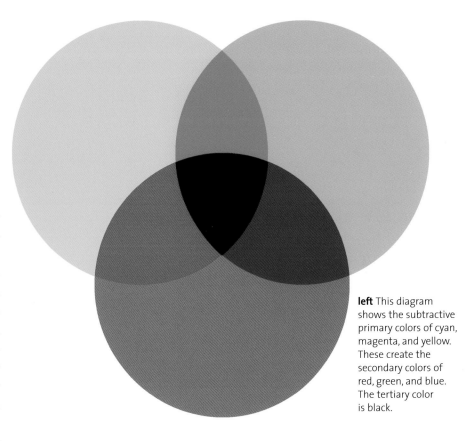

left This diagram shows the subtractive primary colors of cyan, magenta, and yellow. These create the secondary colors of red, green, and blue. The tertiary color is black.

on your computer screen. This limits your color gamut. Special colors, such as metallic effects cannot be created from the primary colors and special paint needs to be purchased. By contrast, these hues are available in the additive system. As we have seen, the type of paper used can greatly add or subtract from this range of subtractive colors, depending on its reflectivity or gloss.

Photographic and modern printing processes use subtractive cyan (C), a light blue, magenta (M), a slightly blue-red, and yellow (Y) dyes as primary colors due to the fact that these are the secondary colors created when additive primaries are mixed. The printing industry uses specific hues of these

subtractive primary colors with slight variations between nationalities. Those used in the U.S., for example, are not the same as those used in Europe or Asia (see pp. 42–43). The lack of a "hard" black is remedied by adding a black to the printing process, and is given the prefix of "K" to complete the printing colors known as "CMYK."

SEE ALSO

TYPES OF INK	42
TRICHROMATIC RGB COLOR	56
CMYK MODEL	70
COLOR MANAGEMENT	154

2

using color

Selecting colors that work well together in a single design can be problematic. Some color combinations enhance each other, while others clash. This chapter introduces the color wheel, a simple tool that helps designers choose harmonious color schemes for their work and select colors to add impact or draw the eye to key information contained in an image. It also shows how color "tastes" and visual meaning differ throughout the world and how to adapt a color palette to suit particular commercial markets.

the color wheel

The color wheel is the key to understanding how to use color.
Use this tool to select colors that work together.

The first color circle was developed by Sir Isaac Newton, but this lacked the usability of later systems. The color wheel as we know it today dates back to the eighteenth century when it was developed by Moses Harris (1731–1785). It has long been used by artists to help select color ranges for their work, including the challenge of mixing colors to create pigments that provide not only the required hue but also the necessary longevity.

The color wheel is still used today to identify which colors work together and to improve color communication. The principles can be applied to any work where color is important, in all areas of media. For example, these theories can be applied to digital TV, the worldwide web, and DVD, as well as traditional painting.

creating the color wheel

A basic color wheel starts with the three primary colors equally spaced around a circle. Primary colors are those that cannot be created by mixing other pigments together, but that can be mixed to match any other color. The primary colors are red,

right There are three primary colors: red, blue, and yellow. By mixing these colors, it is possible to create any color on the color wheel. The secondary colors are a mixture of two primary colors and are placed in between the primary colors. These are green (blue and yellow), purple (red and blue), and orange (red and yellow). Tertiary colors are a mix of all three primary colors.

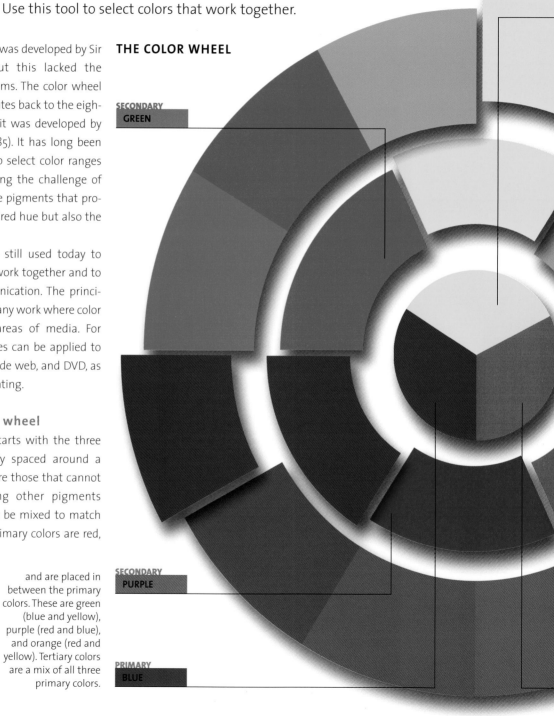

THE COLOR WHEEL

SECONDARY
GREEN

SECONDARY
PURPLE

PRIMARY
BLUE

PRIMARY
YELLOW

SECONDARY
ORANGE

blue, and yellow (labeled sometimes as primary or spectrum red, blue, and yellow). The printing industry uses a slight variation of these primary colors: cyan (blue), magenta (red), and yellow, known collectively as "CMY." It is possible to use the following coordinates in CMY to create the primary colors:

Red	**100% M 100% Y**
Blue	**100% C 100% M**
Yellow	**100% Y**

A color wheel using the printing primaries, 100 percent CMY, is shown in the illustration on the right.

However, because of the different properties of additive and subtractive color (see pp. 20–21), the primary additive colors of light, RGB, cannot be used in the same way. To create a color wheel in RGB on your computer, use the following coordinates:

Red	**255 red**
Blue	**255 blue**
Yellow	**255 green, 255 red**

The secondary colors, a mixture of two primary colors, are then placed between the primary colors on the color wheel:

Green: a mixture of blue and yellow
Purple: a mixture of red and blue
Orange: a mixture of red and yellow

In the illustration (left) we have added a third outer wheel to further break down the primary colors to help show the range of hues available, giving a total of 12

PRIMARY
RED

options. This will give you a good idea of the color range that you can use, apart from tertiary colors (see pp. 28–29), which are made up from a combination of all three primaries.

Work is still being undertaken on the color wheel. Michael Wilcox at the Color Research Group, based in Bristol, England, has developed a new system, based on color "temperature," with warm and cool hues (see pp. 34–35).

CMY SUBTRACTIVE COLOR WHEEL

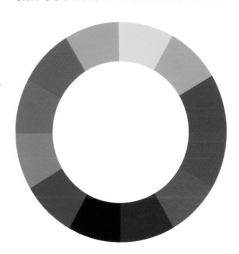

above All color wheels are based on subtractive color but can be applied equally well to additive systems. Additive color wheels have a greater chromaticity than subtractive ones.

selecting color

What we see when viewing an image over time is not the same as what we see at first glance. Our brains and environment influence the way we perceive color.

Selecting colors can be difficult and often the color we choose either does not work, or is not as appropriate as we first thought. Conversely, other colors that we initially reject become favorable, which causes confusion. There are three main reasons for this, outlined below.

how the brain interprets color

We learned in How We See Color (pp. 12–15) how our brain interprets what we see; we view one image through two eyes, and create a full color image despite our color receptors covering only a small percentage of the eye. We see mainly what our brain expects, or desires. This causes problems when we view colors because the brain can change them to be the colors we want. It is not unusual for an art director to comment along the line of: "I don't like that color; actually it is not that bad; I don't mind it; actually I quite like it now." What has happened here is that the brain has changed the color into another that is more pleasing. Generally, we only have a couple of seconds before the brain starts to alter the hue for us, so your initial decision is generally the correct one, and you should stick to it.

A further example of this is when you take a photograph indoors without a flash; the image comes out orange or green. This is due to the lights in the room that give off a color cast that our brain corrects. This cast—orange under tungsten light and green under fluorescent—is transferred to any color that we observe.

different lighting conditions

When working with color, we should avoid "metamerism," where hues change under different lighting conditions. This is a result of the brain interpreting what it sees. However, it does not always get it exactly right, so a color viewed under tungsten lights will appear different in natural daylight. To help overcome this, lighting conditions must be stable when making color judgments (see below and opposite).

stable viewing conditions

To help assess colors accurately, stable viewing conditions must be created. Light is measured in temperature, which was discovered by measuring the glow reflected off a black substrate as it is heated to

FLUORESCENT LIGHT

TUNGSTEN LIGHT

right The room in both pictures is painted white. The brain will duly tell us that we are seeing white, but this is only because it is correcting the colors that are actually there. Photographic film cannot make this interpretation and shows us what the room really looks like before our brains correct it, under two different lighting conditions.

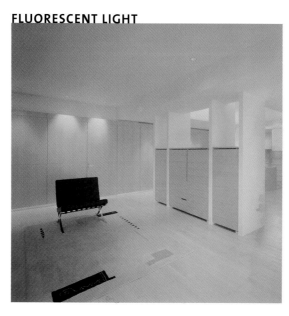
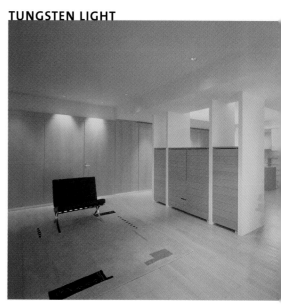

different temperatures. These are classified in degrees Kelvin (K). Because daylight is variable, the scale is based on measurements of direct sunshine on a June day in a temperate latitude. Daylight is considered to be 5,600 degrees K, or D56. If you use a more northerly angle, around Canada for example, the measurement is then a temperature of 6,500 degrees K, or D65. The higher measurement contains more blue wavelengths, as light has to travel through more of the atmosphere. These two measurements are referred to as the "Standard Viewing Condition."

D56 and D65 bulbs can be used to assess additive and subtractive products (images from light or from pigment). Viewing booths and professional photographer's lightboxes are made with standard D56 and/or D65 bulbs. In the display calibrator on the Mac OSX system you can enter your preferred lighting condition.

INDOOR/OUTDOOR TEST

left View each half of these color swatches under a light bulb and then in daylight. You will notice that under one light they appear the same, but under the other, different.

HUE CHANGE

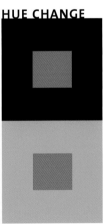
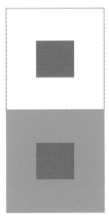

above Professional viewing booths use D56 and D65 bulbs to accurately replicate daylight conditions.

above Colors also visually change depending on their background color. This is because the brain tries to balance the tonal ranges of the hues.

■ color harmony

Colors have personalities of their own and can work well together or clash and cause difficulties. Colors that surround an image are as important as the image itself.

Some color combinations can induce an emotional or physical response in the viewer, making effective use of color a powerful tool. Many industries use color theory to benefit their business and large companies often employ color consultants. Retail outlets use color to help control the average time customers spend on their premises and to encourage them to purchase something. The color wheel can help you choose colors that will make a strong impact on the viewer.

how to use the color wheel

You can use your color wheel to select hues that will harmonize with each other. The colors closest to each other will be harmonious. The colors that have the greatest contrast are called "complementary" and are found directly opposite each other on the wheel; for example, red is complementary to green. Complementary colors should be used together with care because they may cause the viewer optical difficulties.

To use the color wheel when selecting a color scheme, block out one-third of the wheel opposite your chosen color. The remaining visible colors will be harmonious.

tertiary colors

Tertiary colors are created when three primary colors are used to create a color. They are not shown on the color wheel but they do have a purpose. If you want to neutralize a secondary color, make it less saturated or less intense, then add a little of the complementary color to help achieve this. In the illustration on the right, you can see how adding a small amount of the complementary color neutralizes the original.

If all three primaries are added together in equal amounts, using subtractive color systems, then a brown or light black color is created.

COLOR SATURATION

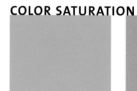

above and right The orange color on the left has been made less intense by

adding some of its complementary color in this case, 10 percent cyan.

COLOR ILLUSION

far left and left The color in the middle of the box is the same, but the left-hand image looks more saturated.

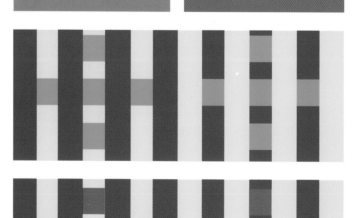

above left and left The red and green squares appear to be different depending on whether the background is blue or yellow.

below This woodland scene uses hues from green to violet. There is little or no yellow in the image.

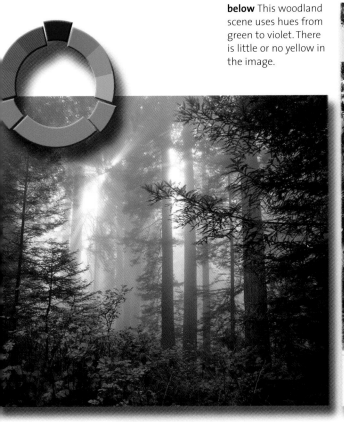

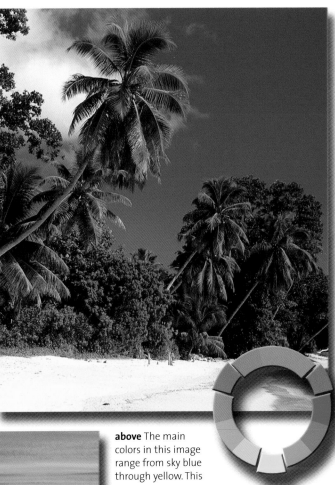

above The main colors in this image range from sky blue through yellow. This image contains very little red.

right This saturated image has hues ranging from yellow to purple. Very little blue is used in this image.

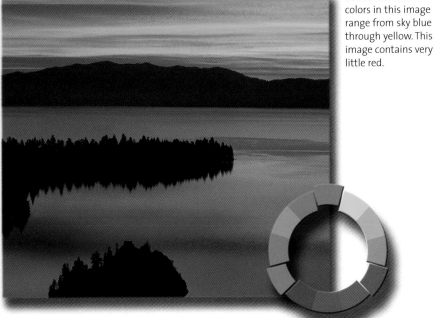

■ color harmony continued

Getting colors to work together can be difficult. Here are some guides to help you select colors that harmonize, or work well, with each other.

TWO-COLOR HARMONY

THREE-COLOR HARMONY

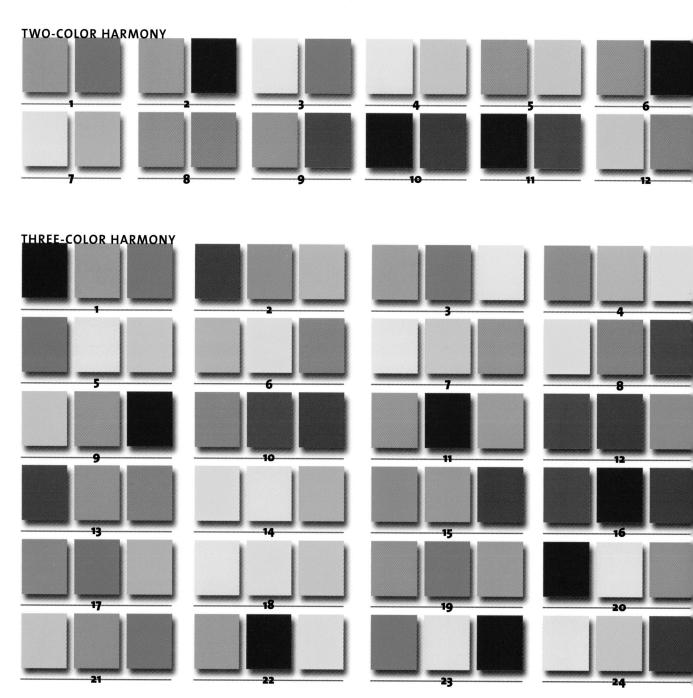

OUR-COLOR HARMONY

1

2

3

4

5

6

7

8

9

10

11

12

13

14

15

16

17

18

IX-COLOR HARMONY

1

2

3

4

5

6

■ natural color usage

The natural world is full of superb examples of effective color usage. Evolution has enabled plants and animals to either attract attention or hide themselves.

As humans, we are surrounded by nature. Although everywhere we go we find different plants and animals, they all share the same characteristics when it comes to color. Animals, with the odd exception, wish to blend in with their background and are often camouflaged. This conforms to the "standard" color wheel theory, where all hues and tones should be close to each other on the color wheel (see pp. 24–25).

However, with vegetation it is a different story. Plants nearly always have some form of green foliage. When they require animals or insects to pollinate them they need to make their flowers stand out so that the pollinators know where to go. If the flowers were similar in hue to the leaves, an insect may easily overlook a garden of roses, but because the petals and surrounding leaves are in complementary colors, the flowers are more conspicuous.

We can copy nature when using colo applying its rules to our own work. As i nature, complementary color can be use to identify key areas of interest. The color o a flower is complementary to the color of leaf so as to attract insects and we can us this principle to draw the eye to a particula aspect of an image, whether it is a compan logo or an element within a picture. Th rule is to add no more color than natur would. Too much and the effect is lost.

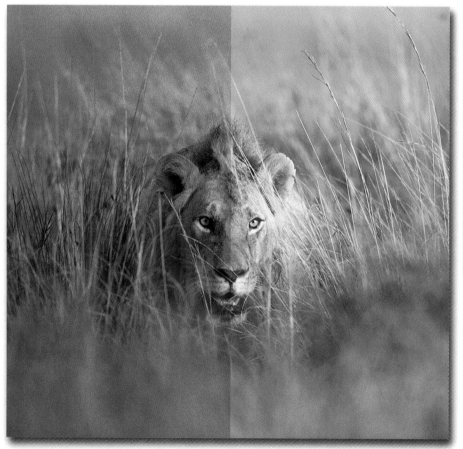

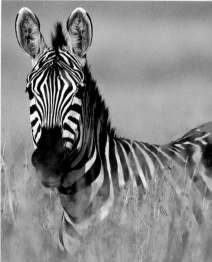

left The tones and hues of the lion and its background are the same, which means it can hide from both prey that sees color and prey that sees only tone.

above The hue of the zebra is clearly different from its surroundings, but it appears camouflaged to predators that see only tone.

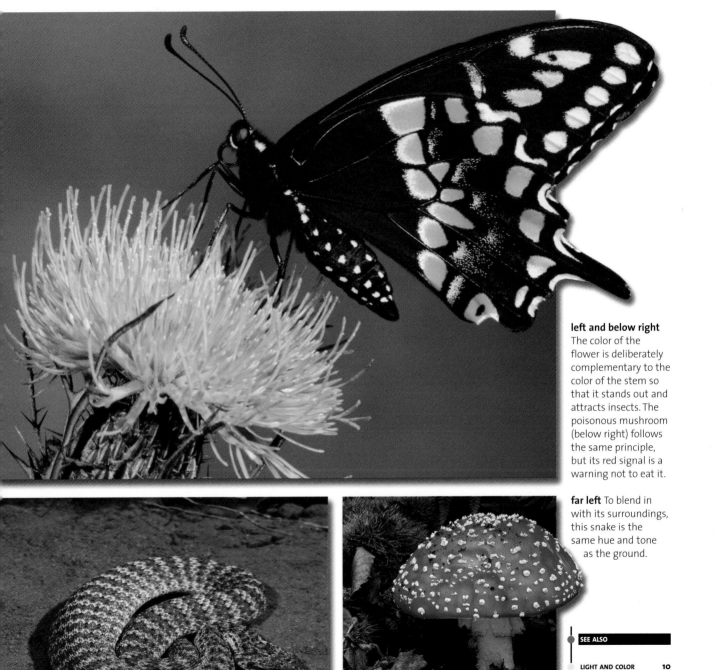

left and below right The color of the flower is deliberately complementary to the color of the stem so that it stands out and attracts insects. The poisonous mushroom (below right) follows the same principle, but its red signal is a warning not to eat it.

far left To blend in with its surroundings, this snake is the same hue and tone as the ground.

■ the temperature of color

Colors have temperature associations, determined by what we have learned from the natural world. You can apply the principles of temperature to your images.

As discussed earlier, color has a strong relationship with temperature (see pp. 26–27). This is a physical association but color also has psychological associations with temperature that are based on our experiences of our environment, and you can use this to great effect to enhance your use of color. Each hue has its own "temperature," some are hot and others cold. Blue is considered to be the coldest color and orange the warmest.

Blue has associations with cold due to the physical effects of freezing temperatures. Our lips go blue when chilled, ice often reflects the sky, giving it a blue tint, and very

cold water running off a glacier often appears blue.

By contrast, red is associated with fire, heat, and burning. Coals glow red and provide heat and our red blood warms us and gives us life. Yellow has fewer associations with warmth than red but is still considered warm. The sun, the source of heat and light, is yellow, and when the sun rises, warmth follows. Yellow also has associations with regeneration due to the fact that the sunrise signifies the start of a new day, reclaiming it from the night, whose black tones are associated with death.

Secondary colors acquire the temperature of the most dominant primary temperature, so hues that contain blue can be warm or cold, depending on the amount of blue used in relation to the other color. Green is a good example of this because you can get warm and cold greens—those containing more yellow are warm, and those containing more blue are cold.

You can use the color height wheel (opposite) to help calculate the relative warmth of colors. Orange at the top is the warmest; the more blue that is added to a color, the cooler it becomes. In the spectrum

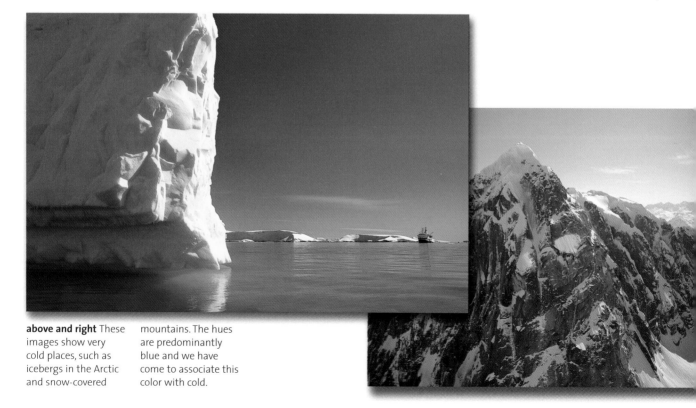

above and right These images show very cold places, such as icebergs in the Arctic and snow-covered mountains. The hues are predominantly blue and we have come to associate this color with cold.

hues of green and purple on the color wheel are considered neutral, as they have equal amounts of warm and cold constituents; green is 50 percent yellow and blue; purple is 50 percent blue and red.

color "height" or depth

Warm and cold colors also have the effect of bringing elements in an image forward or backward. Warm colors naturally tend to come to the foreground and cooler ones recede to the back. The color wheel also serves as a tool to show the relative height or depth of each color, with blue, the coldest, at the bottom of the wheel, and seemingly the furthest away. Orange, blue's complementary color at the top of the wheel, will appear closer to the viewer.

below and right
These images show a desert scene shot at different times of the day. At noon, the hottest part of the day, the hues are yellow. In the cooler evening, the hues are red. Both red and yellow are therefore associated with heat.

COLOR HEIGHT WHEEL

The color height wheel can be used to indicate the temperature of color. The highest point (orange) is the warmest and the lowest point (blue) is the coldest.

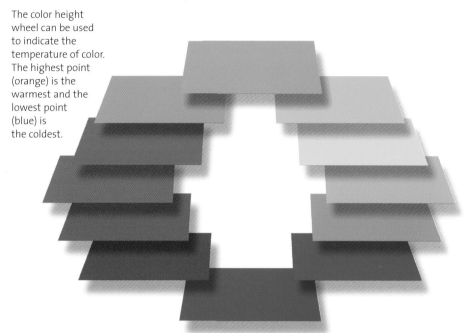

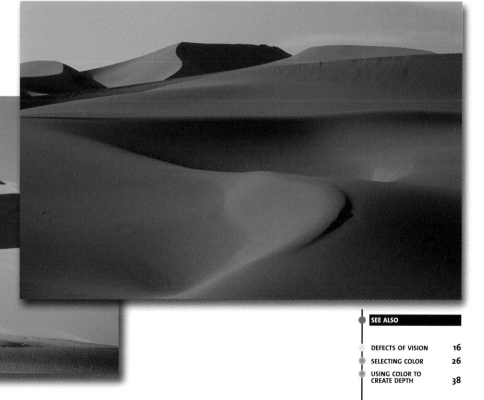

■ color tone

Because our eyes see more tone than color, and no color at all at night, the tonal value of color is very important. When choosing color ranges also consider their tone.

If you use a limited range of "safe" colors, your work can look a little dull or predictable. For greater impact, you will need to break some rules. Rules are meant to be broken, but only with care, or you run the risk of a bad result. Breaking the complementary color wheel theory can add dynamic effects to your design, but to enable this to work well, you will need to utilize your knowledge of the eye (pp. 12–15), the color wheel (pp. 24–25), and color temperature (pp. 34–35).

As we discovered earlier, the eye sees little color, but a lot of tone. When choosing colors you should always consider their tonal values as well as their hues. We see dark images on light backgrounds more easily than light images on dark backgrounds. If the tonal values are the same, then it can be difficult to make out the image.

All hues have a tonal value, as you can see on the desaturated tonal color wheel, below. You can see that many hues have very similar tonal values. For example, magenta, green, and red are almost identical in tone even though they are complementary colors on the color wheel.

If you wish to use these colors together, you will need to be careful with the tonal contrast between them. As a rule, because the eye finds it easier to see dark images on a light background, you will get best results from lightening the background color or darkening the foreground one.

COLOR WHEEL

TONAL COLOR WHEEL

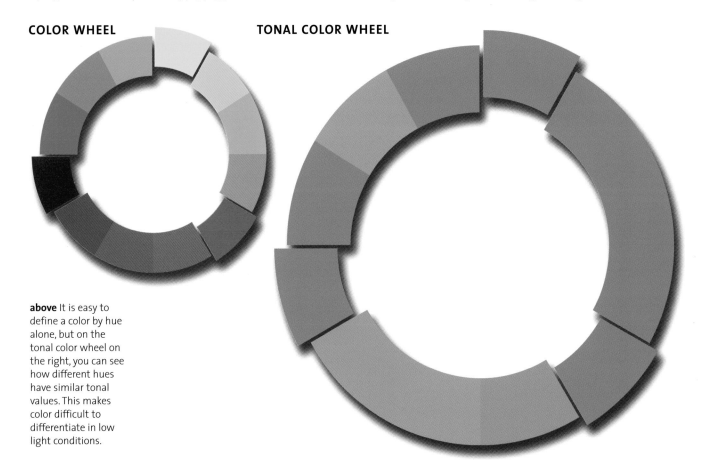

above It is easy to define a color by hue alone, but on the tonal color wheel on the right, you can see how different hues have similar tonal values. This makes color difficult to differentiate in low light conditions.

tonal example

Look at the red-on-green and green-on-red lettering on the right. It is very difficult to read red on green because there is no tonal contrast between the two colors. These colors are also complementary and so will clash and cause the eye discomfort.

To enable red and green to work together, we decided that since green is the coolest color we would place this in the background. We then lightened it to increase the tonal contrast between it and the red. The text is now "comfortable" on the background and is easy to read.

As you can see in the penultimate illustration, if we reversed the decision, using the green against a lightened red, the result would not have been as effective.

above The top two images are difficult to read because the colors have the same saturation and tonal values. The third image has been made easier to read because the tone of the background has been reduced. However, the most effective combination overall is red on a lightened green background.

below The top two lines of text are easy to read. However, when both colors are desaturated, the bottom two lines of text are impossible or difficult to read. This is because the tonal values of yellow and orange are very similar. This demonstrates that using colors with similar tonal values may be problematic.

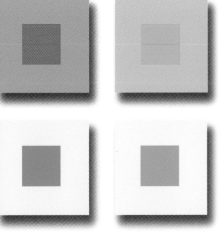

left and above When colors are on a tonal background, they are easy to distinguish, but when the colors are desaturated, some become more difficult to see than others.

using color to create depth

Color can be manipulated to create the illusion of distance. Skillful control of this part of color work can greatly increase the three-dimensional aspect of your images.

One difficulty we face when working on two-dimensional images is creating the illusion of depth. There are three techniques you can use to help generate depth, which are based on how all of us perceive our environment. The rules are:

**THE FARTHER AWAY AN OBJECT,
the less sharp it becomes;
THE FARTHER AWAY AN OBJECT,
the lighter its color;
THE FARTHER AWAY AN OBJECT,
the cooler its color.**

The first technique builds on the experience of photographers and relies on the fact that our eye focuses on individual objects, letting the remainder blur. Photographers use this to great effect by adjusting the aperture of the lens to give the perception of depth with blur, which they call "depth of field."

The second technique, increasing brightness and decreasing contrast and saturation, simulates the illusion that the farther away an object is, the greater the amount of light reflected, decreasing saturation. An easy way to observe this is on a perfect blue sky. The blue directly overhead is a lot deeper than that on the horizon.

The third technique, of adding cooler color casts to objects farther away, is probably the most critical when trying to convey a sense of distance. This technique is used to re-create the natural effect that we encounter on our planet, which has a blue atmosphere: the greater the distance, the more blue we see. When we look out to sea on a clear day it can sometimes be difficult to identify the horizon as the blue from the sea and sky blend together. Alternatively, warm colors can be used to bring objects to the foreground.

right and far right The jet engine in the photograph (right) is difficult to see clearly due to interference from the background detail. Reducing the depth of field and blurring the background (far right) increases the definition of the jet engine and focuses the viewer's attention on the object in the foreground. Blurring therefore reduces the sharpness, contrast, and saturation of unnecessary parts of an image.

TECHNIQUE 1

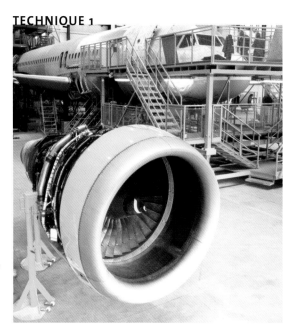

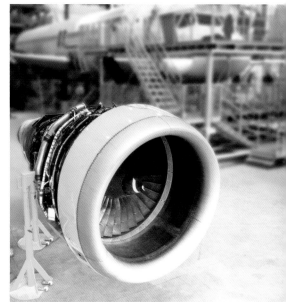

ECHNIQUE 2

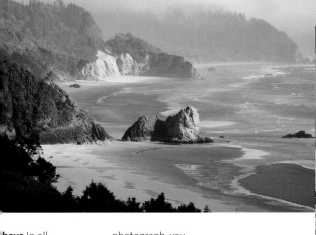

below This photograph shows how the landscape becomes cooler as well as less well defined the farther the distance from the viewer.

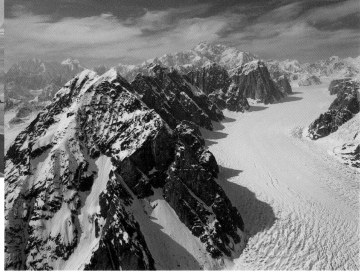

bove In all hotography, the reater the distance he background is rom the lens, the ooler the color. In this photograph, you can accentuate this natural phenomenon by adding cooler blues to the distant background.

ECHNIQUE 3

below If cool colors indicate distance, then warm colors create closeness. The warm greens and yellows in these fields bring them very close to the viewer, sending the background even farther away.

bove This photograph nows how the sea nd the sky blend ogether on the horizon, as the distant background becomes a haze of cool colors and undefined shapes.

▶▶

■ using color to create depth continued

In the illustrations on this spread, you can see how these principles have been applied both individually and collectively to an image to increase its depth.

The original image (right) appears two dimensional, because of its high levels of saturation in both the foreground and background. For example, it is difficult to tell how big the stones are. The image also fails to draw the eye to any one element and fails to convey any atmosphere.

APPLYING PHOTOSHOP

2 ► Mask the areas to protect by using an Alpha Channel in Photoshop. Alpha Channels are used to select specific areas active on the image with differing degrees of intensity, dependent upon the tone. Each Alpha Channel adds an extra eight bits of data to your file, giving 256 variations of tone.

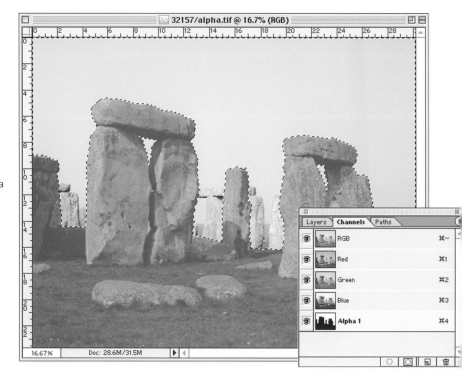

1 The first step is to prioritize what is important in the image. In this example, I want to show how the stones relate to the environment, with the main focus of the image being the two sets of stones in the foreground.

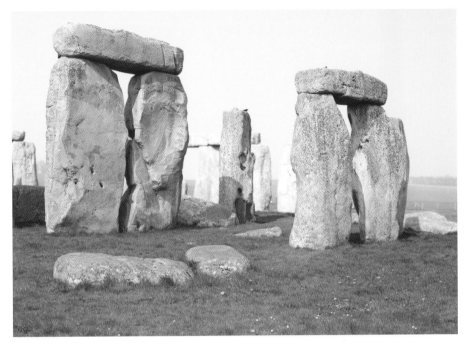

5 Finally, to hide the sharp edges of the stones in the foreground, run over them with the blur tool to soften them into the background.

4 Then, add +25 brightness and +10 contrast. Add a little blue to the mask using the Variations panel and add a little blue and cyan to the image to create the final effect (above).

3 Then, apply the blur filter, using a Gaussian Blur at a setting of 1.8 pixels.

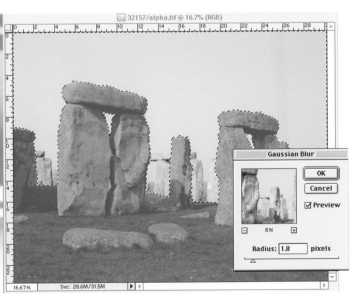

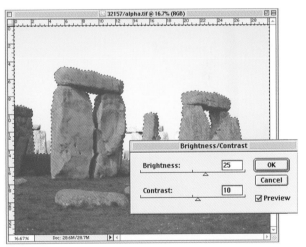

■ types of ink

Different cultures have different color tastes and there are different types of ink to reflect this. It is important to know which type of ink you plan to use.

right and opposite
Three CIEL*a*b* inkset diagrams. There are other ink manufacturers but these are the main ones. High-quality printers carry a range of these inks in order to produce global materials (see also pp. 98–101.)

EUROSTANDARD INKSET (EUROPE)

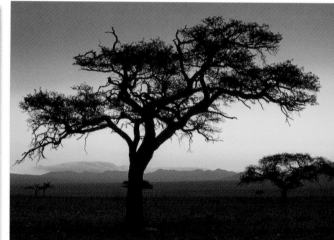

ORIGINAL IMAGE

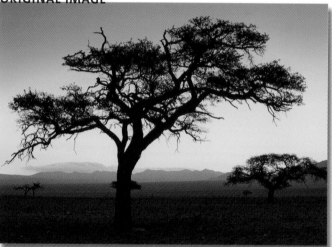

above and right These two digital images containing strong reds and yellows (above) and a variety of greens (right) were printed using three different inksets. The results are described for each.

above and right To help achieve the color imagery that is used in the U.K. and mainland Europe, the Eurostandard inkset is used. The images above and right give a representation of Eurostandard ink.

WOP INKSET (USA)

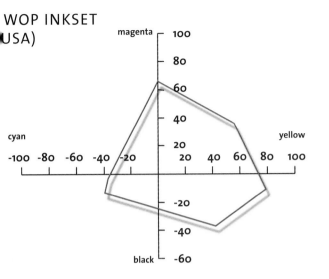

TOYO INKSET (ASIA)

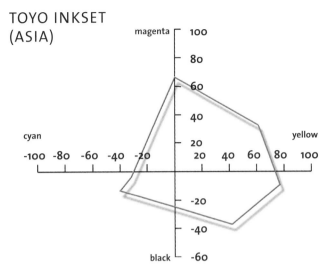

bove and right In the U.S., colors tend to be deeper and slightly more saturated than urostandard. To llow for this, an nkset called SWOP was developed. These mages give a epresentation of WOP ink.

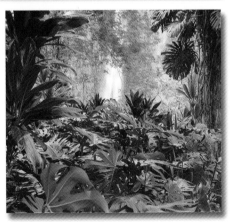

above and right In Asia, the colors are a lot brighter, more saturated, and the ink used is more luminescent. This ink is called Toyo and these images give a representation of the colors that can be achieved.

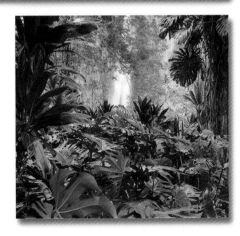

■ applying inksets

Changing your ink settings is easy to do and can dramatically improve the quality of your printing. You will need to take care to choose the right one. SWOP is the standard in the U.S.

You will need to tell your computer what inkset you wish to use. This information will need to come from your printing company if you wish to mass-produce your work. There are many ink manufacturers but these usually match one of the basic

standards in Photoshop. If your printer does not know which ink is most suitable, contact the ink manufacturer. If you are using a desktop printer such as an inkjet, the right settings come with the device and are installed in the operating software.

It is important to follow the instruction from the manufacturer, as they know the products best. Difficulties can occur when you use third party RIPS (see pp. 166–16 that do not hold manufacturer-specif information, because SWOP is the default

LOADING INKSETS IN PHOTOSHOP

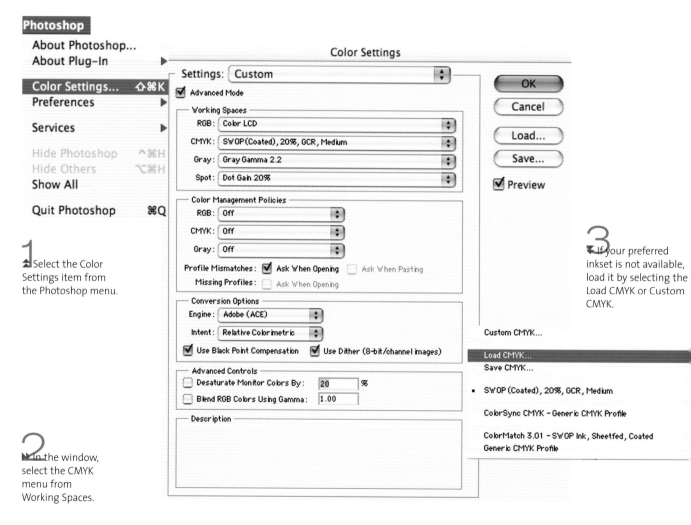

1 Select the Color Settings item from the Photoshop menu.

2 In the window, select the CMYK menu from Working Spaces.

3 If your preferred inkset is not available, load it by selecting the Load CMYK or Custom CMYK.

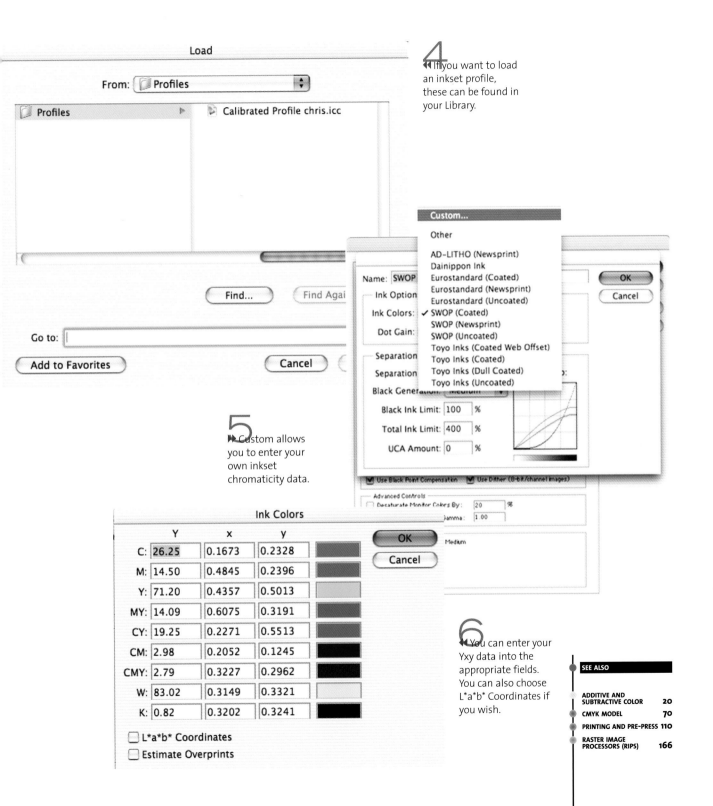

4 If you want to load an inkset profile, these can be found in your Library.

5 Custom allows you to enter your own inkset chromaticity data.

6 You can enter your Yxy data into the appropriate fields. You can also choose L*a*b* Coordinates if you wish.

■ special inks

Working with special colors enables you to work outside the standard CMYK process.
Special inks are ideal when printing with only two or three colors.

No matter which printing product you choose, basic CMY inks cannot produce the full range of colors that are possible in a subtractive medium. Colors outside this range have special properties such as luminescence or a metallic sheen. You can buy these as an extra from manufacturers. The most common software products to match this are Pantone, DIC, Trumatch, Toyo, and Focoltone. All produce swatches so that you can select your ink. It is often also

possible to purchase kits so that you can mix your own inks from raw primary colors.

Special inks also include varnishes that can add reflectivity to the substrate after printing. There are two methods of achieving this, either by varnishing the whole page, or by varnishing selected areas only, a process called "spot varnish." Varnishing increases the color gamut while the added reflectance of spot varnish can lead the eye to specific areas.

Spot colors are often used when producing business stationery, for a variety of reasons. First, because only one or two colors are generally required, using spot colors is less expensive than printing in full color. Also, CMYK printing does not give the same quality in a single flat color, owing to the fact that it requires some of the substrate to be reflected through it. Spot color avoids this by increasing the ink density, giving it a stronger appearance.

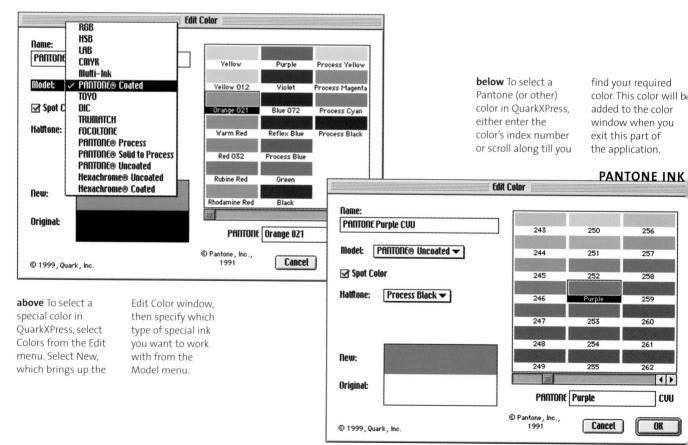

above To select a special color in QuarkXPress, select Colors from the Edit menu. Select New, which brings up the Edit Color window, then specify which type of special ink you want to work with from the Model menu.

below To select a Pantone (or other) color in QuarkXPress, either enter the color's index number or scroll along till you find your required color. This color will be added to the color window when you exit this part of the application.

PANTONE INK

DIC INKS

right DIC inks are made by the Japanese Dainippon Ink and Chemicals company. The accompanying DIC Color Guide is popular in Japan.

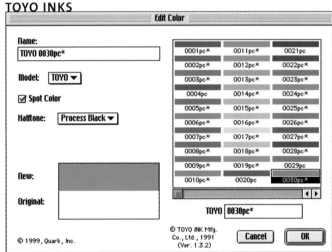

TRUMATCH INKS

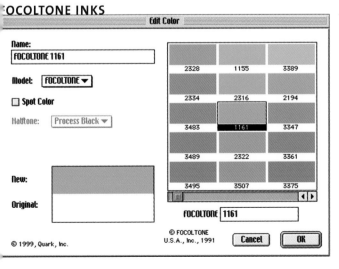

above Trumatch characterizes CMYK ink combinations. The colors are arranged using the HSB (Hue, Saturation, and Brightness) color space.

TOYO INKS

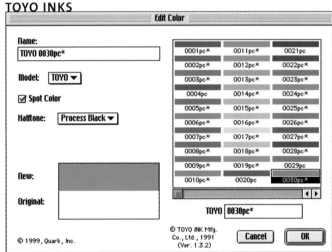

FOCOLTONE INKS

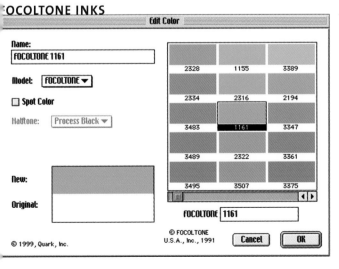

left The Focoltone system, like Trumatch, characterizes four-color ink combinations, up to 763 colors.

above Toyo Ink is another Japanese company. This system can create a total of 1,050 colors.

color communication

Defining and communicating color information precisely is a key issue in color management. This chapter identifies the various color systems that are used in both traditional and digital production, and demonstrates how and when it is appropriate to use them. Many of these systems are based on the visual spectrum and the way in which the eye processes color. No single system is used by everyone and many people have their own preferences. This information is critical to get the most from working with color on digital systems.

■ describing and communicating color

Looking at color can be problematic enough, but describing it can seem almost impossible. Why is it so difficult and how can you go about remedying this?

One of the greatest problems we face when working with color is describing colors verbally. If you ask a variety of people to imagine a color, green for example, and then get them to identify it on a chart, it is quite likely that each person will select a different hue to represent their impression of what green is. This means that all of our references are subjective and open to interpretation—what is green to one person is not the same to another.

Communicating color differences can be extremely difficult, and we sometimes struggle to describe what makes hues different from one another or how to achieve a required shade. Chapters 1 and 2 demonstrated several systems (for example, the color wheel), that help us describe hue changes, the "temperature" of a color, and the tonal value. These are powerful and useful ways of defining color but our vocabulary is still limited. From the illustrations below, try to describe the difference between both reds and all the greens. The illustrations demonstrate how difficult it can be to describe changes to images.

In the example opposite, the "original" image is the one we want to reproduce, but the four images below it have been printed with color imperfections. How would you describe what is wrong with them in order to correct them? Then ask other people and see what they say. Few will agree on how to describe the changes clearly and precisely.

To add complexity to the problem, there is the issue of defining precisely how much change is needed to correct the images. In many packages, such as Photoshop, percentage figures are used to communicate levels of change. This is a system that most users find easy to define: zero percent means alter nothing, 100 percent means maximum change. By defining measurements in this way, it is easy to imagine the amount of adjustment required. So in the example here, image 1 requires 20 percent less contrast; image 2, 50 percent less lightness; image 3, 20 percent more saturation; and image 4, 20 percent less brightness.

Even if the figures are not totally accurate, they provide a clear way of communicating change to another person.

communication

Clear methods and systems to enable the effective communication of color are critical in the graphics and computer industries. On the following pages, different systems are identified that help the user measure, define, and manipulate color to achieve the optimum effect.

IMPRESSIONS OF COLOR—A SHORT EXERCISE

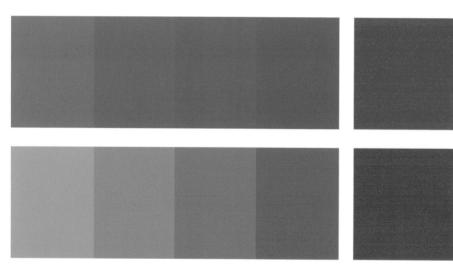

top What is the difference between all these greens? Which one would you describe as the purest green?

above Which one of these colors is green and what names would you give to the other colors?

top and above What is the difference between these two reds? How would you explain how to convert the bottom one into the top one?

ORIGINAL IMAGE

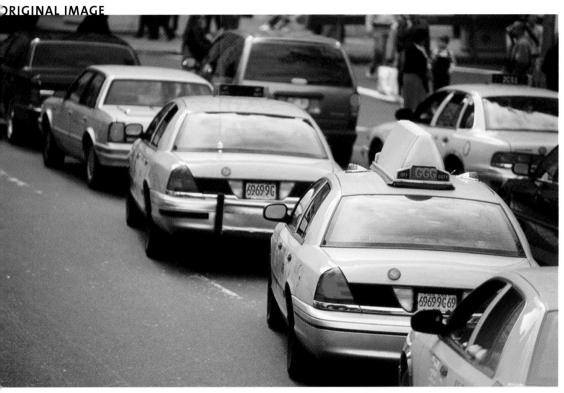

The images on this page demonstrate how difficult it can be to describe changes to color. The image on the left is the one that we want, but the four other images below are incorrect. Describing changes is often best done using percentage figures.

IMAGE 1

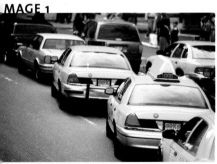

left The contrast is too high in this picture. A reduction of around 20 percent is needed to match the original.

IMAGE 2

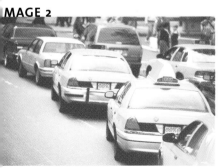

left This image is too light, by about 50 percent.

right This image is too bright and needs a reduction of 20 percent.

IMAGE 3

left This image does not have enough saturation and needs an increase of 20 percent.

IMAGE 4

CIE defining color

We have seen the difficulties in verbalizing color information. The Commission Internationale de l'Eclairage (CIE) created a way of overcoming these problems.

The Commission Internationale de l'Eclairage (CIE) was formed to try to standardize color communication. It created a color system in 1931 based on how humans perceive color. Perceptual models were used to test a group of participants under controlled conditions. The experiments tested the sensitivity of the red, green, and blue cones in the eye. Because the color sensitivity of the eye can vary according to the angle at which an object is viewed, CIE defined a "standard observer" using a 2-degree field of view. This became known as the "2-degree Standard Observer."

In 1964, an additional "observer" was added at 10 degrees, referred to as the "10-degree Supplementary Standard Observer." These two "observers" are now able to perceive colors as if they were under different conditions. The 2-degree Standard Observer uses the maximum density of rods and cones in the eye, whereas the 10-degree Supplementary Standard Observer uses more rods and cones, but with less density. This helps mimic how color changes over distance (see pp. 38–41).

CIE's color spaces

The "color space" created by CIE can describe any color that is within the visible spectrum. A color space can trace a color's position onto a three-dimensional graph and it is possible to move around this graph or "space" to help select and describe color. This is how the first system derived the name "XYZ color space," because it was the first three-dimensional model using X, Y, and Z axes. However, it was a purely mathematical model that was difficult to visualize, so a simple algorithm was created to transfer this into a visual form and became known as the "xyz color space," now usually referred to as the "Yxy chromaticity diagrams."

The graph opposite shows the visible spectrum at maximum saturation and mid-brightness. The nanometer measurements of the visible spectrum are shown on the outer edge of the plot. This new color space combined the measurement of color and the ability to visually plot where it falls within the visible spectrum. Spectrophotometers were made to measure and plot color into the Yxy color space, but this still had its problems because it was not uniform. The area on the diagram representing the red hues is a lot smaller than that representing the green. A small chromatic change in the green area will have almost no effect but in the red, the change could be quite dramatic.

the benefits

For many years, scientists worked only with the visible spectrum on humans, but when televisions and computers started to use color, Yxy proved to be useful in identifying the color range that was achievable through each device. It could be used to measure the color gamut of a variety of output devices and to compare, and map the quality of each (see pp. 54–55). These color systems are called device-dependent because the device places the restriction on the color range, or gamut. A computer is restricted by its graphic card and a television by the signal it is sent.

2-DEGREE VIEWING ANGLE

CONE VISION ONLY

10-DEGREE VIEWING ANGLE

ROD AND CONE VISION

above CIE tested two viewing angles to gain information on cone imaging in the eye, at 2 degrees and 10 degrees.

right The CIE system can be mapped into this type of chromaticity diagram, which includes the full visual spectrum.

CIE COLOR SPACE / CHROMATICITY DIAGRAM

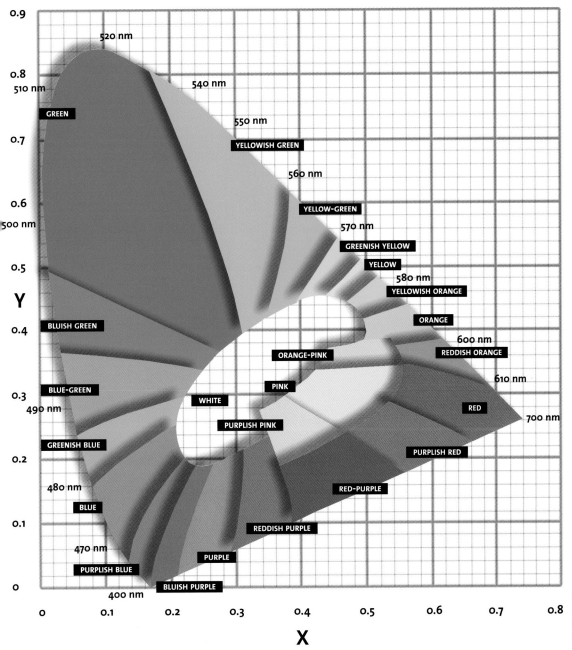

left This diagram of Yxy chromaticity shows the visible spectrum at maximum saturation and at mid-brightness. The nanometer measurements of the visible spectrum are shown on the outer edge of the plot.

■ gamut mapping

With the ability to measure and accurately define color came the potential to see how much color is available on any given device. This is called gamut mapping.

CIE's development of the XYZ color system in 1931 (see pp. 52–53) enabled us to measure how many colors we can use on any device, and the development of Yxy allowed us to visually plot this on a graph. Because XYZ is based on perception it can plot any color that is within our visual range. This range of colors is called a "gamut." The development of spectrophotometers demonstrated that each system that we use to display color—monitors, oil paints, cameras, and so on—have a unique gamut. No device can display the full visual gamut—we can see more colors than we can create.

Printing in CMYK ink gives the smallest gamut because it uses subtractive color (see pp. 20–21 and 24–25), and has limited luminosity. Bright or glossy paper, which reflects more light, has a larger color gamut than mat paper; the brighter the white, the greater the gamut. Computer screens and televisions have a larger color gamut because they use additive color (see pp. 20–21), where light is used to create brightness. Blacks are easy to achieve with

below In this chromaticity diagram, you can see the gamuts of different types of monitors, ranging from the high-end Barco to Apple Studio TFT monitors.

below In this chromaticity diagram, you can see the gamuts of different types of RGB color spaces. You can see that these carry more color information than can be displayed on a monitor.

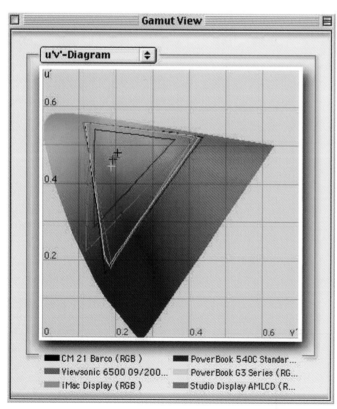

■ CM 21 Barco (RGB)
■ Viewsonic 6500 09/200...
■ iMac Display (RGB)
■ PowerBook 540C Standar...
■ PowerBook G3 Series (RG...
■ Studio Display AMLCD (R...

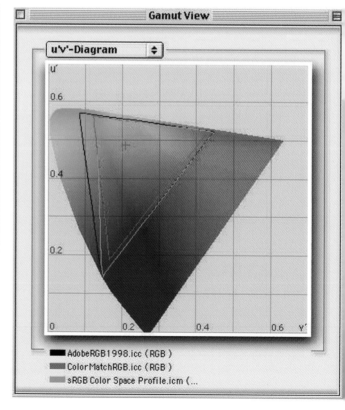

■ AdobeRGB1998.icc (RGB)
■ ColorMatchRGB.icc (RGB)
■ sRGB Color Space Profile.icm (...

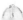

additive color because they represent the absence of light and white represents maximum light on each of the RGB channels. The greater the difference between the white and the black the greater the potential for a larger gamut.

CIE's chromaticity Yxy diagram offers the potential to display a variety of gamuts graphically. In the illustrations below, you can see plots for the CMYK and RGB color gamut. The closer the plot is to the outside edges of the diagram, the greater the color. RGB has a larger gamut due to the ability to use luminosity and brightness. This highlights the greatest problem that we have when we work with color, namely how do you get from one color gamut to another?

To enable this, complex computer algorithms have been developed. The greatest problem is translating additive color to subtractive, or in color terms, RGB to CMYK, and this is discussed in more depth in Chapter 5.

gamut alarms

Many applications give gamut alarms when you select a color that is not within the required color gamut. For example, in Photoshop, an alarm icon appears when you select an RGB color that does not fall into the CMYK gamut. Underneath the color is a sample of the nearest in-gamut color. If you double click on it then the out-of-gamut color will be replaced.

below In this chromaticity diagram, you can see the gamuts of different printers and papers. The lowest quality printing product (newsprint) gives least color.

below In this chromaticity diagram, you can see the gamuts of different types of ICC profile based on printed products.

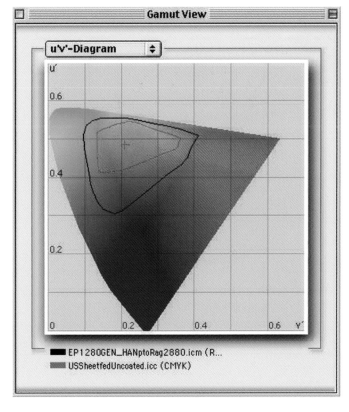

■ trichromatic RGB color

There are three types of screen that can be used to display digital images. These are cathode ray tubes (CRT), liquid crystal displays (LCD), and plasma screens.

In the seventeenth century, Sir Isaac Newton indicated that color had a "triple" nature. In 1722, Jakob Christoffel LeBlon (1667–1742) developed a trichromatic printing process to produce a greater range of colors, marking the start of full-color printing. By 1807, Thomas Young (1773–1829), a physician in London, gained acceptance for the idea that the human eye also filtered light into three colors. In 1861, James Clerk Maxwell (1831–1879), a professor at King's College, London, took this idea and produced the first trichromatic color photograph using three separate photographs, one shot through a red filter, another through a green, and the last through a blue filter. The three slides were then placed in separate units and projected in register on to a white screen, which was the start of color photography.

Today we use this same principle, although more refined, to create the "illusion" of color on computer systems, using red, green, and blue filters. It is also at the heart of modern image-capture devices, which are discussed in Chapter 4.

how monitors display color

RGB color is an additive process (see pp. 20–21), so your computer monitor uses light to display images. There are now three types of display systems available and they all use color filters to create images. These three types are cathode ray tubes (CRT), liquid crystal displays (LCD), and plasma screens.

cathode ray tubes (CRT)

These are the oldest types of display in current use. They use three electron guns, one for each primary color. Signals are sent to the CRT and then to the electron guns, which shoot a stream of electrons at phosphors on the screen. The glowing phosphors create the image on the screen.

CATHODE RAY TUBE (CRT)

below CRT monitors shoot a stream of RGB electrons at phosphors on the front of the screen to create an image.

These devices are big and the phosphors degrade over time, which means that they need constant maintenance.

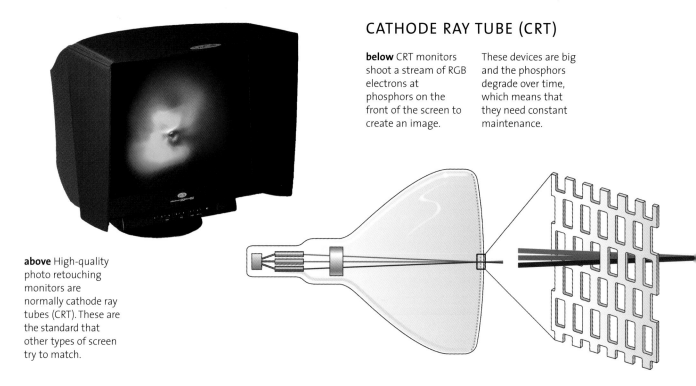

above High-quality photo retouching monitors are normally cathode ray tubes (CRT). These are the standard that other types of screen try to match.

liquid crystal displays (LCD)

Today, laptop computers commonly have an LCD. The devices have a backlight, which adds luminosity. The signal from the computer rotates the liquid crystal cells to allow a variable amount of light through three filters—red, green, and blue.

plasma screens

Although still expensive, and very large, plasma screens are becoming more common. These screens work by exciting atoms of neon and xenon gas in a cell, which then ejects ultraviolet light through a red, green, or blue filter to display a color on a phosphor like a CRT (see opposite).

LIQUID CRYSTAL DISPLAY (LCD)

right Laptop computers use LCD monitors because they need less power and are smaller and lighter than CRTs. Today, the quality of these screens can match that of CRTs.

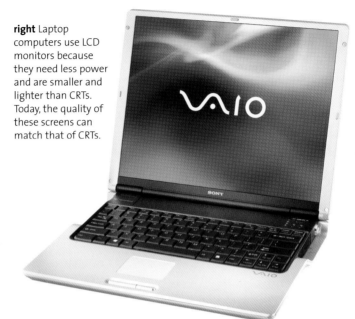

PLASMA SCREEN

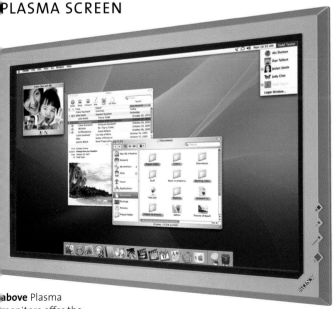

above Plasma monitors offer the best of LCD and CRT technology and could be the future of displays.

below With phosphors and element-based imaging, plasma screens offer the best elements of CRTs and LCD displays.

above Each liquid crystal filters one primary color. The matrix allows 256 shades of each hue, which will give a total of 16.7 million colors.

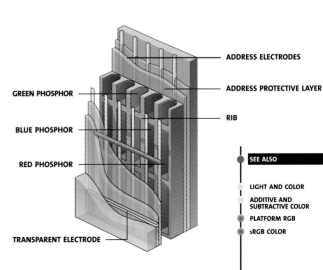

GREEN PHOSPHOR

BLUE PHOSPHOR

RED PHOSPHOR

TRANSPARENT ELECTRODE

ADDRESS ELECTRODES

ADDRESS PROTECTIVE LAYER

RIB

■ bit depth

Digital files are constructed with "bits" of data. The number of bits determines the quality of your image in terms of resolution and color gamut.

The signal that your monitor receives is dependent on the device that sends it. In the case of a computer, this device is the graphic card. Any limitations that you encounter in creating colors come from the number of bits available on the graphic card.

A modern computer works with 24-bit color, giving the user a color palette of 16.7 million colors, but what is a bit and how does it create all these colors?

A bit is the smallest piece of data that a computer can process. A 1-bit chip has one cable going into it. If an electric charge passes through the cable, it registers a 1, if not, a 0, in binary. Below is a 1-bit image, black or white, and either sends a signal to the monitor to create a white color, or not. This is the basis for bitmap graphics. To add more colors, we need more bits. Two cables going into the chip would create four color options as

there are four possible variables in a 2-bit chip, as shown here:

Current down none

Current down cable 1

Current down cable 2

Current down cable 1 and 2

Current technology is limited to 8-bit color chips on graphic cards. The card uses sets of three 8-bit chips, one of the red, green, or blue channels, each of which can create a range of 256 colors. In many graphic packages you will notice that each primary additive color is

DIAGRAM OF 1-BIT CHIP IMAGE

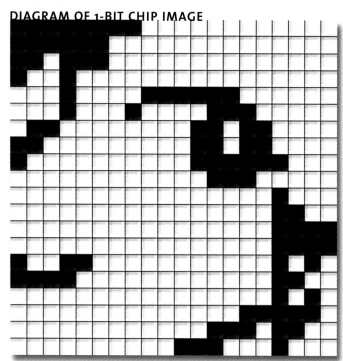

above A basic pixelated image is called a bit map, where each pixel is either black or white. This is a 1-bit image.

right The data to create the image above uses a binary structure, where 1 is a white pixel, and 0 is a black one.

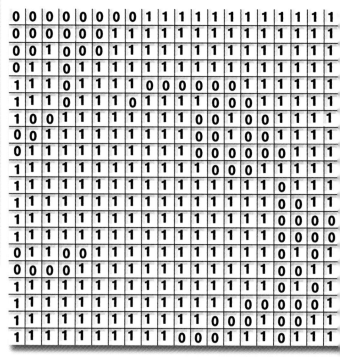

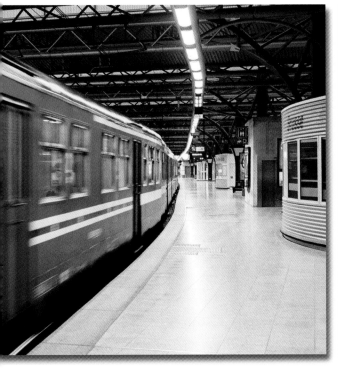

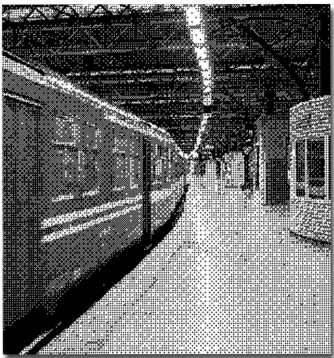

BIT DEPTH / COLORS

BIT DEPTH	CALCULATION	COLOR RESOLUTION
1-bit	2^1	2 colors
2-bit	2^2	4 colors
3-bit	2^3	8 colors
4-bit	2^4	16 colors
5-bit	2^5	32 colors
6-bit	2^6	64 colors
7-bit	2^7	128 colors
8-bit	2^8	256 colors
16-bit	2^{16}	65,536 colors
24-bit	2^{24}	16,777,215 colors

top left and above
The image on the left is constructed with an 8-bit palette (256 shades of gray), whereas the image on the right is a bitmap, constructed with two colors (black and white).

left The amount of color you can use on your computer is determined by the number of bits you have for each pixel. Modern systems work with 24-bit images.

above Enlarging the bitmap image (top right) clearly shows how the image was created using two colors, black and white.

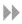

■ bit depth continued

separated into a color range of 0 to 255. If you combine all three channels, you get a 16.7 million color gamut:

**256 red x 256 green x 256 blue
= 16.7 million RGB**

No matter what graphic card you have, your data is always stored as 24-bit color if you use RGB (see Chapter 4). However, most tasks can be achieved by viewing 16-bit color (thousands of colors), which improves the speed of production. This is because viewing millions of colors needs more processing power than viewing colors at lower levels. The number of colors you view will not impact on the quality of the final print. You can change your monitor settings by following the steps opposite.

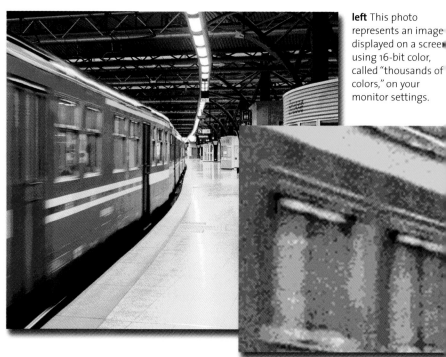

left This photo represents an image displayed on a screen using 16-bit color, called "thousands of colors," on your monitor settings.

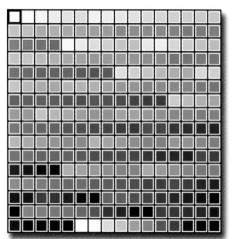

above In an 8-bit image, each pixel can generate 256 colors, from the range of 16.7 million.

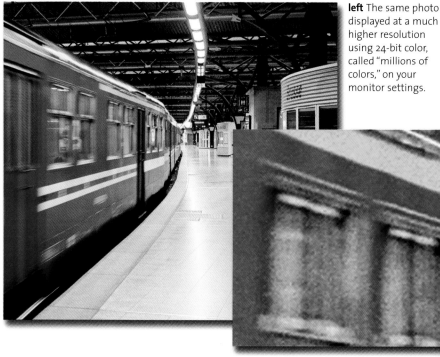

left The same photo displayed at a much higher resolution using 24-bit color, called "millions of colors," on your monitor settings.

CHANGING MONITOR SETTINGS ON A PC

1 Select Admin, then Control Panel from the Admin menu.

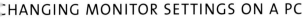

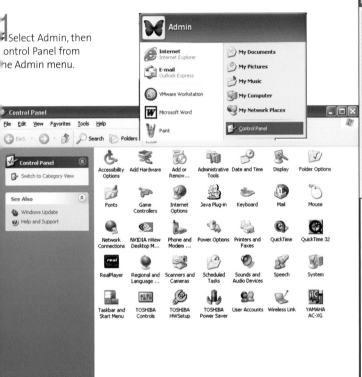

3 Select box 1 from the Display Properties window. Then select the display quality you require from the Color quality menu.

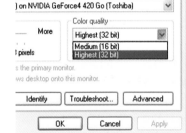

2 Select Active Window then OK in the Display Properties window.

CHANGING MONITOR SETTINGS ON A MAC

1 Open the System Preferences folder in the Apple menu.

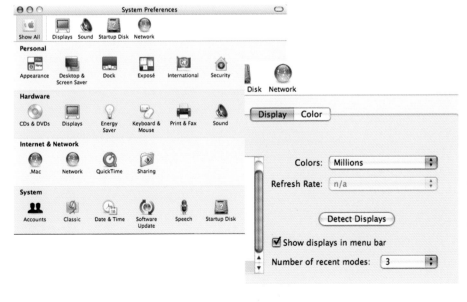

2 Select Displays from the top menu bar, then Display from the window that appears. You can then choose your resolution and the number of colors you want to display.

SEE ALSO

PRINTING AND PRE-PRESS 110

RASTER IMAGE
PROCESSOR (RIPs) 166

platform RGB

Calibrating your monitor is critical to ensuring the quality of the color you view. This is a straightforward process and should be repeated every couple of months.

Despite the convergence of Apple Mac, PC, and other computer hardware, there are still differences in their screen display and color accuracy. There are many reasons for this but the important issue is to set your computer up correctly and to check it regularly. There are two places where this needs to be done, in the operating system (OS) and within applications themselves. This can be laborious, but the results are worth it.

gamma

Your computer comes with its own set of characteristics that controls color accuracy, and this is called "gamma." Gamma controls the relationship between the image data and the monitor that is displaying it. All monitors are slightly different, but by controlling the gamma, you can reduce the differences. The Mac has the advantage that the OS has ways to calibrate your monitor to give the best results (see pp. 158–159). The files that you install with your monitor, if they are not already preinstalled, are for the color of the average device of that kind. However, no matter what you do, images generated on one platform will always look slightly different on the other. This is because of the difference between the Mac's 1.8 gamma and the PC's 2.2 gamma.

above Calibrating a monitor using a LaCie Colorimeter. This device measures screen colors and adjusts your computer according to the results.

CALIBRATING YOUR MONITOR / PANTHER

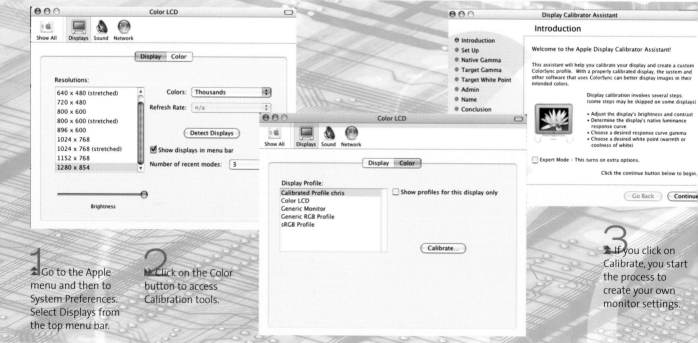

1 Go to the Apple menu and then to System Preferences. Select Displays from the top menu bar.

2 Click on the Color button to access Calibration tools.

3 If you click on Calibrate, you start the process to create your own monitor settings.

CALIBRATING YOUR MONITOR / CLASSIC

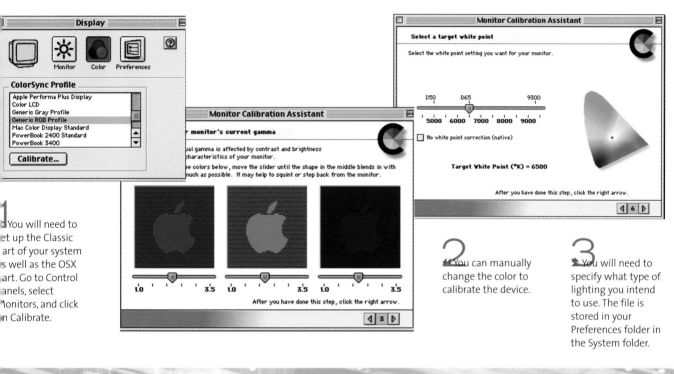

1 You will need to set up the Classic part of your system as well as the OSX part. Go to Control Panels, select Monitors, and click on Calibrate.

2 You can manually change the color to calibrate the device.

3 You will need to specify what type of lighting you intend to use. The file is stored in your Preferences folder in the System folder.

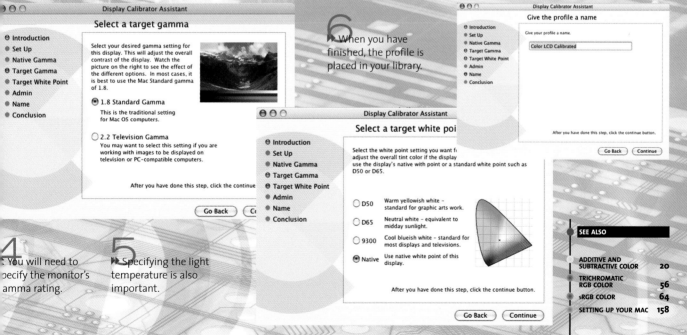

4 You will need to specify the monitor's gamma rating.

5 Specifying the light temperature is also important.

6 When you have finished, the profile is placed in your library.

SEE ALSO

■ sRGB color

sRGB color is a new way of handling RGB data and enables you to keep any color gamut information with a file. This enables you to change it at a later point if you wish.

Owing to all the different types of RGB color spaces, there has been a move by all parties with an interest in color, such as Apple, Hewlett Packard, Microsoft, and Adobe, to standardize RGB. Past differences between manufacturers have required computers to make a huge range of calculations, slowing down processes as everything is calculated into and out of CIEXYZ or CIEL*a*b* (see pp. 52–53 and 98–101). The solution, to simplify the process, is sRGB color.

The aim of sRGB is to complement the current color management strategies by offering another method of handling color in the operating systems, device drivers, and on the Internet, using a simple and robust device-independent color space (see pp. 94–95). It provides good-quality results with backward compatibility, so that older software can still access the data, with minimum file sizes and reduced system processing. This has allowed it to be quickly incorporated into computer hardware and software.

It is based on a calibrated colorimetric RGB color space, which embeds color data into the RGB file. It is also suitable for many output processes such as cathode ray tube monitors (see pp. 56–57), TVs, scanners, digital cameras, and printing systems. The specific data for each device can be embedded into the graphic file, and easily changed.

sRGB is easy to utilize and suitable for all users, even if they do not use a color management system. It is also usable on other computer systems, HDTV, digital and analog TV, Apple and PC platforms, as well as many others, making it very user friendly.

using sRGB

sRGB, although relatively new, is already a background process, and you may be using it without knowing. It allows you to embed

sRGB COLOR GAMUT

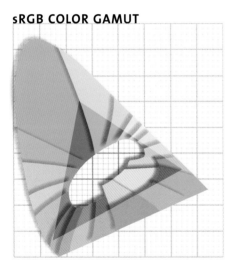

above The sRGB gamut within the CIEYxy color space.

right When you save a file, you save in sRGB when you click on the Embed Color Profile radio button.

below When you open an sRGB file you will be asked if you want to keep the embedded profile or select another one.

olor information about your image with minimum effort. In Photoshop, you automatically use sRGB whenever you work on GB images. When you save an image, you an choose the profile (see pp. 156–157) that ou wish to use with your image, and it hen attaches it when you save the file (see hapter 5).

This will usually be the best one for your ystem but you can change the color profile n Color Settings (see pp. 162–165) when ou wish to simulate other output profiles. Normally, you change these color settings o match your monitor but you can also hange them to represent the final output nd ink type. You are also asked about the rofile when you open a file, and can keep he existing one or choose another.

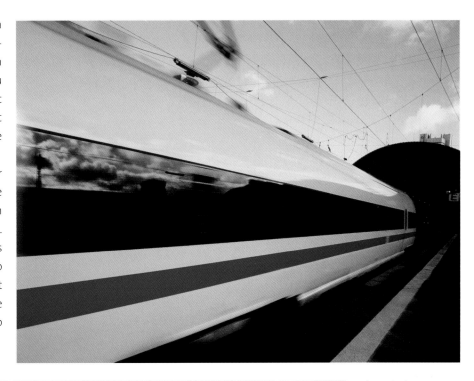

ght An image pened in RGB without using the mbedded profile. can still produce a leasing image, but is ot accurate.

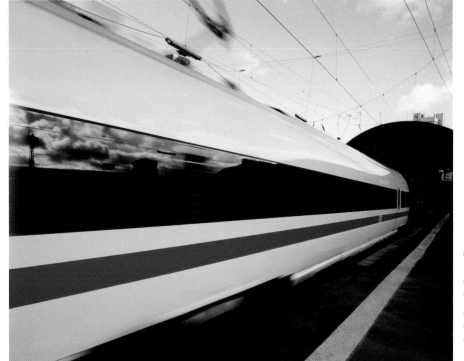

above An image opened in RGB with embedded profiles. The image is more accurate with more blue being reflected off the white.

■ HSB color

The HSB (Hue, Saturation, and Brightness) color model is similar to the RGB color space and has the same additive color gamut. It is commonly used by artists.

The HSB (Hue, Saturation, and Brightness) color model closely resembles the RGB color space (pp. 56–57). It is an intuitive, or perceptual, model based on the requirements and working practices of artists, is easy to use and understand, and unlike RGB, it does not require any mathematical knowledge. The principle is that you first choose a hue that you want to work with and then select the amount of saturation and brightness that you wish to add. In the illustrations below, you can see how this is achieved when using Photoshop's Color Picker.

To the left side of the HSB data fields (where you can type in your measurements if you already know them), are radio buttons that allow you to change the way that you use the HSB model. The default set-up is to have the H (Hue) button checked, which means the vertical pillar controls the hue selection. If you check the S (Saturation) or (Brightness) buttons, then these can also be controlled with the vertical pillar.

HSB COLOR SELECTOR

right, below, and below right HSB color selection is done in the Color Picker window in Photoshop. To bring up the Color Picker window, click on the Foreground/ Background color tool in the tool bar. Use the vertical pillar to select your required levels of Hue, Saturation, or Brightness, after checking the relevant radio button next to either H (Hue), S (Saturation), or B (Brightness). It is up to you to decide the best method of color selection, either H, S, or B.

HUE (H)

SATURATION (S)

BRIGHTNESS (B)

You will have noticed that the saturation and Brightness controls are measured in percentages, which makes it easy to control, visualize, and communicate requirements. The Hue, however, is measured in degrees. This enables easy and effective use of the color wheel to aid your color selection and control. In the diagram on the right, you can see the Hue color wheel. Red is at the top, at o degrees, green at 90 degrees, cyan at 180 degrees, and purple at 270 degrees.

The HSB color model comes in several different variations, where terms other than Hue, Saturation, and Brightness are used to describe the role or purpose of the coordinates. These differences are mirrored in the terminology used in some applications, but the principle of their use remains the same. These differences in terminology are as follows:

HSL: **Hue, Saturation, and Lightness (Lightness replaces Brightness)**
HCL: **Hue, Chroma, and Lightness (Chroma replaces Saturation and Lightness replaces Brightness)**
HSV: **Hue, Saturation, and Value (Value replaces Brightness)**

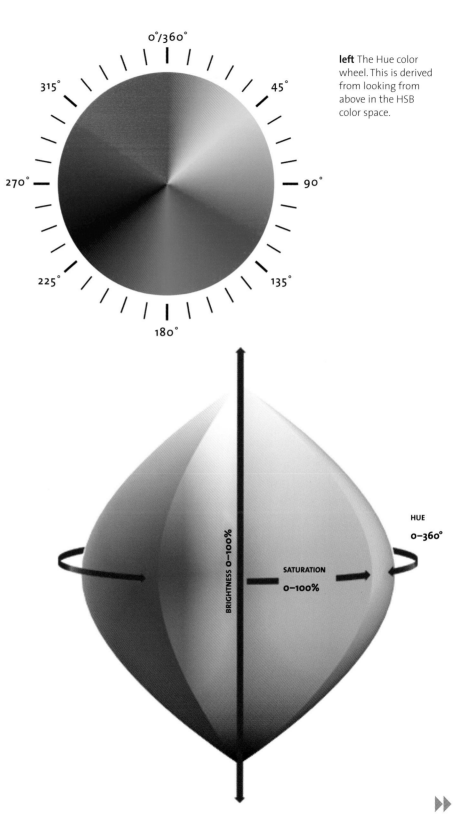

left The Hue color wheel. This is derived from looking from above in the HSB color space.

right The HSB color space. Saturation increases the closer you get to the outside of the space. Brightness changes vertically, and Hue is around the middle.

■ HSB color continued

HSB offers a great deal of flexibility to correct or distort images according to the effects you want to create.

below To use HSB, select the Image menu, then Adjustments, then Hue/Saturation to bring up the correct window.

above The starting picture is of a red and gray truck, set on a gray road against a blue and white background. The truck is prominent because of its red hues.

right Hue is measured in degrees. Decreasing hue by more than 100 degrees turns blues to reds and reds to green. This makes the sky the most prominent aspect, although the complementary truck still stands out.

Hue/Saturation

Edit: Master

Hue: -108

Saturation: 0

Lightness: 0

OK
Cancel
Load...
Save...

☐ Colorize
☑ Preview

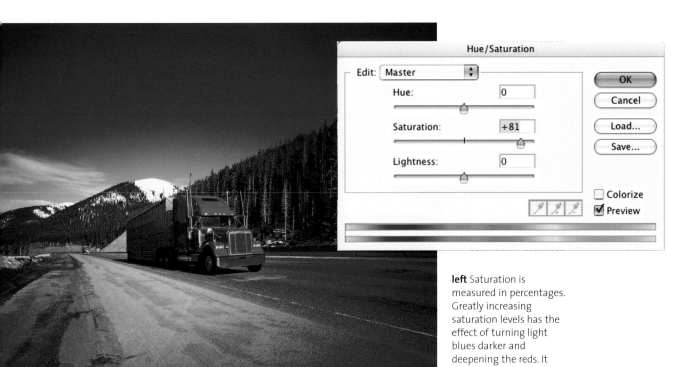

left Saturation is measured in percentages. Greatly increasing saturation levels has the effect of turning light blues darker and deepening the reds. It also flattens the image.

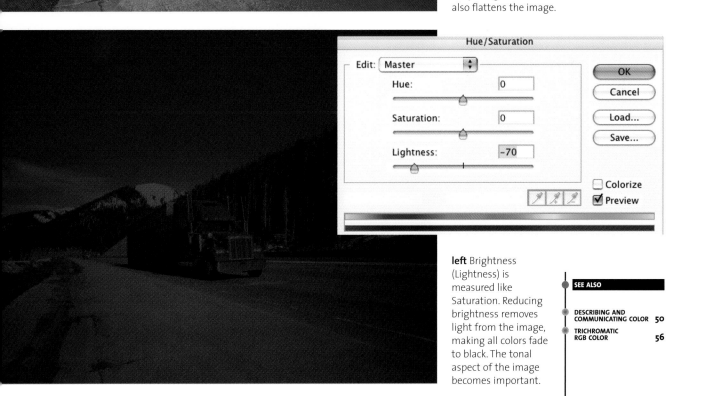

left Brightness (Lightness) is measured like Saturation. Reducing brightness removes light from the image, making all colors fade to black. The tonal aspect of the image becomes important.

■ CMYK model

When printing images, we use cyan, magenta, yellow, and black. These are the secondary colors of the additive range and can be mixed to give the impression of full spectrum colors

Artists work with red, blue, and yellow primary colors using a subtractive color system (see pp. 20–21). These colors work well with pigments that are opaque and that radiate color, and do not require any reflection from the substrate. In printing, the substrate is critical in giving brightness to the image because the ink does not fully cover the paper, and the inks are slightly translucent to allow them to be overlaid. To compensate for this, the printing industry

has developed lighter versions of the spectral colors. These colors are based on the additive color wheel, where the interaction of the primary colors of light (red, green, and blue) produces the colors cyan, magenta, and yellow (CMY).

CMY(K)

Printing uses CMY color but this lacks density, or depth, in the darker areas. When cyan, magenta, and yellow are mixed, they

create a soft black or dark brown, and th weakens the final image quality. To con pensate for this, black (K) is added at th end of the separation process to the dark areas of the image.

A CMYK image contains 32 bits of dat eight bits for each color channel. Th increases the file size when compared RGB files, which have three color channe (24-bit color) (see pp. 58–59). Note that ca must be taken with 32-bit scanners. Thes

RGB IMAGE—8MB

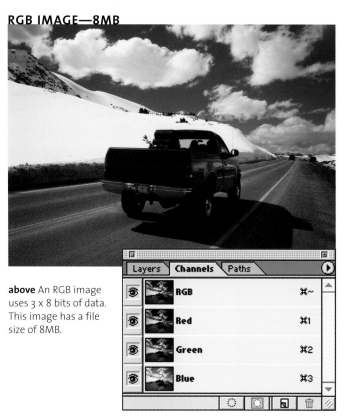

above An RGB image uses 3 x 8 bits of data. This image has a file size of 8MB.

CMYK IMAGE—10MB

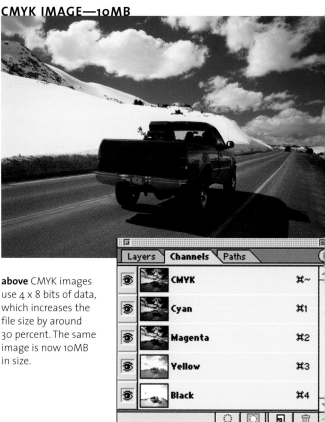

above CMYK images use 4 x 8 bits of data, which increases the file size by around 30 percent. The same image is now 10MB in size.

uggest that they scan in CMYK. However, ll scanners scan in RGB and then convert o CMYK at a later point. Low-end scanners o not perform this conversion very well nd it is best to do this in other applica-ons (see pp. 122–127).

The images below are 8MB in RGB and oMB in CMYK. This difference will affect rocessing and printing time, as well as aking up extra disk space.

CMYK also has the smallest color amut, which is itself dependent on the quality and type of ink and the amount of reflectivity in the substrate. The hardest aspect of color management is to transfer RGB color (additive color) to CMYK (subtrac-tive color). To add to this complexity, where and when this conversion is done can dra-matically change the result. We will look at converting additive color to subtractive color in Chapter 5.

The CMYK chromaticity diagram on the right shows the color gamut of different of types of paper.

CMYK CHROMATICITY

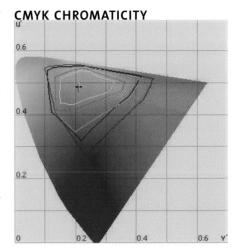

■ **US sheetfed coated.icc**
■ **US sheetfed uncoated.icc**
■ **US web coated SWOP.icc**
■ **Photoshop default CMYK.icc**
■ **Newsprint CMYK.icc**

above The color gamut of CMYK is dependent upon the paper it is printed on. The glossiest substrate (shown by the dark blue line) gives the most colorful final print, since more light is reflected. Newsprint (light blue line) has the least chromaticity.

MY IMAGE—8MB

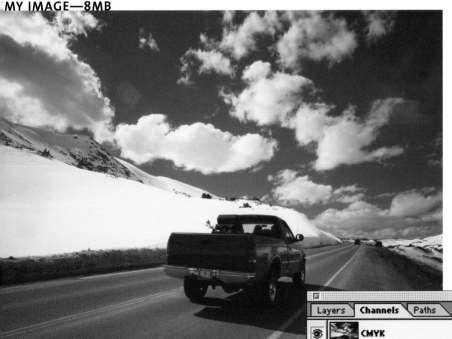

bove CMY images, as reated on some rinting systems, use x 8 bits of data and re therefore the same file size as RGB. However the image does not look as good as the CMYK image, which has added black.

■ CMY color selection charts

Working in CMY is ideal if you only need an image to print. The following CMY charts will help you to specify colors when you are working to fit into the subtractive color gamut.

If you are producing work that is to be sent to print, it is easiest to select colors that are available for use from the start. The following charts allow you to select colors in CMY. They are very easy to use. Each chart has 100 percent yellow in the top right corner and 100 percent magenta in the bottom left. The top left corner has zero percent of these colors and the bottom right 100 percent of yellow and magenta. Each of the 11 charts has added cyan, the first zero percent and the last 100 percent. From these you can select any color in 10 percent increments by

cross-referencing the percentages of each color. This is very useful in Vector software, such as Adobe Illustrator and Macromedia Freehand, where you can enter the coordinates for color specification. However, in Raster software, such as Photoshop, where images are constructed out of pixels, the percentages can change when you print owing to the separation processes which use Gray Chroma Removal and Under Color Removal (see pp. 174–177). These systems of separation add black to the color, using tone as well as hue to create the desired effect.

the problems of black

Black is not always black. There are different types depending on the amount of cyan, magenta, and yellow printed with the black. Because printed products are subtractive (see pp. 20–21), the more pigment you use, the greater the darkness. In the chart on page 91, you can observe this where the black (100 percent in each patch) has added cyan, magenta, and yellow.

For reasons of economy and drying time, it is not advised to have more than 50 per cent undercolor.

SELECTING CMYK COLORS IN QUARKXPRESS

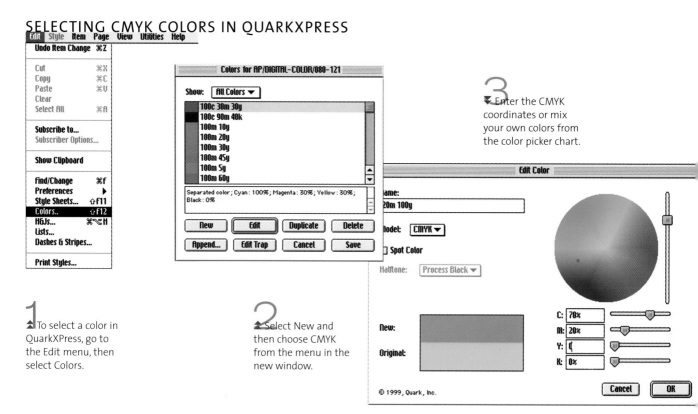

1 To select a color in QuarkXPress, go to the Edit menu, then select Colors.

2 Select New and then choose CMYK from the menu in the new window.

3 Enter the CMYK coordinates or mix your own colors from the color picker chart.

© 1999, Quark, Inc.

YELLOW

	0	5	10	20	30	45	60	70	80	90	100
0	0% CYAN										
5											
10											
20											
30											
45											
60											
70											
80											
90											
100											

▶▶

■ CMY color selection charts continued

YELLOW

	0	5	10	20	30	45	60	70	80	90	100
0	10% CYAN										
5											
10											
20											
30											
45											
60											
70											
80											
90											
100											

MAGENTA

YELLOW

MAGENTA

	0	5	10	20	30	45	60	70	80	90	100
0	20% CYAN										
5											
10											
20											
30											
45											
60											
70											
80											
90											
100											

■ CMY color selection charts continued

YELLOW

		0	5	10	20	30	45	60	70	80	90	100
MAGENTA	0	30% CYAN										
	5											
	10											
	20											
	30											
	45											
	60											
	70											
	80											
	90											
	100											

YELLOW

	0	5	10	20	30	45	60	70	80	90	100
0	40% CYAN										
5											
10											
20											
30											
45											
60											
70											
80											
90											
100											

MAGENTA

▶▶

CMY color selection charts continued

YELLOW

MAGENTA

50% CYAN

YELLOW

	0	5	10	20	30	45	60	70	80	90	100
0	60% CYAN										
5											
10											
20											
30											
45											
60											
70											
80											
90											
100											

▶▶

CMY color selection charts continued

YELLOW

MAGENTA

70% CYAN

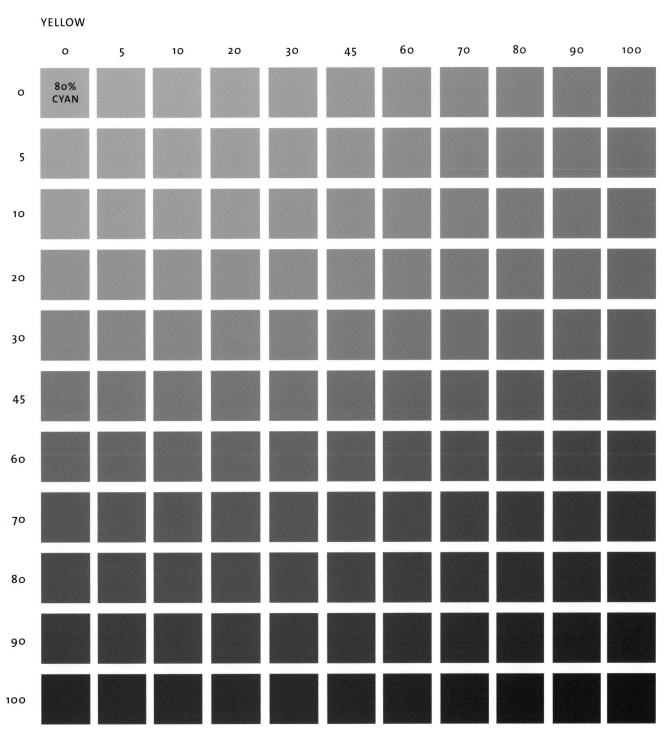

CMY color selection charts continued

YELLOW

	0	5	10	20	30	45	60	70	80	90	100
0	90% CYAN										
5											
10											
20											
30											
45											
60											
70											
80											
90											
100											

MAGENTA

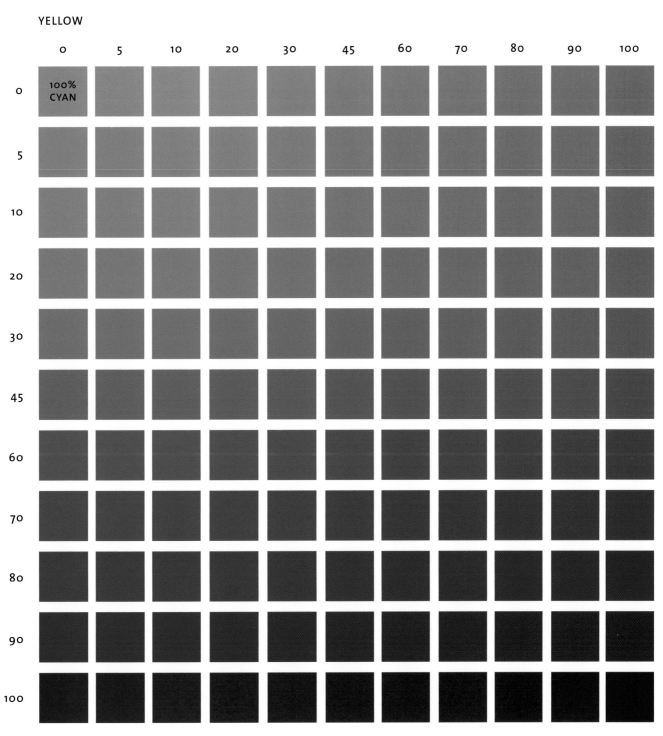

YELLOW

■ CMY color selection charts continued

YELLOW Adding black to the CMY charts can neutralize the colors

MAGENTA

YELLOW

	0	5	10	20	30	45	60	70	80	90	100
0	20% CYAN 20% BLACK										
5											
10											
20											
30											
45											
60											
70											
80											
90											
100											

CMY color selection charts continued

YELLOW

YELLOW

■ CMY color selection charts continued

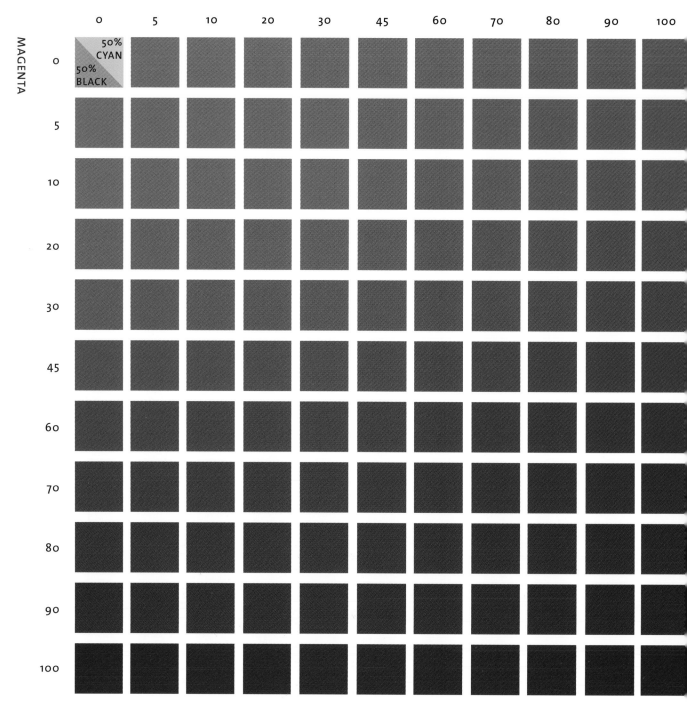

YELLOW

MAGENTA

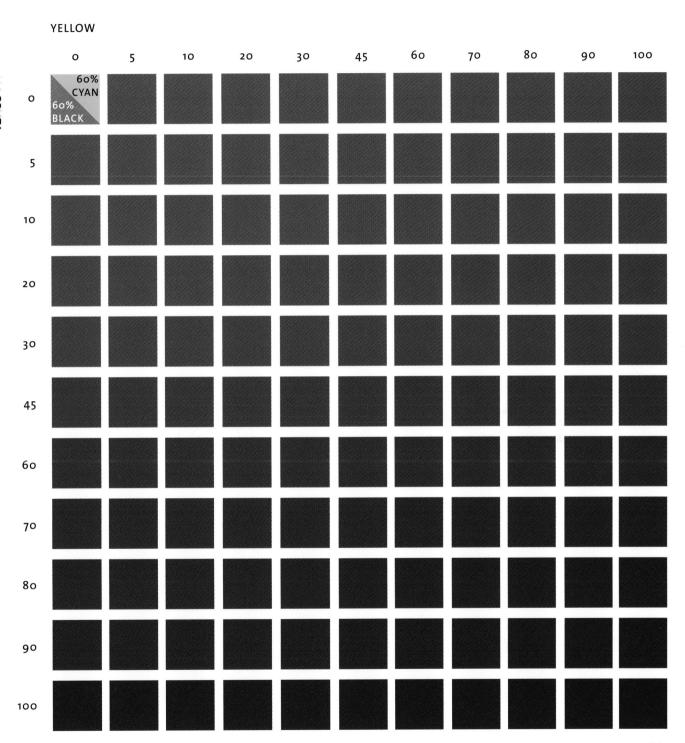

YELLOW

| | 0 | 5 | 10 | 20 | 30 | 45 | 60 | 70 | 80 | 90 | 100 |

CMY color selection charts continued

YELLOW

00% BLACK / 0% CMY

00% BLACK / 25% CMY

00% BLACK / 50% CMY

00% BLACK / 75% CMY

00% BLACK / 100% CMY

5% BLACK / 25% CMY

% BLACK / 100% CMY

■ CMYK+

Cyan, magenta, yellow, and black give the smallest color gamut from any device. By using additional colors, the color gamut can be increased, but proceed with caution.

Because printing processes, which use CMYK, have a small color gamut, there have been many developments to try to improve it. These generally involve adding colors to the standard set and come under a banner of "CMYK+" or "HiFi" color, and use up to seven colors. Different manufacturers use a variety of solutions; some use CMYK and RGB ink, some use CMYK and secondary colors with added brightness (normally orange and green), and others use CMYK and chromatically changed cyan and magenta.

The aim is to achieve the same color gamut as RGB additive color, so most systems try to add luminosity to the ink to increase its brightness. Modern "photographic quality" inkjet printers use a form of CMYK+ color with added colors, which are mainly lighter and darker hues of cyan and magenta. The printer drivers that come with the printer translate RGB files into the CMYK+ color gamut before transferring the data to the printer.

It is clear that CMYK+ gives a larger gamut than "normal" CMYK. In the chromaticity

diagrams opposite you can see the diffe ence between the two systems.

The high-end printing industry has bee slower to adopt CMYK+ technology com pared to the home inkjet printer market, fo a variety of reasons. The high-end screer ing technology currently used is not alway appropriate for CMYK+, so newer "FM screening is required. FM screening work in a similar way to an inkjet printer with i dithering system (see pp. 112–113). In add tion, there is currently a lack of experience

right Most modern "photographic" inkjet printers use a CMYK+ color system. Normally they have six colors: cyan, light cyan, magenta, light magenta, yellow, and black.

below Printing presses are designed to handle many colors in addition to CMYK. Modern presses can have 12 or more inking processes.

eople in this area who understand the echnology and business practice. Large-cale, industrial equipment is specialized nd therefore expensive to replace, and it is nclear whether the market will tolerate a udden and dramatic price increase for bet-er color. However, if there is a demand, the echnology is ready to supply.

Instead of printing with a four-color ress, a bigger printing press is needed to ccommodate the CMYK+ systems. At mil-ons of dollars each this is a sizeable invest-nent. Many printers already use extra color rinters to add special colors and varnishes ee pp. 46–47). The extra units will be in ddition to these.

bove right Modern rinting presses use tate-of-the-art echnology and equire considerable kill and knowledge o operate.

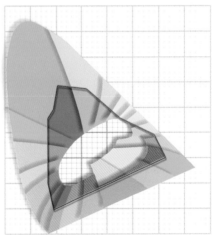

left and right This chromaticity diagram displays the increased gamut available from CMYK+ printing devices (right) compared to CMYK (left).

■ device-independent color

Device-independent color gives computer artists the ability to work to any color standard or gamut, and then change their mind at any point.

When CIE developed the XYZ color space in 1931 (see pp. 52–53) they developed the first system of specifying color, which can be applied to anything, because it was perceptual, based on observation, and covered the entire visual spectrum. The development of the more visual chromaticity diagram made it easier to use and visually plot color gamuts. This system is now termed "device-independent" color system and can define color with or without reference to the output device (such as a printer). It lays down standards with which data can be compared in a quantitative way.

XYZ is at the heart of modern digital color systems, although you will not be aware of it because it works in the background and in mathematical code. It is therefore often referred to as "reference XYZ" and was one of the first color spaces to be universally accepted.

As described earlier, there were some problems associated with XYZ and Yxy color spaces relating to how we interact with them, so other developments were implemented to find different and more usable device-independent color spaces. These were started by EFI (Electronics for Imaging) and were then quickly adopted by Adobe and other graphic software manufacturers in their imaging systems, allowing portable image data to be transferred across different computer platforms.

measuring color

To measure color we use spectrophotometers and colorimeters. These can measure spectral data from any additive or subtractive source. Because all color references are based on CIE systems, it is easy to transfer data from one color space to another with mathematical algorithms.

CIEXYZ COLOR PROFILE IN OSX

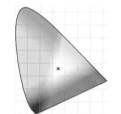

▷ pslabpcs.pf

#	Tag	Data	Size	Description
	Header		128	
1	'A2B0'	'mft2'	222772	Intent-0, 16-bit, device to PCS conve
2	'B2A0'	'mft2'	50740	Intent-0, 16-bit, PCS to device convi
3	'cprt'	'text'	71	Copyright ASCII Text String
4	'dmnd'	'desc'	110	Localized device manufacturer descr
5	'dmdd'	'desc'	143	Localized device model description
6	'wtpt'	'XYZ '	20	Media white-point tristimulus
7	'desc'	'desc'	161	Localized description strings
8	'K013'	'ui32'	12	Unsigned 32-bit integers
9	'K019'	'desc'	161	Localized strings
10	'K030'	'ui32'	12	Unsigned 32-bit integers
11	'K031'	'text'	14	ASCII Text String
12	'K070'	'ui08'	10	Unsigned 8-bit integers
13	'K071'	'ui08'	10	Unsigned 8-bit integers

White X: 0.9643
Y: 1.0000
Z: 0.8251

above CIEXYZ color profiles come with all computers and are stored in the operating system.

left The subtractive spectrophotometer can measure under D56 or D65 lighting conditions (see pp. 26–27). The screen (additive) spectrophotometer measures the luminance from the screen's phosphors.

A DEVICE-INDEPENDENT MODEL MUST BE

1 Based on CIE systems

2 Based on vision perception models to include the full visual spectrum

3 Able to match colors from any device

4 Able to translate to and from device-dependent color spaces

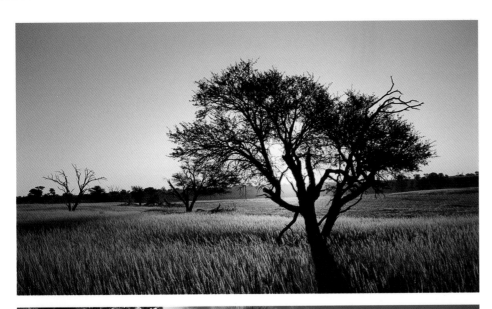

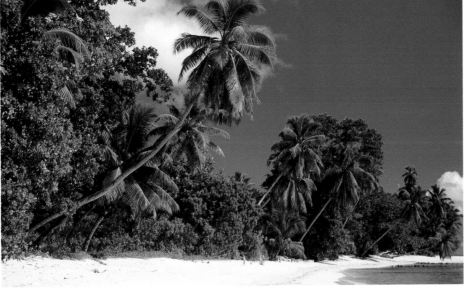

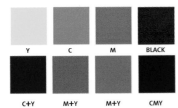

left This is a
printer test page.
The important
information is given
by the swatches
below, but the images
also help to make
perceptual choices.

using device-independent color in Photoshop

You can use device-independent profiles in many applications, but the most common is Photoshop. Entering the data here gives the greatest potential for accuracy.

In Photoshop, Yxy color is used to define the characteristics of the ink used in printers, and should improve your results.

using Yxy color

To use Yxy color, print out a test page with 100 percent of each primary and secondary color; cyan, magenta, yellow, black, red, green, and blue (use the previous page as a guide). You will also need a full CMY black and a full CMYK black (see pp. 174–177).

You then measure the colors using a spectrophotometer with a D56 or D65 light source in Yxy coordinates. You can then enter the Y, x, and y coordinates into the Ink Set-up section in Photoshop.

using xy color

Xy color can be used to define your monitor's RGB coordinates and should help to improve your display. To use xy color, you will need to make a test screen image to measure the characteristics of your display. This shou have white, representing the brightness, ar red, green, and blue to show the hue and sa uration. Monitor profiles software com with these charts. This should be measure on a colorimeter in xy color space.

In the Color Settings window there is als an RGB Working Space. If you click on the RG button and move up to Custom RGB, a ne window will appear. Type in the xy coord nates of the white point and the RGB colors

PLOTTING YXY COORDINATES

1 ▶▶ Go to the Photoshop menu, then select Color Settings.

2 ◀◀ Select the CMYK menu from Working Spaces, then select Custom CMYK.

PLOTTING XY COORDINATES

Color Settings

Settings: Custom	OK
☑ Advanced Mode	Cancel
Working Spaces	Load...
RGB: Color LCD	Save...
CMYK: SWOP (Coated), 20%, GCR, Medium	☑ Preview
Gray: Gray Gamma 2.2	
Spot: Dot Gain 20%	

Color Management Policies
RGB: Off
CMYK: Off
Gray: Off
Profile Mismatches: ☑ Ask When Opening ☐ Ask When Pasting
Missing Profiles: ☐ Ask When Opening

Conversion Options
Engine: Adobe (ACE)
Intent: Relative Colorimetric
☑ Use Black Point Compensation ☑ Use Dither (8-bit/channel images)

Advanced Controls
☐ Desaturate Monitor Colors By: 20 %
☐ Blend RGB Colors Using Gamma: 1.00

Description
Color LCD
Copyright Apple Computer, Inc., 2000
Macintosh HD Library ColorSync Profiles Displays Color LCD-4270800.ico

1 ◄◄ The xy coordinates can be used to put custom settings into the Mac OS to control your monitor. In Color Settings, select the RGB menu from Working Spaces, then Custom RGB.

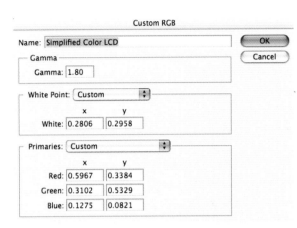

Custom RGB

Name: Simplified Color LCD

Gamma
Gamma: 1.80

White Point: Custom		
	x	y
White:	0.2806	0.2958

Primaries: Custom		
	x	y
Red:	0.5967	0.3384
Green:	0.3102	0.5329
Blue:	0.1275	0.0821

2 ▶ You can enter the gamma of the device and the xy coordinates of your monitor.

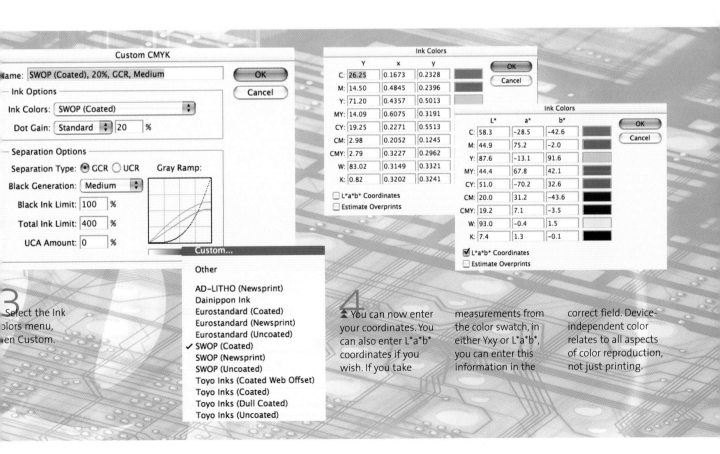

Custom CMYK

Name: SWOP (Coated), 20%, GCR, Medium

Ink Options
Ink Colors: SWOP (Coated)
Dot Gain: Standard 20 %

Separation Options
Separation Type: ● GCR ○ UCR Gray Ramp:
Black Generation: Medium
Black Ink Limit: 100 %
Total Ink Limit: 400 %
UCA Amount: 0 %

Ink Colors	Y	x	y	
C:	26.25	0.1673	0.2328	
M:	14.50	0.4845	0.2396	
Y:	71.20	0.4357	0.5013	
MY:	14.09	0.6075	0.3191	
CY:	19.25	0.2271	0.5513	
CM:	2.98	0.2052	0.1245	
CMY:	2.79	0.3227	0.2962	
W:	83.02	0.3149	0.3321	
K:	0.82	0.3202	0.3241	

☐ L*a*b* Coordinates
☐ Estimate Overprints

Ink Colors	L*	a*	b*	
C:	58.3	-28.5	-42.6	
M:	44.9	75.2	-2.0	
Y:	87.6	-13.1	91.6	
MY:	44.4	67.8	42.1	
CY:	51.0	-70.2	32.6	
CM:	20.0	31.2	-43.6	
CMY:	19.2	7.1	-3.5	
W:	93.0	-0.4	1.5	
K:	7.4	1.3	-0.1	

☑ L*a*b* Coordinates
☐ Estimate Overprints

Custom...
Other
AD-LITHO (Newsprint)
Dainippon Ink
Eurostandard (Coated)
Eurostandard (Newsprint)
Eurostandard (Uncoated)
✓ SWOP (Coated)
SWOP (Newsprint)
SWOP (Uncoated)
Toyo Inks (Coated Web Offset)
Toyo Inks (Coated)
Toyo Inks (Dull Coated)
Toyo Inks (Uncoated)

3 Select the Ink Colors menu, then Custom.

4 ▲ You can now enter your coordinates. You can also enter L*a*b* coordinates if you wish. If you take measurements from the color swatch, in either Yxy or L*a*b*, you can enter this information in the correct field. Device-independent color relates to all aspects of color reproduction, not just printing.

CIEL*a*b* color space

We have seen that XYZ, Yxy, CMYK, and other color spaces all have inherent problems in terms of perception and usage. CIEL*a*b* provides a possible solution.

In 1976, the XYZ model was transformed, via mathematics, to a new system called Lab color tolerance (or CIEL*a*b*, often abbreviated to L*a*b*), which can match the distance between colors closer to their "perceived" values. This makes L*a*b* color space the most perceptual available, all colors having an equal area. All colors that have the same lightness values appear on the same flat plane across the a, b axes (see opposite). L*a*b* color space is a sphere: up and down is lightness and darkness and all around is the visible color. The further the hue is from the center, the more colorful, or saturated, the color will be.

L*a*b* has advantages over other systems because it is a uniform model, unlike XYZ and Yxy, and is therefore easier to perceive, compared to other systems, and it can be relatively easy to implement and calculate. It has also been introduced to all major professional design software. At maximum chromaticity, it is possible to observe the uniformity of this color system—each hue has an equal amount of space.

This system has become a standard benchmark and has developed transmissive (additive) and reflective (subtractive) reference charts, where it is possible to check the gamuts of "available" color from

input and output devices. It works usi measurements that range from -1(through to +100, representing the whe visible spectrum in a variable saturati making it easy to visualize.

L*a*b* is easy to use in Photoshop in t Color Picker window. The file data can stored in L*a*b* by going to the Ima menu, then selecting Mode, then Lab Col

L*a*b* color space can be used in Photosh in the Color Picker window, to select colc and as a color mode, to save the image in t color space. The advantage of this is that y can use the full perceptual spectrum rath than a device-dependent one, such as RC

SELECTING L*A*B* COLOR SPACE IN PHOTOSHOP

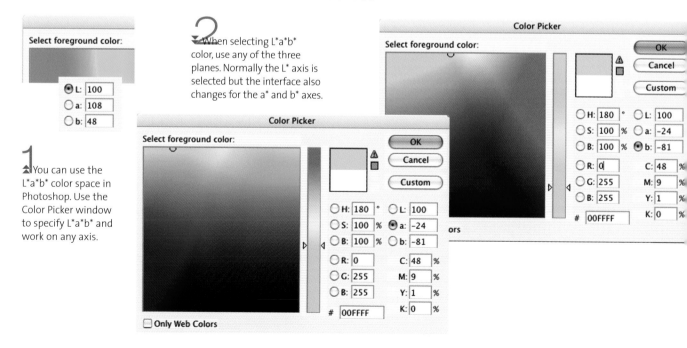

2 When selecting L*a*b* color, use any of the three planes. Normally the L* axis is selected but the interface also changes for the a* and b* axes.

1 You can use the L*a*b* color space in Photoshop. Use the Color Picker window to specify L*a*b* and work on any axis.

CIEL*A*B* COLOR SPACE

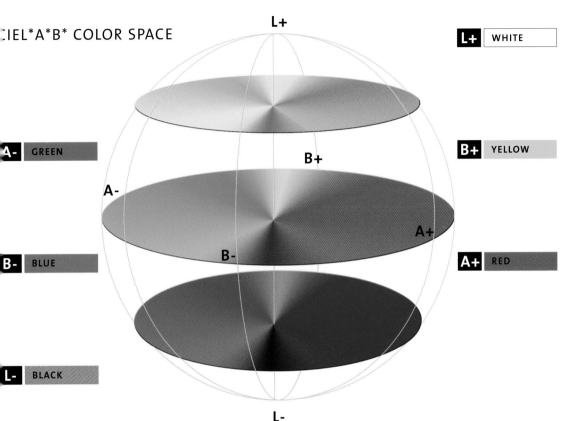

L+

L+ | WHITE

A- | GREEN

B+ | YELLOW

A-

B+

A+

B- | BLUE

B-

A+ | RED

L- | BLACK

L-

left L*a*b* has advantages over other systems because it is a uniform model and easy to perceive. This makes it relatively easy to implement and calculate.

CHANGING AN IMAGE INTO L*A*B*

◀◀ You can change the color mode of your image by selecting the Image menu, then Mode, then Lab Color.

USING L*A*B*

Ink Colors			
	Y	x	y
C:	26.25	0.1673	0.2328
M:	14.50	0.4845	0.2396
Y:	71.20	0.4357	0.5013
MY:	14.09	0.6075	0.3191
CY:	19.25	0.2271	0.5513
CM:	2.98	0.2052	0.1245
CMY:	2.79	0.3227	0.2962
W:	83.02	0.3149	0.3321
K:	0.82	0.3202	0.3241

OK
Cancel

☐ L*a*b* Coordinates
☐ Estimate Overprints

Ink Colors			
	L*	a*	b*
C:	58.3	−28.5	−42.6
M:	44.9	75.2	−2.0
Y:	87.6	−13.1	91.6
MY:	44.4	67.8	42.1
CY:	51.0	−70.2	32.6
CM:	20.0	31.2	−43.6
CMY:	19.2	7.1	−3.5
W:	93.0	−0.4	1.5
K:	7.4	1.3	−0.1

OK
Cancel

☑ L*a*b* Coordinates
☐ Estimate Overprints

▲ Ink set-up in Photoshop can be specified in either Yxy or L*a*b* color spaces. You can use L*a*b* color space to set up the ink specification in the color management aspects of Photoshop.

■ CIEL*a*b* color space continued

CMYK, and HSB, which all have limited color gamuts. However, many printers and RIPs (see pp. 166–169) still cannot interpret L*a*b* files, so it may not be suitable for final output.

Because of L*a*b*'s uniformity, it is an ideal color space to measure gamuts to assess how much color any system can create or use. It is also very useful to observe the color differences between various manufacturers of hardware and software.

In the illustrations below and right, we used an image with CMYK and RGB color squares and measured their colors using different substrates and printers. From this, it is evident how color alters according to the substrates and how useful L*a*b* is to display this in a graphic, or perceptual, manner.

below From the graph, you can see that the color gamut changes when different substrates are used. You can see that the laser print, on cheap paper, can give the same gamut as other printers using more expensive paper. Details on how to control this can be found in Chapter 5.

EPSON C44

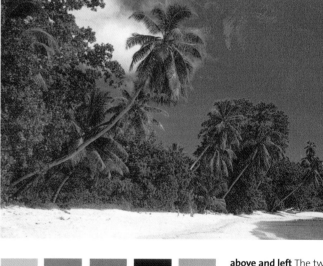

- ■ **Epson C44 (photo)**
- ■ **Epson C44 (uncoated)**
- ■ **Laserjet EFI RIP (uncoated)**
- ■ **HP 3500 (gloss)**

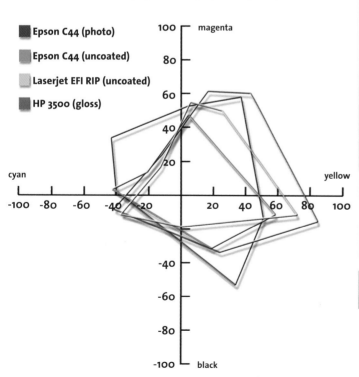

above and left The two images and swatches were printed on an Epson C44 printer. Mat (uncoated) paper was used, though the color gamut for gloss (photo) paper is also shown on the graph (far left).

HP 3500

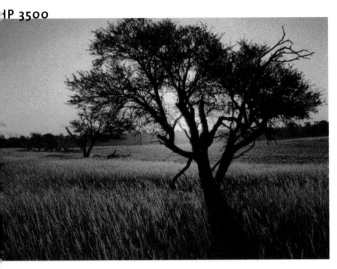

LASERJET EFI RIP

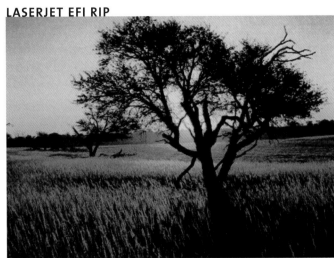

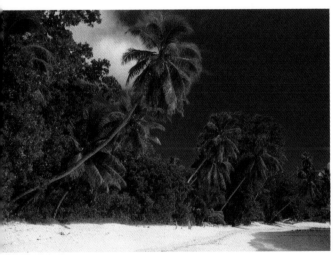

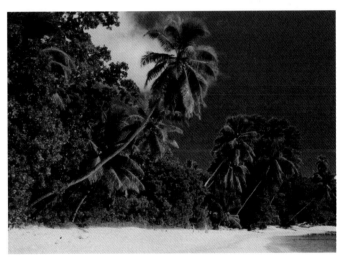

above and left The two images and swatches were printed on an HP 3500 wide-bodied inkjet printer. Special HP gloss paper was used for this print.

above and left The same images and swatches were printed on a color laser printer with an EFI RIP. Standard, uncoated laser paper was used.

Munsell color system

Albert Munsell developed a color specification system based on the way we perceive color. Although this is not a uniform color space, it is very useful for digital photography.

Professor Albert H. Munsell (1858–1918), an American artist, developed his color model at the beginning of the twentieth century in response to the need to improve methods of communicating color, based on theories by the U.S. scientist Ogden Rood (1831–1902), in the late nineteenth century. Rood suggested color could be modeled on a three-sided pyramid. White was at the top point of the pyramid, and red, green, and blue were at the three corners; a spectral color wheel was painted around the joins between each side of the pyramid, and each face was filled in so as to make smooth transitions along each of the surfaces.

Rood and Munsell's color spaces were developed before the creation of CIE (see pp. 52–53) and were used as a reference to crosscheck CIE's data.

The Munsell color system uses three color attributes: Hue, Value, and Chroma. In many ways, this is similar to the HSB model (see pp. 66–69), in which Value is similar to Brightness and Chroma to Saturation. Munsell developed a numerical system, in uniform steps, to describe color difference, easily relating one color to another.

Munsell tree

Munsell based his system on a color tree consisting of 10 hues. The principal hues (red, yellow, green, blue, and purple) were placed equally around a circle. Five intermediate hues (yellow-red, green-yellow, blue-green, purple-blue, and red-purple) were then inserted. For simplicity, the initials R (red), YR (yellow-red), Y (yellow), GY (green-yellow), G (green), BG (blue-green), B (blue), PB (purple-blue), P (purple), and RP (red-purple) were used as symbols to designate the 10 hue sectors:

The Munsell Color Laboratory is now located at GretagMacbeth's worldwide headquarters in New Windsor, New York.

below The Munsell color space is a visual way to work and has been established for more than a century. This diagram shows the "Munsell Tree."

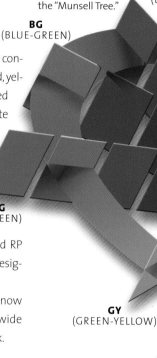
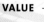

PB
(PURPLE-BLUE)

B
(BLUE)

BG
(BLUE-GREEN)

G
(GREEN)

GY
(GREEN-YELLOW)

Y
(YELLOW)

VALUE

HUE

Munsell divided the hue circle into 100 steps of equal visual change. Each hue was allotted 10-degree segments around the circle and was numbered from 5 to 100, with 5 marking the beginning of the red sector. In the inner circle, the hue number, together with the color initials, for example 5R or 4Y, identified the hue within that sector. The zero stage is not used, so while there is 10R there is no 0R. This system is useful to allow easy access to the system to people with limited numeracy, compared to other systems.

VALUE

The Value, or lightness, is divided into nine increments; one represents white and nine represents black. This contains only tonal information, and Munsell called these "neutral colors." Munsell's scale of value is visual, or perceptual, and based on how we see differences in relative light rather than on a strict set of mathematical values from a light source.

The Value coordinate is designated after the Hue and is notated in the following way: 6RP 5. This means the Hue is 6 red-purple with a Value of 5.

HUE DIAGRAM

right This diagram shows the Hue "angles" used to specify colors in the Munsell system and the codes that are used to name colors.

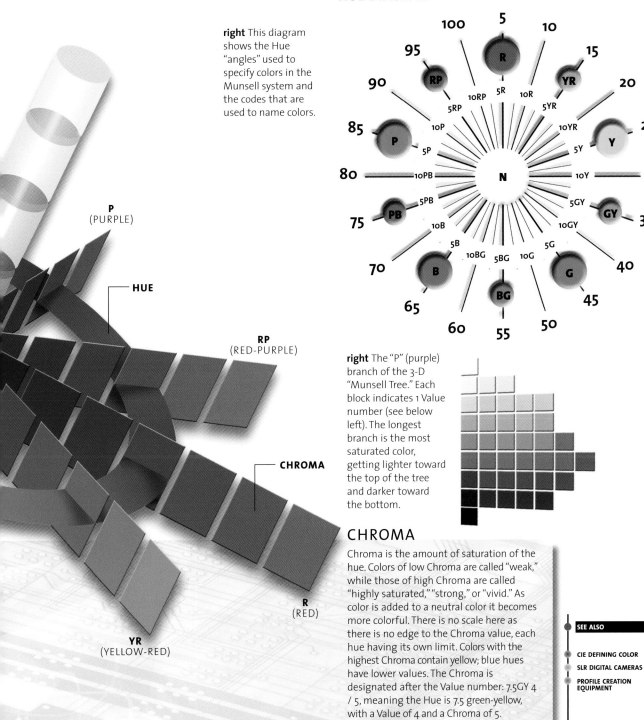

P
(PURPLE)

HUE

RP
(RED-PURPLE)

CHROMA

R
(RED)

YR
(YELLOW-RED)

right The "P" (purple) branch of the 3-D "Munsell Tree." Each block indicates 1 Value number (see below left). The longest branch is the most saturated color, getting lighter toward the top of the tree and darker toward the bottom.

CHROMA

Chroma is the amount of saturation of the hue. Colors of low Chroma are called "weak," while those of high Chroma are called "highly saturated," "strong," or "vivid." As color is added to a neutral color it becomes more colorful. There is no scale here as there is no edge to the Chroma value, each hue having its own limit. Colors with the highest Chroma contain yellow; blue hues have lower values. The Chroma is designated after the Value number: 7.5GY 4 / 5, meaning the Hue is 7.5 green-yellow, with a Value of 4 and a Chroma of 5.

SEE ALSO

CIE DEFINING COLOR 52

SLR DIGITAL CAMERAS 130

PROFILE CREATION
EQUIPMENT 178

■ indexed color

As its name suggests, this is a system where colors are indexed so that they can easily be referenced. Indexed colors are useful in printing where a limited range of colors is used.

When we scan an image into the computer it uses a color palette of 16.7 million colors, known as 24-bit color (see pp. 58–61). This requires lots of memory and processing time. Because we do not always require the highest level of color display (only needed when doing detailed photo manipulation, for example) we can reduce the bit depth on the monitor to improve processing speeds. Changing the display does not reduce the quality of the actual image, or alter its data, it just limits the range of colors that are displayed. On the opposite page

you can see three different display modes: 24-bit color (16.7 million colors), 16-bit color (67,000 colors), and 8-bit color (256 colors).

If we work with a 16- or 8-bit display, the computer uses a Look-Up-Table (LUT) to reduce the color range and to find the closest match. LUTs are common throughout computer systems and are a way of reducing the number of calculations required to render the image and to enable the computer to work with a standard reference palette.

Reducing the color palette reduces the file size. You can reduce the palette by

selecting Mode from the Image menu i Photoshop (see below). It is not possible t reduce the palette of the data down to ■ bits—only the screen display can do that— but it is possible to reduce a file down t eight bits. This type of reduced color, whe set ranges of colors are used and each pixe is changed to the closest match, is calle "indexed color." Changing to indexed colo greatly reduces the image quality of the di play and print, and reduces the file size. Mac and PCs have slightly different palettes, bu share 216 of the 256 colors (see pp. 146–149

CREATING INDEXED COLOR

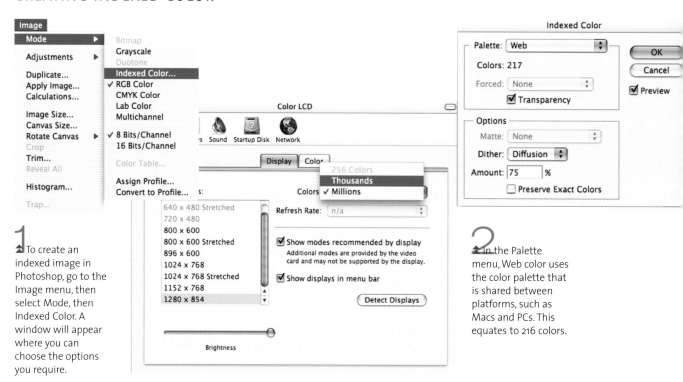

1 ↥ To create an indexed image in Photoshop, go to the Image menu, then select Mode, then Indexed Color. A window will appear where you can choose the options you require.

2 ↥ In the Palette menu, Web color uses the color palette that is shared between platforms, such as Macs and PCs. This equates to 216 colors.

4-BIT COLOR

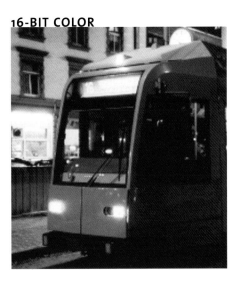

16-BIT COLOR

8-BIT COLOR

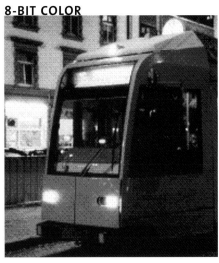

bove In this 24-bit mage, the original file was 24MB in size, aved as RGB color.

24-bit color gives the highest possible color range—16.7 million colors.

above Your graphic card has the ability to switch to 16-bit color, decreasing the color range to 67,000 colors. Visually,

there is little difference and the image is still the same size (24MB), because it is still stored in 24 bits.

above This image has been changed to an 8-bit color space, reducing the palette to just 256 colors. The

palette is fixed by the operating system's LUT but the image is now a lot smaller (8MB).

Indexed Color

Palette: Local (Adaptive)

Colors: 256

Forced: Black and White

☑ Transparency

OK

Cancel

☑ Preview

Options

Matte: None

Dither: Diffusion

Amount: 75 %

☐ Preserve Exact Colors

8-BIT WEB RGB

Color | **Swatches** | Styles

left and below 8-bit Web color uses a reduced palette of 216 colors. The 8-bit color palettes for Mac and Windows both offer 256 colors, but the palettes are not entirely the same.

3 Local (Adaptive) color selects a custom color palette, from the full 24-bit range, and chooses the closest 256 colors. When you have finished your election, click OK.

8-BIT MAC RGB

Color | **Swatches** | Styles

8-BIT WINDOWS RGB

Color | **Swatches** | Styles

SEE ALSO

SPECIAL INKS — 46
BIT DEPTH — 58
GIF COMPRESSION — 146

■ Pantone color

Pantone is a standard referencing system for specifying ink colors. Pantone also offers the ability to convert easily to CMYK and is found in many applications.

Special color ink systems, such as Pantone, can be considered similar to indexed color (see pp. 104–105). They work with a set range of colors that can be easily specified and used. In printing, adding these colors can greatly increase the available color gamut on the printed page (see pp. 46–47). Pantone colors are often used in CMYK+ or HiFi color systems (see pp. 92–93).

Most software applications allow you to specify Pantone colors, but some have limitations. Vector packages, such as Illustrator, and DTP packages, such as QuarkXPress, allow you to specify Pantone colors as "spot colors," or "process colors," while Raster packages, such as Photoshop, prefer to con-

vert them to the nearest CMYK process color, giving a gamut alarm warning. The gamut alarm informs you what color will be substituted when you convert the color space (see pp. 54–55). In Photoshop, you can select the Pantone range (see below) in the Color Picker, click on the foreground Color Picker, or go to the Color window.

When you use Pantone colors in Photoshop, they convert back to another color space, normally CMYK, for print. To overcome this and create an extra spot color, select a New Spot Channel (see right) from the Channels window. This will add a further eight bits of data to your file, and will output as a separate plate when color separating.

CMYK

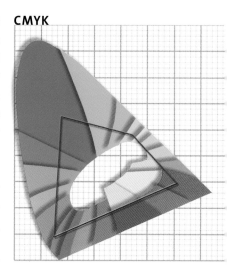

PANTONE

SELECTING PANTONE COLOR IN PHOTOSHOP

1 In the Swatches window of Photoshop, select Pantone Color Systems.

Dock to Palette Well

New Swatch...

✓ Small Thumbnail
 Small List

Preset Manager...

Reset Swatches...
Load Swatches...
Save Swatches...
Replace Swatches...

ANPA Colors
DIC Color Guide
FOCOLTONE Colors
HKS E
HKS K
HKS N
HKS Z
Mac OS
PANTONE metallic coated
PANTONE pastel coated
PANTONE pastel uncoated
PANTONE process coated
PANTONE solid coated
PANTONE solid matte
PANTONE solid to process
PANTONE solid uncoated
TOYO Colors
TRUMATCH Colors
VisiBone
VisiBone2
Web Hues
Web Safe Colors
Web Spectrum

2 You can load the whole swatch into your window if you require this.

above Adding Pantone to CMYK adds a lot to the color gamut, as you can see from the larger area covered by the lines on the graph.

SELECTING PANTONE COLOR IN QUARKXPRESS

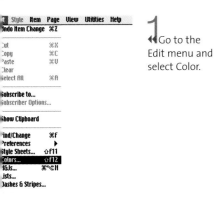

1 Go to the Edit menu and select Color.

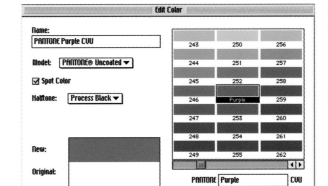

2 Select Pantone from the menu. You can visually select a color or enter the swatch number. When you save this, you will have a new channel added to your file.

CREATING SPOT COLOR CHANNELS IN PHOTOSHOP

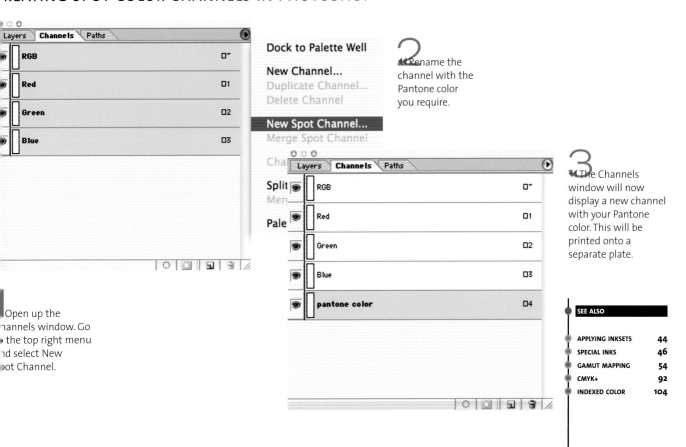

1 Open up the Channels window. Go to the top right menu and select New Spot Channel.

2 Rename the channel with the Pantone color you require.

3 The Channels window will now display a new channel with your Pantone color. This will be printed onto a separate plate.

◼ resolution

Working with the correct resolution is critical to working efficiently. Using the incorrect resolution results in either too much or too little data. Both can create problems.

The resolution of your picture can have a direct impact on the quality of your final image, in terms of both color and quality. If you have too little data, the image will start to break up, showing the pixels (pixelating). If you have too much, the image can lose sharpness and detail, and it will take longer to achieve the required post-capture manipulation because your computer will need to process more data.

The image should be created at the resolution that is required for its final purpose. The measurements are described in "pixels per inch" (ppi) or, in some software, as "dots per inch" (dpi). There is a great deal of confusion over dpi and ppi and many manufacturers of hardware and software have not standardized their terminology. Dpi should be used to measure the resolution of the printing device and ppi should be used to measure the number of pixels contained in the image.

Generally, you can use the information that follows in the sections below as a rule, providing you do not require any enlargement or reduction.

working with pixels per inch (ppi)
If you want to show the image on a screen display (for the Internet, DVD, or TV for example), then a resolution of 72 ppi is adequate. Digital video cameras designed for screen delivery use this resolution.

If you want to print an image on an inkjet printer, then you should use a resolution of

NORMAL 300 PPI 4.87MB

150 ppi. Digital still cameras are designed for inkjet printing, using 2 x 72 ppi (144 ppi), which is enough to get a good output.

high-end print
Professional printers print with images at 300 ppi, using lasers to generate very high quality work with a resolution normally in excess of 3,200 dpi. This equipment is very expensive. Cheaper inkjets, which work at around 2,800 dpi, do not produce such high quality results, because an ink spot is not as precise as a laser dot (see pp. 112–113).

above The optimal image (with inset detail), printed at 300 dpi using coated paper.

CREEN 72 PPI 287K

left The resolution at 72 ppi is too low for printing, but would be fine for screen use. The image starts to break up and lose sharpness. You can see the image start to pixelate in places.

HIGH 1,600 PPI 138.5MB

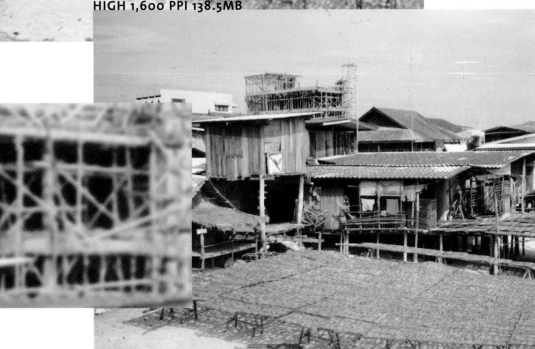

left This image has been overscanned, at 1,600 ppi. Although the image holds extra detail, this cannot always be represented in the final product. The image has about 133MB of data that it cannot use.

■ printing and pre-press

Achieving professional-quality images requires sophisticated equipment and lots of data. This ensures that the halftones can be imaged at all angles to achieve color.

To create a tonal image with a single ink, or a full-color image with four inks, printing presses use a system called "halftones." This process uses a variety of small dots to re-create the tone of the image. If the image is light in tone, then these dots are small, but where the image is dark, a larger dot is required. The dots themselves have a resolution of their own, measured in "lines per inch" (lpi).

The dots are all placed in a line but when more colors are used, the dots need to be placed at different angles. This avoids an optical illusion called a moiré effect. Generally, the following preset angles are used:

Cyan: 105 degrees
Magenta: 75 degrees

Yellow: 90 degrees
Black: 45 degrees

Professional printers do not want to see a pixelized image with jagged edges ("jaggies"). To avoid this, they use one pixel for each of the four CMYK colors. The printer's lpi resolution is multiplied by at least two to give the required input resolution:

lpi x 2 = input ppi

As magazine printing uses 150 lpi (a very common form of color printing), multiplying this by two equals 300 ppi. This is often the resolution used on automated systems, which assume printing at 150 lpi. These systems require one pixel for each dot.

However this is not a definitive measure ment. Where flat colors are in the image it possible to reduce the multiplication to 1 but where the image has a lot of texture, is best to increase this to 2.5 or even 3.

High-end printers use lasers to gene ate images from the data that they a supplied with, and the dpi is very high create as accurate a dot as possible. T laser generates an image on a matrix, ar the finer the matrix, the better the fin printed image.

A further issue is that the screen angl complicate the dot shape. From the illu trations (below and opposite) you can s that the 105-degree dot is not as we formed as a 45-degree one, since it los part of its edge when placed at an angle

CYAN 105 DEGREES

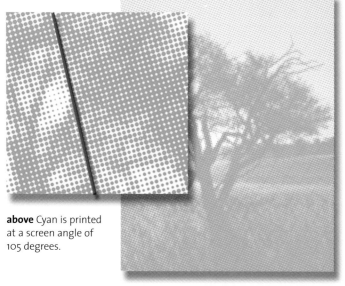

above Cyan is printed at a screen angle of 105 degrees.

MAGENTA 75 DEGREES

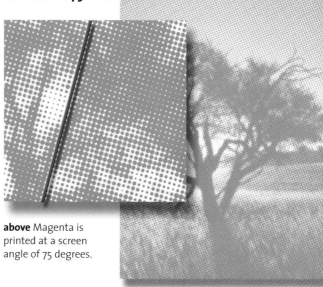

above Magenta is printed at a screen angle of 75 degrees.

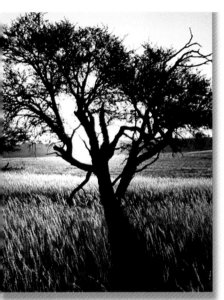

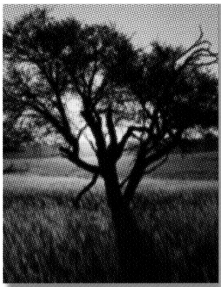

LASER DOT AT 45 DEGREES

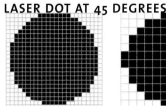

above A fine laser dot using a dense matrix for imaging. This matrix gives a good shape to the dot.

above A coarse laser dot with a large matrix give a less precise dot shape.

LASER DOT AT 105 DEGREES

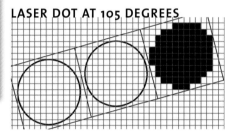

above When the halftone dots are imaged at an angle, part of the dot is lost

(see the right-hand edge). To counteract this, high dpi printers are required.

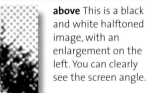

above This is a black and white halftoned image, with an enlargement on the left. You can clearly see the screen angle.

above This a color CMYK halftoned image, with an enlargement on the left. You can clearly see a rosette pattern on the image.

YELLOW 90 DEGREES

BLACK 45 DEGREES

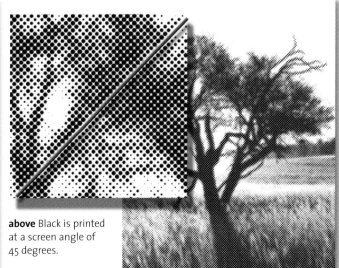

above Yellow is printed at a screen angle of 90 degrees.

above Black is printed at a screen angle of 45 degrees.

■ Postscript

The development of Postscript allowed computer hardware to communicate with a greate range of printers. This meant that designers were not tied down to one manufacturer.

The problem in the early age of digital production was that only certain computers could "talk" to each other. This was because different machines used different languages, so only a printer compatible with your particular machine would work.

To remedy this, a language was developed by Xerox researchers that enabled machines and printers of different types to work together, which eventually led to the creation of Adobe Postscript in 1985. Postscript was adopted by Apple for the Macintosh, the first system with Xerox's Graphic User Interface (GUI). This partnership started the digital revolution.

working with Postscript

When you send a file to a printer, it translates the file into Postscript and sends it to the printer as a self-running application. The printer executes the program, runs it, then erases it. Any special features of the printing device, such as color management, are held in the Postscript file.

below These are the steps involved in Postscript/ printer communication.

Postscript is an "extensible language" meaning it is free to use and add to, bu under the control of Adobe. By the ear 1990s, there were so many additions, allow ing for new technologies such as digit color and separation, that a new version of Postscript was developed, Postscript Level This allowed the professional color printin industry to adopt this technology and dev astated the traditional reprographic indu try. A further development of Postscrip was in 1998, when Adobe announced th release of Postscript Level 3, which adde more functionality for print and th Internet, as well as greater speed.

HOW POSTSCRIPT COMMUNICATES WITH PRINTERS

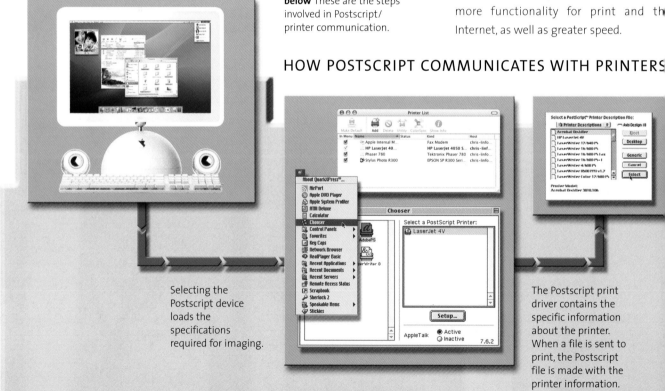

Selecting the Postscript device loads the specifications required for imaging.

The Postscript print driver contains the specific information about the printer. When a file is sent to print, the Postscript file is made with the printer information.

hy we need Postscript

ostscript gives a result suitable for profes-
onal printing processes and allows for
:curate color separations and dot genera-
on for printing. If a high-end system (a
stem that requires a lot of data) is being
ed, Postscript will send high-end data;
wer-end printers will receive less data. It
for this reason that Postscript printers
e more expensive, and essential for the
ofessional printing industry.

For home use, Postscript is not always
quired, and the print driver that comes
ith your laser or inkjet allows for a
thered system of mixing colors as well as
sing CMYK+ colors. However these are not
:curate enough to create a high-quality
alftone dot, which is required for profes-
onal printing. A halftone dot is used in the
rinting industry to create the "illusion" of
ne on paper (see pp. 110–111).

DITHER

left and right Two halftone dots. The one on the left was generated on an inkjet printer and the one on the right on a laser printer.

above left and above right Dithering (representing a color using patterns of tiny colored dots to simulate that color) is not supported on high-end printing systems.

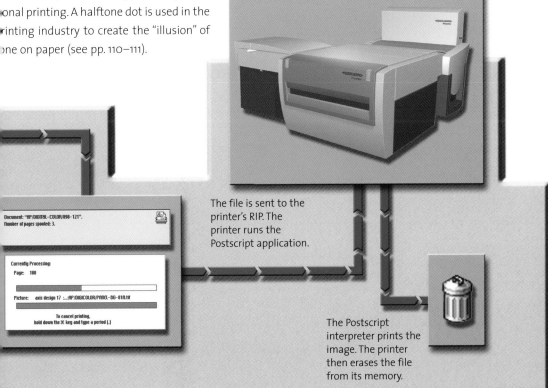

Document: "AP/DIGITAL-COLOR/090-121".
Number of pages spooled: 3.

Currently Processing:
Page: 100

Picture: axis design 17 :...:AP/DIGICOLOR/PANEL-BG-01A.tif

To cancel printing,
hold down the ⌘ key and type a period (.)

The file is sent to the printer's RIP. The printer runs the Postscript application.

The Postscript interpreter prints the image. The printer then erases the file from its memory.

■ PDFs (Portable Document Format)

PDFs are generated from Postscript files. They allow you to see exactly what a file contains, all within the open architecture of Postscript.

Portable documents have been around for a long time. The quest for portable data, or file formats, started in the 1950s and 1960s with early computers and the development of the ASCII file format for text files.

The problem with Postscript (see pp. 112–113) is that it is a language, which makes it difficult to take it back into the computer for further work. Today, we need to turn Postscript files back into workable data. Previously, there were few software packages that could interpret Postscript back to a graphical format. Today, Adobe's PDF (Portable Document Format) allows this by creating documents from Postscript that are application-independent. PDFs can incorporate text, images, sound, video, interactivity, databases, and many other types of data suitable for the Internet, CD-ROMs, DVDs, and print work. Everyone can access the files because the "reader," or "interpreter," is freely distributed and easily downloadable from the Internet and is now standard on most operating systems.

CREATING A PDF WITH ACROBAT DISTILLER

1 Many applications allow you to create PDFs. This option is normally found when you use the Save As command. Using Acrobat Distiller, first make a Postscript file of your design, then select your Postscript printer and driver.

2 When you go to print, select File rather than Printer as your destination. The Print button will change to a Save button and the file name will be given a .ps extension to identify it as a Postscript file.

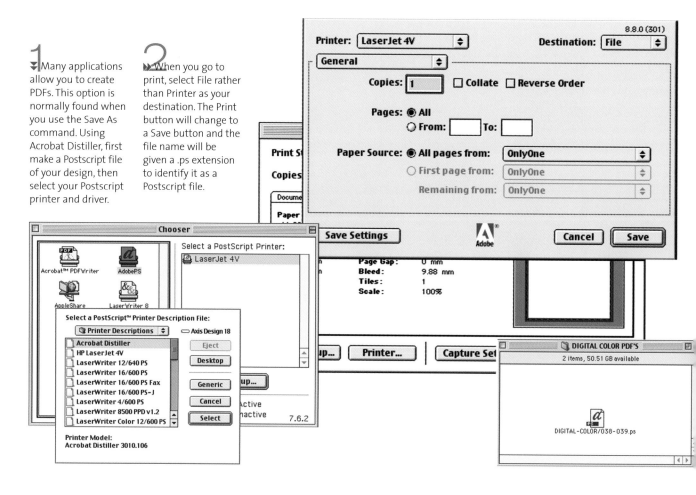

The PDF format can work with a variety of resolutions and color systems, and compresses efficiently for easy distribution across the internet, using the tried and trusted JPEG compression system (see pp. 144–145). This has now become a perfect format for image output because it uses a good compression system that reduces the file size, creates files that are easily transferable, and allows all computer users to read them. However, for best results, they need to be created at the appropriate resolution and compression.

PDF RESOLUTIONS

When PDF first appeared, it was only able to make screen representations of pages that were suitable for local, low-end printing. That changed in 1996 when Adobe Acrobat 4.0 was released, supported by Level 3 Postscript, which allowed it to use high-end data to create high-end PDFs.

To get the correct output, the resolution should be calculated as for any other rasterized file. The standard settings are:
Screen viewing: 72 ppi
Local, low-end printing: 150 ppi
High-end printing: 300 ppi

3 Open Distiller, Adobe's application that converts postscript files to PDFs. Specify the resolution and requirements that you have for the file. Select the .ps file.

4 Distiller will then RIP the file into a PDF format and add the .pdf extension to the file name.

6 You will end up with three files; the one created by the original application; the .ps Postscript file; and the .pdf PDF file.

5 The saved file can then be opened in Adobe Acrobat for viewing.

Successfully managing the devices used to capture an image is an important step in achieving a high-quality result. This chapter introduces the different image-capture systems available, including flatbed desktop scanners, digital cameras, and Photo CDs. The benefits and limitations of each system are identified, as well as how to get the best out of each type of device. In addition, issues relating to file compression are explained to help you choose the most appropriate way of handling your digital data.

■ high-end drum scanners

Original digital scanners used light-to-energy devices called photomultiplier tubes (PMTs). Although not now in common use, PMT scanners still offer the best color accuracy.

Professional color bureaus and reprographic studios used to have high-end color drum scanners at the center of their operation. These were very expensive machines, costing tens of thousands of dollars, and required a great deal of knowledge and skill to operate. This meant that staff costs, as well as initial outlay for the equipment, were high.

Digital drum scanners have been available since the early 1970s and were made by prestigious companies like Crosfield, now owned by Fuji; Hell, now Linotype Hell; and Scitex, now Creo Scitex. These companies set the standard by which all other scanners operated—and still do. Normally these devices could only scan flexible artwork or transparencies, which were stuck onto the drum. Hard or ridged artwork needed to be photographed onto transparency film first before it could be scanned. Because the drum rotated, artwork and photographs needed to be secured firmly to the drum to avoid the potential for damage if the images fell off the drum.

Drum scanners use photomultiplier tubes (PMTs) to turn light into an electrical current. Early scanners could only capture data for immediate color separation, and were often custom-made, making it difficult to transfer skills from one manufacturer to another. Later, as technology improved, it became possible to store data from the scanner onto a computer's hard drive, but by then there was already competition from flatbed CCD scanners (see pp. 122–123) for the desktop computer.

A drum scanner (see illustration below) uses very fine, laser-beam-quality light to reflect data onto the PMTs through a range of mirrors. The PMTs then filter red, green and blue light through three PMTs to create

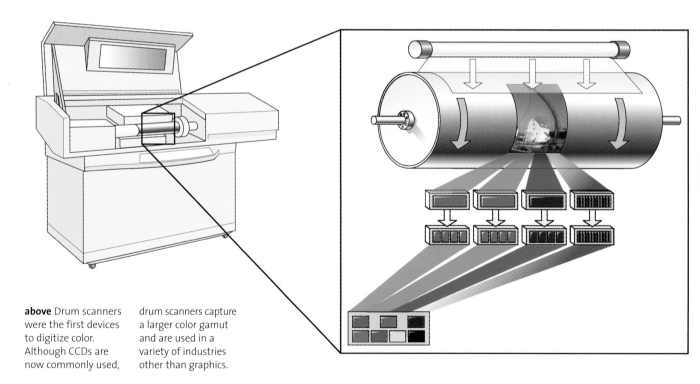

above Drum scanners were the first devices to digitize color. Although CCDs are now commonly used, drum scanners capture a larger color gamut and are used in a variety of industries other than graphics.

...he RGB image. High-end scanners often ...ave a fourth PMT, called Un-Sharp Mask ...JSM), to enhance the definition of the ...mage. This creates contrast between edges ...n images, which aids visual clarity in the ...nal print. Applying the USM filter on the ...canner generally gives better results than ...sing filters in programs such as Photoshop.

Historically, these drum scanners have ...nly been used to create images for final ...utput rather than just image capture; ...hey normally have their own high-end ...GB to CMYK conversion hardware, which gives excellent, professional results for high-end printing.

Drum scanners using PMT technology are still generally considered to achieve the best results and their operation has been simplified to conform to CCD capture software (see pp. 120–127). PMT scanners can give greater color accuracy than flatbed desktop scanners, detecting lower levels of electromagnetic radiation, from X-ray through infrared. They also have high-quality manipulation and calibration software to make color corrections prior to the scan.

left Modern scanners are now vertical so that they can fit onto a desktop for easy access and use.

...ght Modern PMT ...anners now ...se similar software ... CCD scanners and ...ave become more ...ser friendly by ...tilizing familiar ...indows-style ...reen displays.

PROS OF PMT SCANNERS

1 Are high quality

2 Produce professional results

3 Have greater capture range

4 Have direct CMYK conversion

5 Scan quickly

6 Are used by experienced staff

CONS OF PMT SCANNERS

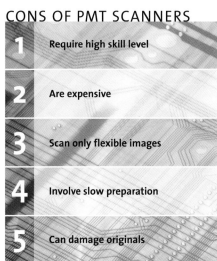

1 Require high skill level

2 Are expensive

3 Scan only flexible images

4 Involve slow preparation

5 Can damage originals

■ CCDs

CCDs (Charged Coupled Devices) have largely replaced PMT technology. CCD technology is cheap and easy to use, but often does not provide the same quality image as PMTs.

CCD stands for Charged Coupled Device. Today, this is the most common system used for turning light into electrical energy. CCDs were first used in desktop scanners in the late 1980s to capture black-and-white images, but by the 1990s, improved technology enabled them to scan color. The first scanners captured data by passing the CCD element over the image three times, once for each of the primary additive colors (red, green, and blue). Later, they scanned in a single pass, the CCD elements being exposed with red, green, and blue filters.

CCDs capture and process light in a similar way to our eyes. Like the cones in our eyes, each CCD is coated in an additive primary color. The data collected by CCDs (or our eyes) is of no value by itself; it needs the computer, or the brain, to interpret it. Our brain changes images, converting two inverted images, each with a blind spot at the optic nerve entry point, and limited color information, into one full-color image (see pp. 12–15). Thus what we really see is different than what our brain finally shows us.

Likewise, a computer converts an electrical signal into color with the capture software that controls the device. This means that the real power is in the software (or the brain that works with the data. Low-quality software is like a human with color blindness; all images appear to be acceptable until you know how they should be.

CCD (CHARGED COUPLED DEVICE)

DIGITAL CAMERA CCD

left and below CCDs in your digital camera are often similar to film, with each CCD element capturing 24 bits of color. These elements relate directly to pixels.

above CCDs are multi-layered chips. The charge is transferred from one layer to the next until enough electrical current is generated to convert light to electrical energy. The CCD shifts one whole row at a time into the readout register, then shifts one pixel at a time to the output amplifier.

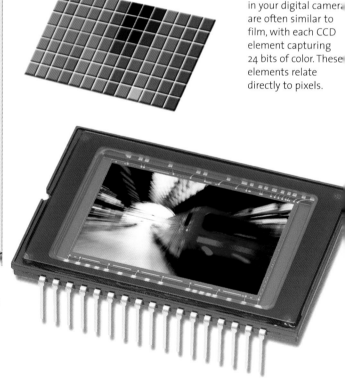

CCDs originated from satellite technology and are constructed from thousands of tiny light-sensitive elements, which are capable of transforming light into electrical energy. They can capture more than 60 percent of the visible spectrum and can record wide ranges of light, from shadow to bright light. CCDs sense small differences between tone and color, which enables them to capture a lot of information, especially in low light.

CCDs are now used in nearly all modern image-capture devices. They are found in desktop flatbed scanners and digital cameras, as well as in digital and analog video cameras—and even the Hubble telescope.

FLATBED SCANNER COMPONENTS

Flatbed scanners all work using the same principles and often the accompanying software is visually similar on screen. The main difference between models is the quality of the optics and the sophistication of the software.

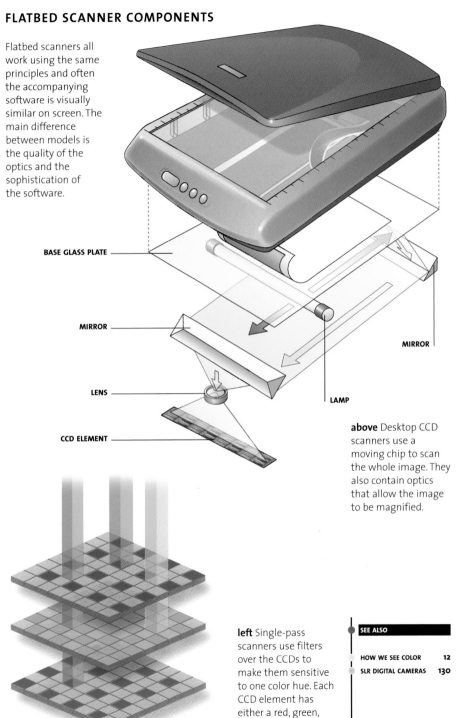

BASE GLASS PLATE

MIRROR

MIRROR

LENS

LAMP

CCD ELEMENT

above Desktop CCD scanners use a moving chip to scan the whole image. They also contain optics that allow the image to be magnified.

PROS OF CCD SCANNERS

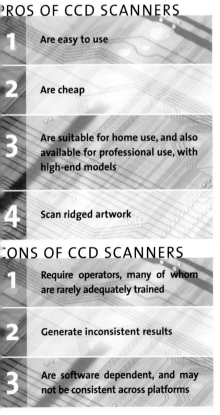

1	Are easy to use
2	Are cheap
3	Are suitable for home use, and also available for professional use, with high-end models
4	Scan ridged artwork

CONS OF CCD SCANNERS

1	Require operators, many of whom are rarely adequately trained
2	Generate inconsistent results
3	Are software dependent, and may not be consistent across platforms

left Single-pass scanners use filters over the CCDs to make them sensitive to one color hue. Each CCD element has either a red, green, or blue filter.

SEE ALSO

| HOW WE SEE COLOR | 12 |
| SLR DIGITAL CAMERAS | 130 |

flatbed scanner image capture

Flatbed scanners are now the standard method of digitizing images for computer systems
They work in a similar way to our eyes, but cannot capture the same gamut.

The first flatbed CCD scanners became available in the late 1980s, with the introduction of the Agfa Focus scanner. This early model captured black-and-white images in 8-bit color, which is enough for monotone reproduction. At that time, most designers had black-and-white monitors that could only display 16 shades of gray on standard 17-inch monitors. This remained the case until the early 1990s. This made any photo-manipulation completely impossible and mostly scans were used for positioning images only; these "positionals" were then replaced at a later point in the production process with high-end scans from a PMT drum scanner.

Then, color monitors became more common as their price reduced, Postscript Level 2 became available for color output, an early color scanners became available These early scanners made three passes t capture the image in RGB. By the mic 1990s, high-end flatbed scanners becam available, even though these were sti expensive, often only slightly cheaper tha a PMT system. However, they were easier t operate and enabled a faster turnarounc

left Flatbed CCD scanners come in a variety of shapes and sizes, but their operation and function remains the same. The main issue is the final quality of the image.

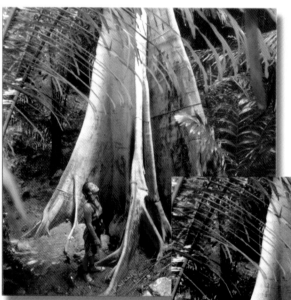

left and below An image captured on a mid-range scanner in CMYK, using the scanner's own software to convert RGB to CMYK (left). The same image was then converted on a RIP into CMYK (below). The difference is clear.

ith the result that they quickly took over om the PMT drum scanners.

Flatbed scanners scan reflective images, ıch as photographic prints, and paintings, ıt they can be used to capture transmissive aterial such as photographic transparen- ɔs. To capture the data, light is reflected off r through) the original and then, via mir- rs, directed onto the CCD elements. This ıta is sent to the computer for processing ıing an 8-bit capture system. Some scan- ɔrs capture in 10 or more bits, but this is ɪen "down-sampled" into eight bits.

A common misconception is that 32-bit scanners capture CMYK data (4 x 8 bits for each color). This is not the case because all scanners capture additive light and there- fore use RGB data. If the scanner outputs a CMYK file, it is because it has gone through the scanner's own conversion algorithm, which may result in a poor final image.

The image is scanned by the CCD array passing over the image. The array is fixed and cannot be changed. Modern scanners tend to have CCD arrays in excess of 1,200 x 600. These are normally single-pass

devices, capturing RGB color in one pass, although some triple-pass scanners, which scan the image three times, are still avail- able on the market.

Flatbed scanners now come in a variety of prices, ranging from less than $100 to more than $50,000. Inexpensive scanners can never be expected to produce as good results as more costly ones. The main ele- ments that separate models are the resolu- tion of the scanner and the software that processes the data to control image quality and color accuracy.

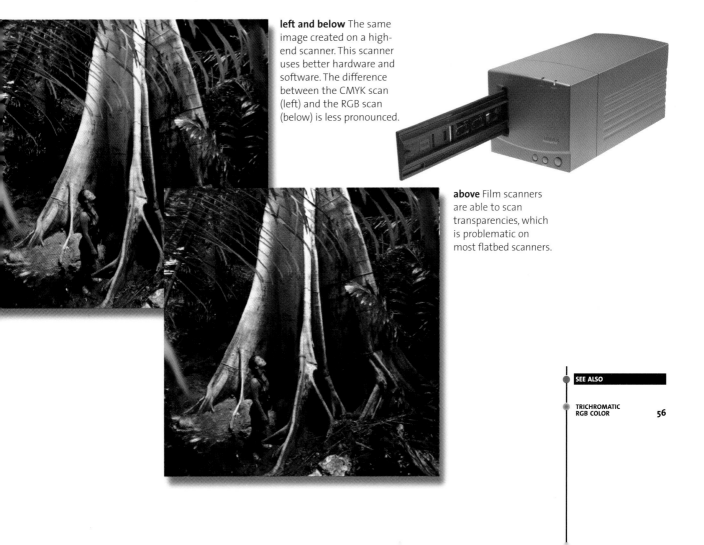

left and below The same image created on a high- end scanner. This scanner uses better hardware and software. The difference between the CMYK scan (left) and the RGB scan (below) is less pronounced.

above Film scanners are able to scan transparencies, which is problematic on most flatbed scanners.

■ scanner differences

Some scanners may operate in the same way, look similar, and even have a similar price, but they are not all the same when it comes to the accuracy of their color capture.

Not all scanners create the same image. They all have their own characteristics. Sometimes these characteristics are common to all scanners of a particular type, while others are more individual. This is why all scanners that are required to produce high-quality results are individually measured and characterized. However, this is not always the case. The settings that accompany the scanner are normally acceptable for general usage; because our brains interpret what we are actually seeing, an image often seems acceptable until we see a better one.

When you install the software that controls your scanner, you also install the baseline settings for that device, based on the manufacturer's calculations of the average device. This software can also install IC profiles (color information) into your sytem to aid color management (see Chapt 5), and other software. Most scanners, b not all, have scanning software that wor inside your photo-manipulation softwa applications, such as Photoshop, as a plug in. When this option is available, you hav to specify which software you wish to us

below This image was scanned in RGB on a Canon LIDE scanner with no Levels applied.

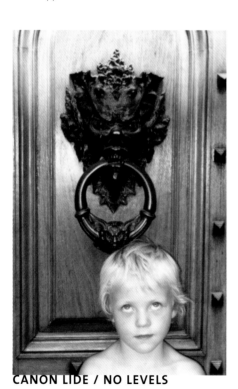

CANON LIDE / NO LEVELS

EPSON 1680 PRO / AUTO LEVELS

above This image was scanned in RGB using an Epson 1680 Pro scanner with Auto Levels applied.

below This image was scanned in RGB using an Epson 1680 Pro scanner with the Level applied manually, whic gives a better result.

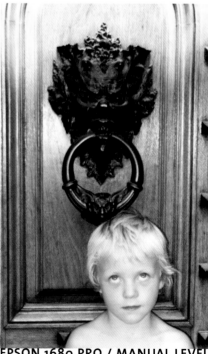

EPSON 1680 PRO / MANUAL LEVEL

or scanning and photo-manipulation.
lug-in scanner drivers offer the same
unctionality as the stand-alone software.
igh-end scanners often only have a stand-
one application to control the device. This
an be for many reasons, but it is normally
ecause it allows the operator to control the
rocess with greater precision to ensure
otimal quality.

The images below have been scanned on
variety of scanners, with different Levels
plied. There is more on Levels on pages
6–137. The different results are clear.

right Scanners come in all shapes and sizes. Generally the more you pay, the better the scanner will be.

USTEK / NO LEVELS

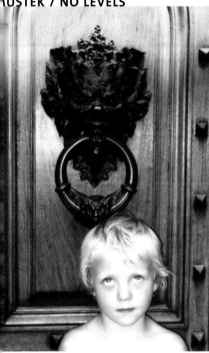

below This image was scanned in RGB using an Agfa Horizon scanner with Auto Levels applied. These make the darker areas too dense.

AGFA HORIZON / MANUAL LEVELS

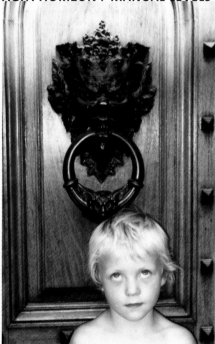

oove This image was anned in RGB using inexpensive ustek scanner with Levels applied.

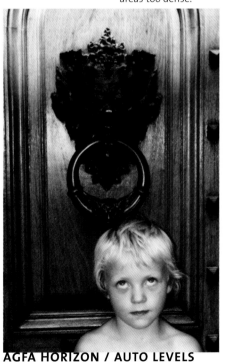

AGFA HORIZON / AUTO LEVELS

above This image was scanned in RGB using an Agfa Horizon scanner with the Levels applied manually, which defines the darker areas with more detail.

scanning software

High-end scanning software offers a greater range of options than low-end software. However, to operate it effectively, you will need a firm grasp of color theory.

Most flatbed scanning software works in the same way. You place an image on the scanner, select Preview (to crop the scan), and then select Scan. However, the results are not always consistent because the scanner has no "knowledge" of the image or its requirements. All it does is respond to the commands of the computer and user, and turn light into an electrical response. The software drives the device that takes the data and turns it into color on your screen. The quality of this software dictates the quality of the result. Often the cost of the scanner reflects the cost of the software that runs it. The more you pay, th better the result, or the greater your contrc

The best results are obtained whe the image is scanned in RGB color. CMY interpretation on cheap, low-end scanner is often poor and a better result is ofte obtained by making the conversion in othe

CONTROLLING HIGH-END SCANNERS

1 ▼ Agfa's FotoLook software is a high-end solution that enables you to gain maximum control of your image.

2 ▶ It is possible to enter the white and black point of the image inside the software and to the Levels.

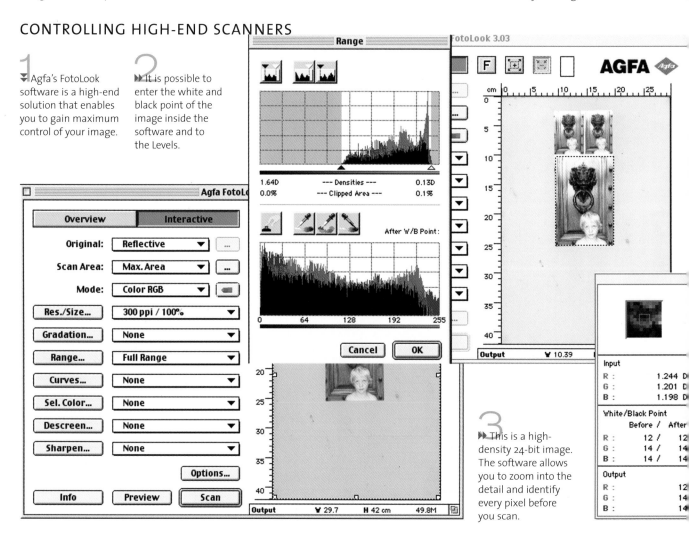

3 ▶ This is a high-density 24-bit image. The software allows you to zoom into the detail and identify every pixel before you scan.

ftware, such as Photoshop. This is because ne algorithms that low-end software uses re often poor when compared to more xpensive solutions.

Scanners also offer the opportunity to an at a wide range of resolutions (see pp. 8–109), often in excess of that obtainable 1 digital cameras, and can enlarge, or duce, the image to the required size. owever, you are limited to the scanner's aximum resolution, or the number of

CCDs. The lower the number of pixels per inch (ppi), the lower the amount of enlargement possible from the scanner because there are a finite number of CCDs. This is called the maximum resolution.

Most scanning software has controls that allow you to adjust any color casts on the original image. Many also allow you to enter a white and black point on the image to help calibrate the scanner. This feature is often of poor quality on low-end scanners

(8-bit color) so it is better to manipulate your image after the scan.

Some scanners can now scan images directly in CIEL*a*b* color space (pp. 98–101). This has the advantage that it can use the full visual color gamut, but you are still restricted to a 24-bit monitor to display it. You will need to convert to RGB or CMYK when you want to output your image because many printers cannot yet read CIEL*a*b* color.

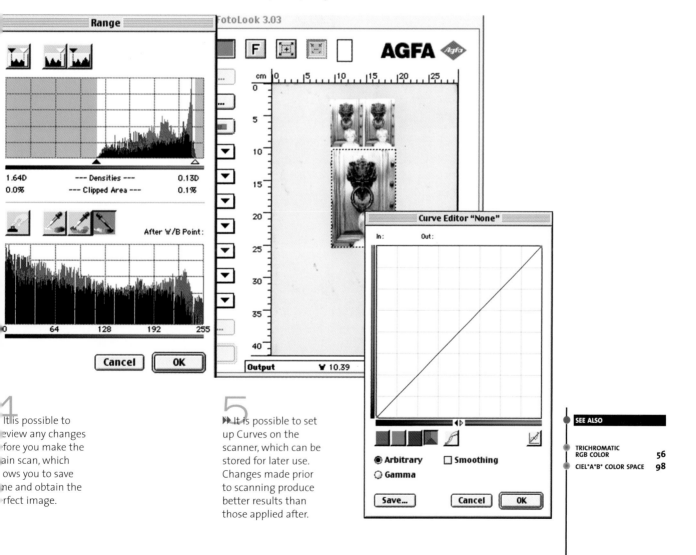

4 It is possible to eview any changes fore you make the ain scan, which ows you to save ne and obtain the rfect image.

5 It is possible to set up Curves on the scanner, which can be stored for later use. Changes made prior to scanning produce better results than those applied after.

SEE ALSO

TRICHROMATIC
RGB COLOR 56
CIEL*A*B* COLOR SPACE 98

■ single-shot digital cameras

The ease of point-and-shoot cameras and the sophistication of professional cameras offer a variety of solutions for capturing digital images.

The standard digital camera is a single-shot device that works in a similar way to a single-pass desktop scanner. The difference with the digital camera is that the CCD array does not move, but stays fixed while the image is registered on it, very much like conventional film. It is not possible to enlarge digital photographs without good interpolation software, because the pixels will enlarge and you will lose the required resolution for optimum output (see pp. 108–109). It is for this reason that the number of pixels generated by the camera is very important, and normally clearly labeled on the camera. The CCD arrays are normally measured in millions of pixels, otherwise known as megapixels.

Many different digital cameras are on the market but the resolution, or number of pixels, is critical to the final image. The lowest-quality image is a still from a digital video camera, when filming onto tape then extracting the image using video software such as Adobe Premier. These cameras generally capture at 72 ppi at either 640 x 480 or 800 x 600 pixels.

Many modern digital video cameras go one better than this and offer the opportunity to take digital stills and have extra CCDs available for this, sometimes as high as two megapixels (1,600 x 1,200 pixels) and capture at 144 ppi, which is a resolution suitable for inkjet printing.

The best quality comes from high-end digital still cameras, which are often Single Lens Reflex models (SLRs) that can capture images at 6.5 megapixels or more (3,000 x 2,250 pixels) and also capture at 144 ppi.

megapixels equal print size

A two-megapixel camera (actually capable of 1,680 x 1,230 pixels) will generate an image capable of printing at approximately 8½ x 11 in (21 x 27.2 cm), at 144 ppi, on an inkjet printer. This image will be around 5MB in size.

The dimensions of a print can be calculated using the following equation:

Number of pixels ÷ ppi = length of one side in inches

1,680 ÷ 144 = 11.5 in (29.6 cm)

If you wish to print this on a printing press, which requires twice the resolution of an inkjet printer, you will need to increase the pixel density by dividing the size by two (see pp. 108–109).

CHOOSING A CAMERA

**Nikon Coolpix 2000
2 megapixels**

This entry-level digital camera is ideal for the family. The low resolution enables a lot of images to be stored on the internal disk.

**Minolta DiMAGE F300
3 megapixels**

This is rapidly becoming the entry-level camera for consumers, with increased resolution that enables good 8½ x 11 in (21 x 27.2 cm) or 11 x 17 in (27.2 x 42 cm) home prints.

**Pentax Optio S4
4 megapixels**

With four megapixels, this camera gives the option of larger prints. These types of camera are still automated point-and-shoot models, which are easy to operate.

**Nikon Coolpix 5000
5 megapixels**

This is the start of the professional range, where images are suitable for output with professional printers, which require higher resolutions.

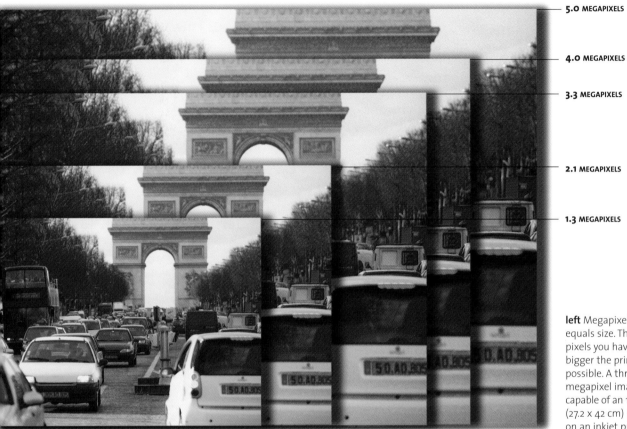

5.0 MEGAPIXELS

4.0 MEGAPIXELS

3.3 MEGAPIXELS

2.1 MEGAPIXELS

1.3 MEGAPIXELS

left Megapixels equals size. The more pixels you have, the bigger the print possible. A three-megapixel image is capable of an 11 x 17 in (27.2 x 42 cm) print on an inkjet printer.

left These three images show the difference in detail between different levels of megapixels. From left: five megapixels; three megapixels; two megapixels.

SEE ALSO

RESOLUTION	108
CCDs	120

SLR digital cameras

Single Lens Reflex (SLR) digital cameras offer the professional photographer the potential of film with the convenience of digital. These cameras start at around six megapixels.

The standard consumer point-and-shoot camera is limiting to anyone who takes photography seriously. These cameras have a limited capacity to control the image when taking the picture. The perfect image should not depend on your post-capture manipulation skills, but the settings used on the camera when you shot the image in the first place. A large amount of time can be saved by not having to use your post-capture computer skills if images are taken correctly. For example, it is easier to change the aperture of the lens than to add blur effects later on in Photoshop.

The traditional tool for good amateur and professional photographers is the 35 mm SLR that has interchangeable lenses and the ability to change the exposure speed, focal length, and aperture, depending on the model. The main companies in this field are Nikon and Pentax, and it is these manufacturers, with the addition of Fuji, that lead the field in digital SLRs. These cameras are still relatively expensive, but as is the case with most technology, prices are coming down all the time while quality is constantly increasing.

A 6.5 megapixel camera will be able print an image to the size of 18 in (46 cr along the longest side on an inkjet, and 9 (23 cm) on a printing press.

SLR digital cameras put creativity in the hands of the digital photographer. N only do these cameras offer greater resol tion than point-and-shoot models (at no mally over six million pixels), but also ha

NIKON D2H

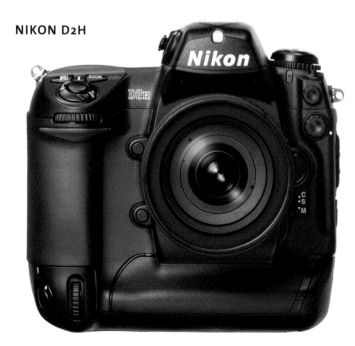

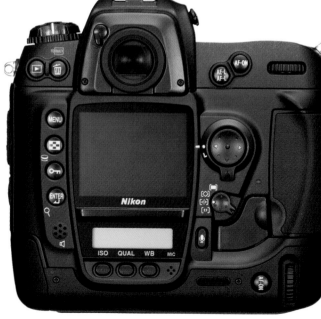

below Nikon cameras offer a large number of manual controls, just like traditional film cameras. This allows photographe to be creative at the time the shot is take

above and right Nikon produces a range of SLR cameras for professionals. These start at six megapixels and produce very high-quality results, mainly for photojournalists.

the advantages of conventional, film-
aded SLR cameras. They use the same
nses, which means that photographers
n use "old" equipment. These cameras
so come with software, both in the cam-
a and for the computer, that give better
lor control than more amateur devices.

SLRs use a single exposure to capture the
nage and can use very fast shutter speeds
capture high-speed movement, which is
quired in fields such as sports photogra-
ny. They can also operate well in low light
nditions, using slower shutter speeds,
abling the image to acquire the atmos-
here of the surroundings, which is good for
terior photography.

TRIPLE-SHOT CAMERAS

Single-shot exposure cameras are essential for capturing moving images, because a fast exposure is required. However, these cameras have resolution limitations because you cannot increase the CCD array size.

Triple-shot cameras have a higher resolution than single-shot ones. This is because all the CCD elements can be used to capture each primary color. Therefore, the CCDs will generate an image three times the resolution of a single-shot camera. All the CCDs in the array are used for each primary color channel, RGB. A disk on the front of the camera body rotates so that the image can be captured through each filter. When all three captures have taken place, they are combined to create one file.

These cameras are used for still-life photography and are now in use in many art galleries where high-quality digital copies of paintings and sculptures are required, both for archives and catalogs. These cameras are very expensive.

right Historically, the first color image was created by filtering light through red, green, and blue filters. These were later combined, via three projectors, to create one full-color image. Triple-shot cameras operate in reverse, capturing rather than projecting.

NAR M GRAFIC

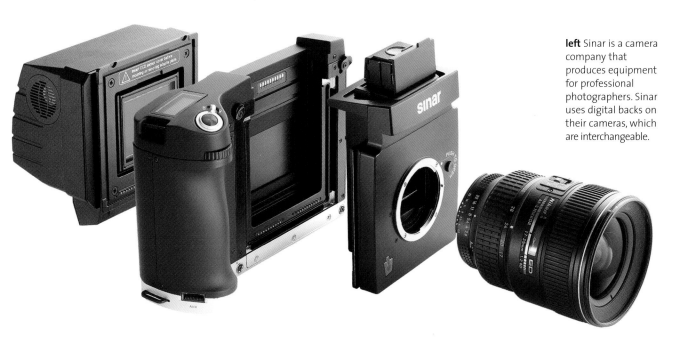

left Sinar is a camera company that produces equipment for professional photographers. Sinar uses digital backs on their cameras, which are interchangeable.

color casts

The color cast from artificial lights causes many problems when taking a photograph.
Often corrections are needed to make the image conform to the expectations of our eyes.

Many images have color errors created when the image was captured on a camera or a scanner. The use of the wrong type of film or lights for the conditions is often the main reason for this. Outdoor film, the most common type, is designed to capture light as accurately as possible, with yellow light that has been through a blue filter. When this type of film is used indoors, you often see color casts created by the room lighting. Tungsten light (from a lightbulb) gives a brown cast and fluorescent tubes, a light green cast (see pp. 26–27). It is possible to buy special indoor film to compensate for this.

Alternatively, it is possible to correct color casts digitally if the image cannot be taken again. Correction can be done on a scanner, (although the results are usually poor), or in image-manipulation software. Photoshop has a variety of tools that you can use to correct color casts.

The first is the Color Balance tool (select the Image menu, then Adjustments, then Color Balance). With this tool, you can move the sliders to alter the color tone of each of the red, green, and blue color channels. You can adjust the color cast in the highlights, midtones, and shadows of the image

independently. This system is useful for simple tasks and scanners often use it.

A more sophisticated method of adjusting the color balance is to use the Variations to (see right). Select the Image menu, the Adjustments, then Variations. This allow more flexibility in adjusting color and allow you to work in a more visual way. With the Variations tool, just select the color that you wish to add and control the coarseness of the change with the slider. There are also control for the shadows, midtones, and highlight areas. Finally, you can adjust saturation and lightness with this tool.

ADJUSTING COLOR BALANCE

1 This image has been photographed under fluorescent lighting, which has given the image a green color cast.

2 Selecting the Image menu, then Adjustments, then Color Balance, gives you the controls to edit the image.

3 In the Color Balan window, use the sliders to control the cast. You can amend the shadows midtones, or highlights as require

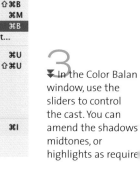

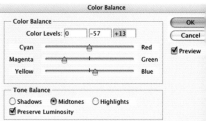

DJUSTING VARIATIONS

The Variations window, also found by selecting Image, then djustments, allows more visual method adjusting the lor cast.

2 **The Variations window allows you to see the changes more easily, and allows you to adjust saturation and lightness.**

3 **Whatever method you use, the result should be an improvement over the original image.**

Curves

Controlling the tone of an image can greatly increase the color gamut that you can use. The Curves function allows you to adjust tone and is an important tool.

Getting the tonal range of an image right is critical to producing a high-quality result. A good image should have a complete tonal range from black to white. If this is not the case, then the image can look weak, flat, or even as if it was shot on a foggy day.

A basic scanner or digital camera has no, or poor, controls for altering tone and it is often necessary to put tonal information into the image after capture, using the Curves function in Photoshop.

To use Curves, first select the Image menu, then Adjustments, then Curves. A window will appear with a diagonal line in

ORIGINAL CURVES

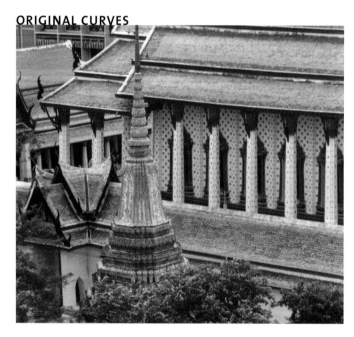

AUTO CURVES

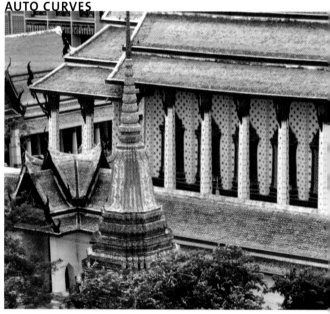

above This is the original image, which requires manipulation. The image has no tonal balance and looks weak and foggy. Adjusting the Curves allows you to compensate for scanner errors. When

you open an image, it has the scanner's tonal curve applied. Normally, this is just a straight line from bottom left to top right. This line can be adjusted to improve the visual features of the image.

above This image uses Auto Curves (using the Auto button), which will increase the tonal range. The curve still appears as a straight line.

quare box. The bottom left-hand corner is e black point, the top right-hand corner, e white point.

There are three "eye droppers" in the bottom right-hand corner of the window. The white eye dropper is used to select the point that you wish to be white, and vice versa for the black. The middle eye dropper, which is gray, is used to select what should be a midtone (50-percent tone). If you have the Info window open, you will be able to see the tonal values to help your selection.

Using a different midtone point can radically change the image. Indeed, the midtone is critical to the detail shown in the image and Curves are an ideal way of controlling it. To adjust the midtone, just click on the diagonal line and lift or lower the line until the image displays the required detail.

Avoid choosing a reflected highlight as your white point because these should "burn out," giving extra brightness. Also, avoid the Auto Curves setting because this just finds the lightest and darkest pixels and makes them white and black. Lastly, use Freehand Curves to create special effects.

MIDTONE CURVES

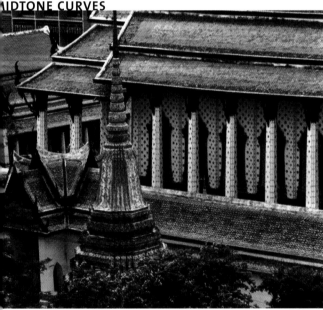

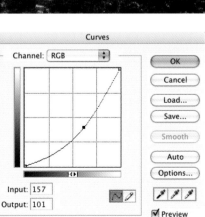

above Adjusting the midtone makes the image richer and the colors more saturated. The colors in this image are now also more defined.

FREEHAND CURVES

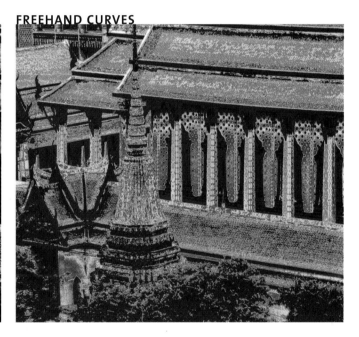

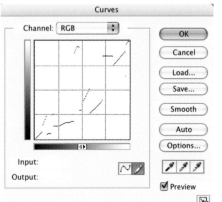

above By using the Freehand Curves you can create different graphic effects.

■ Levels

Levels work along the same lines as Curves, but many users find them easier to control, especially if you want to produce only basic changes in the tone of your image.

Another way of controlling the tonal values of an image is to use Levels (select the Image menu, then Adjustments, then Levels). This system is a little easier to use than Curves but is limited because it uses white, black, and midtone adjustments only, whereas Curves has a great deal more flexibility along the whole length of the curve.

The Levels window shows the tonal range of the image in the form of a histogram. The taller the graph, the more tone there is at that value. The tonal value can be seen below the graph on the gray tonal bar.

Levels are adjusted just like Curves, with the eye dropper tools. You can also use the triangles below the histogram to control the tone by clicking on them and dragging them to where you want them. The middle triangle is the midtone tool, which is very easy to control using this method.

You can also easily use the midtone tool to lighten the image with the tonal bar below the histogram. By sliding the triangle at each end of the grayscale, you can control

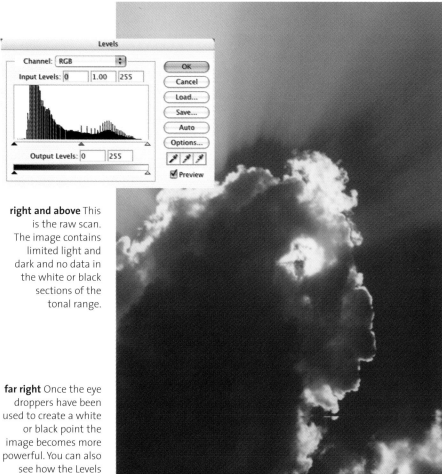

right and above This is the raw scan. The image contains limited light and dark and no data in the white or black sections of the tonal range.

far right Once the eye droppers have been used to create a white or black point the image becomes more powerful. You can also see how the Levels have changed.

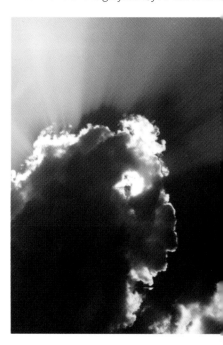

he tonal range available for the image.
his is very useful when you want to reduce
he intensity of an image so that it can be
sed as a background image.

Finally, use the Levels tool on any one of
he color channels to adjust any color cast
n an image. The images below show the
ffects that Levels can create.

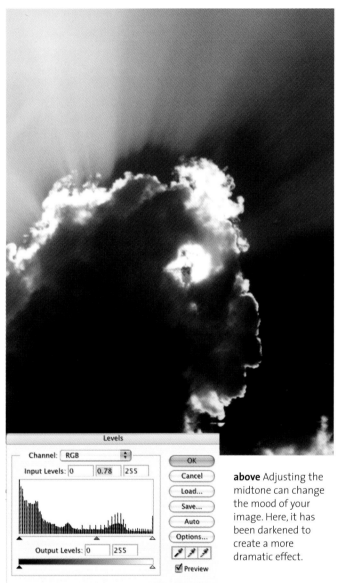

above Adjusting the midtone can change the mood of your image. Here, it has been darkened to create a more dramatic effect.

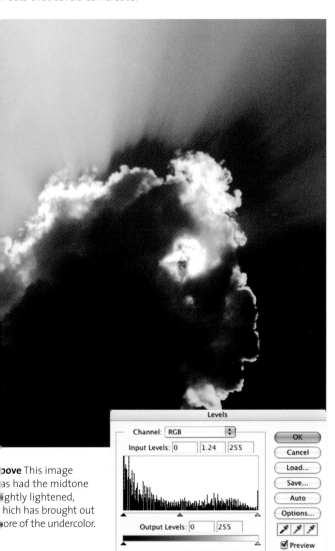

above This image has had the midtone lightly lightened, which has brought out ore of the undercolor.

high-end capture software

With high-end scanners and cameras come the need for more sophisticated software.
These allow you to make all the tonal calculations before capture.

As we have noted, a lot of the cost of desktop scanners and digital cameras is in the software that runs and controls the device. With cheap, low-end systems, the software offers limited capabilities, whereas more expensive devices offer a greater range of functions. High-end capture software allows you to control the image before you scan, which allows you not only to gain the most from the system but also the image itself. It is better to enter Curves and Levels data and correct any color casts before the image is captured, by using the controls in the capture software, than after the image is scanned. Extra cost normally also equates to better optics and better resolution. Scanners at this time have more than enough resolution for most tasks because of the moving CCDs, but digital cameras need more CCD elements, as these do not move in single-shot cameras.

High-end scanner software allows the scanner operator to fully control the image before scanning. The preview image in low-end scanners is normally on 8-bit color and at 72 ppi. However, in a high-end system, the image is at full resolution and in 24-bit color. This allows the scanning software greater scope to select white and black points and to control any cast.

High-end digital cameras allow settings to be entered into the hardware and software to maximize the quality of the final shot. They use the first shot to calibrate the image and then reshoot it to get the best from the system. As digital capture does not cost anything (unlike film), you can always alter the settings and shoot again.

SINAR CAPTURESHOP

left Sinar professional digital camera software allows you to work in a variety of file formats, depending on what the image will be used for.

right Moiré is a problem with digital systems and printing. Sinar's software allows you to control this.

Software Moiré Suppression 6
Default Value
low medium high
6
Apply

Please select a default moiré suppression value for new action shot images...

11:3
n Sy's Mac:CyberKit:)
WORKSHOP_06-09-010021
1
WORKSHOP_06-09-010028
1
WORKSHOP_06-09-010046
1
WORKSHOP_06-09-010050
1
WORKSHOP_06-09-010054
1

Offline / Process / Export / Separate

Curve Standard Curve 3
-3 -2 -1 0 1 2

In Out

▷ Saturation Color
▽ Unsharp Mask 140%

Info

Raw Data	Exposure	Export Value
2991	+0.3 EV	136/165
2147	-0.2 EV	103/119
1690	-0.6 EV	82/86
2347	-0.1 EV	

Detail WORKSHOP_06-09-010034 ...

Controls

Capture / Process / Export

▷ Orientation Landscape
▷ Exposure Time 1/8
▷ Aperture f4
▷ Live Image Off
▷ Focus Assistant Off
▷ Grid & Axis Off
▷ Shading Correction Off
▷ Flash On
▷ Amore HW Off
▷ Camera Sinarcam2 (late flash)
▷ Capture Mode Action Shot (11)
▷ Light Meter Underexposed
▷ Session Peter

Capture

bove The contact heet allows you to review all images on reen before you nish the shoot.

above Studio photographs go straight into the computer system. This allows changes to be made instantly to match colors accurately before the image leaves the studio, or a photographic set is dismantled.

left High-end systems offer professional photographers everything that they expect from traditional photographic practice.

SEE ALSO

PRINTING AND PRE-PRESS 110
SCANNER DIFFERENCES 124
SLR DIGITAL CAMERAS 130

photo CDs

Photo CDs (PCDs) were invented by Kodak to digitize analog photographic images. PCDs can be purchased from most leading photographic film processing laboratories.

Before digital cameras were widely available, Kodak developed a system where images could be scanned and placed onto a CD ROM. These CD ROMs are called Photo CDs (PCDs), and they are playable on computer systems, video CD players, and some DVD systems. Kodak made the Image Pac format, which PCDs use, an open format, allowing third-party developers to freely use it, which has made it accessible to most image-users through image-manipulation software such as Photoshop. The images are scanned at a variety of sizes, ranging from low-resolution files for screen display through to high-resolution files suitable for printing.

Photo CDs offer many advantages for the graphic arts industry. First, you are provided with the images at a variety of sizes so that they can have a wide variety of applications. They are also created from transparency c negative film, which enables designers t rescan data if a higher resolution is require as a backup, providing a flexible resource. It also an easy solution for photo libraries fc supplying digital files. Finally, it capture images more perceptually than other system

There are many suppliers who now offe photo CD services, but their quality is nc always uniform. Specialist photographi

above PCDs offer a range of resolutions and a preview of each image for easy selection.

above Special software is often required to work with PCDs, but this is supplied free of charg

ompanies that offer this service are generally etter than consumer-based outlets. rofessional companies offer the ability to pecify color requirements, either to match he film's color characteristics or to use a stan- ardized photographic color space that tries o create the colors of the original subject, ounterbalancing the weaknesses of the film.

Photo CD images can be opened directly nside image software such as Photoshop, but here are also a variety of specialized packages vailable if you do not have this facility. To open our images in Photoshop, Kodak's CMS plug-in vill need to be properly installed.

CD READ / WRITE PLAYER

left While specialist PCD hardware used to be required, PCDs can now be read on any computer CD drive and some DVD players.

above PCDs supply the images in RGB and CMYK formats. This is very useful and avoids conversion problems later.

photo CDs and YCC color

Photo CDs (PCDs) use their own color space, called YCC, which offers a great potential for inexperienced digital photographers, as well as unique facilities for experienced ones.

Photo CDs use a color space called YCC, which has its base in CIE's perceptual color spaces (see pp. 98–101). Y is the luminant value and the two C channels represent the color ranges, from magenta to green and from yellow to blue. In many ways, this is similar to CIEL*a*b* color, with the Y equalling the L axis and both C channels the a, b axes.

It is preferable to keep your files in a color space that can be used to represent the whole visible spectrum because film can capture more information than we can use on either an RGB device or CMYK process. This allows the system to use as many colors in the final image as the output system will allow.

using and correcting YCC

Most image-manipulation software will not open PCDs's YCC color space, so it needs to be converted into another space that the software can handle. As soon as you do this, you will compress the tonal range of the file, which means any tonal or color correction will restrict the gamut. To compensate for this, it is preferable to transfer the data into CIEL*a*b* color space first (to correct tone and color), then transfer later into RGB, for screen display, or CMYK, for printing, at the end of the manipulation stage (see pp. 98–101). The Kodak plug-in used in Photoshop will handle this conversion. This will allow you to use the complete additive color palette until the final stages of production, where it is converted into either RGB or CMYK color.

SWAPPING COLOR SPACES

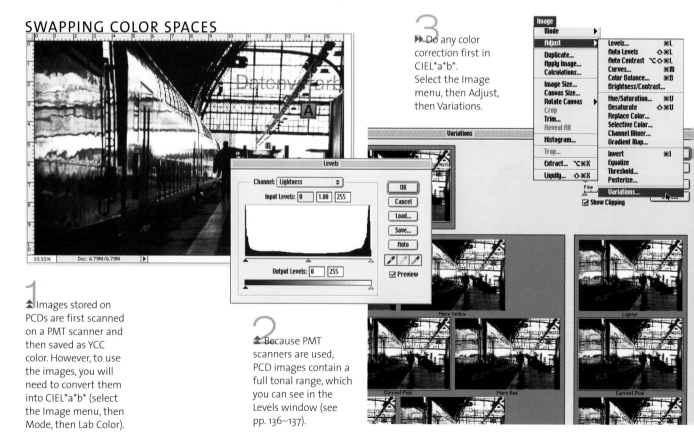

3 ▶▶ Do any color correction first in CIEL*a*b*. Select the Image menu, then Adjust, then Variations.

1 ▲ Images stored on PCDs are first scanned on a PMT scanner and then saved as YCC color. However, to use the images, you will need to convert them into CIEL*a*b* (select the Image menu, then Mode, then Lab Color).

2 ▲ Because PMT scanners are used, PCD images contain a full tonal range, which you can see in the Levels window (see pp. 136–137).

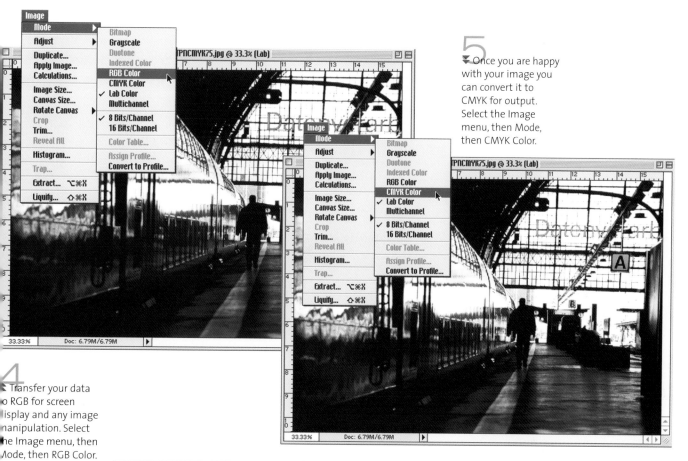

5 ▼ Once you are happy with your image you can convert it to CMYK for output. Select the Image menu, then Mode, then CMYK Color.

4 ◀ Transfer your data to RGB for screen display and any image manipulation. Select the Image menu, then Mode, then RGB Color.

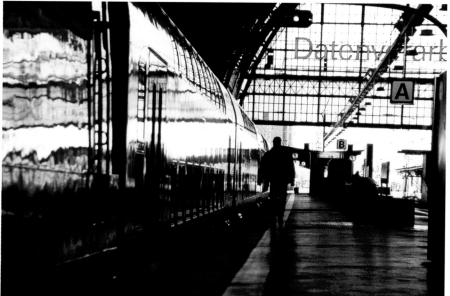

6 ◀ The final image should provide all the benefits of analog and digital photography.

■ compression

High-quality digital images usually result in very large file sizes, which need to be compressed for storage and transportation. Lossy and lossless compression are the two systems available.

The most common form of image compression is the JPEG (Joint Photographic Expert Group). This is what is called a "lossy" compression format, meaning that when you save your file, you lose information. The way that JPEG compresses is to analyze each pixel and see if there are any others around it that have similar values. If there are, it makes them the same color. JPEG has a variety of compression settings; the greater the compression, the larger the errors. In the image of the sky below, you can see the same image

JPEG OPTIONS

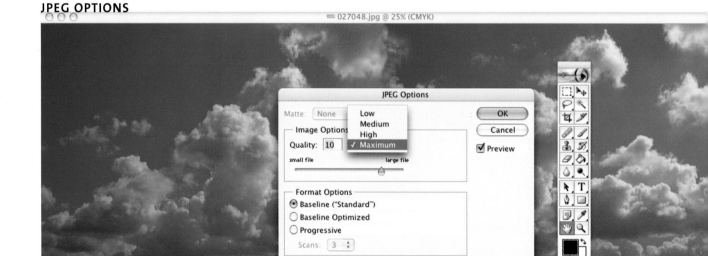

JPEG—HIGH COMPRESSION 92K

above This is the original image, with no compression. Its quality cannot be improved upon but the file is big and takes up a lot of storage space.

right A JPEG at high compression. The image starts to pixelate and distort.

a high and low compression. You will see at the high compression format has some xelization owing to the fact that the colors ave been grouped together.

However, not all software compresses PEGs in the same way. In the bar chart below, he same size file is compressed using a variety of software packages. You can see that ompression does not create the same file zes for each, nor the same rates of reduction files sizes, especially below 50 percent.

above Selecting LZW compression in a TIFF file. Some systems do not like LZW compression, so it is important to check that all your systems can support it.

PEG COMPRESSION FILE SIZES

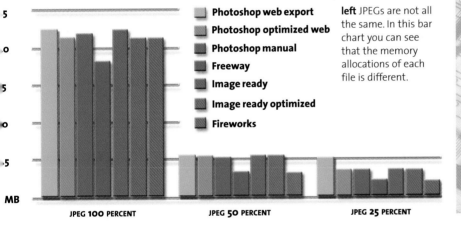

- Photoshop web export
- Photoshop optimized web
- Photoshop manual
- Freeway
- Image ready
- Image ready optimized
- Fireworks

left JPEGs are not all the same. In this bar chart you can see that the memory allocations of each file is different.

JPEG 100 PERCENT JPEG 50 PERCENT JPEG 25 PERCENT

LZW COMPRESSION

LZW compression was invented by Lempel-Ziv and Welch, and can compress files by around 50 percent without any loss of data, making it a "lossless" (or "zipped") system.

LZW compression analyzes the original file and looks for patterns that repeat themselves. Where it identifies a pattern, it writes this into a dictionary for later reference and decompression. The dictionary is stored with the file. Rather than all data being written to disk it stores patterns and then provides pointers to where to look in the dictionary. The level of compression is determined by the size of the dictionary.

Example: The cat sat on the mat
There are a lot of "at" patterns in the phrase above. The letters "at" could be placed in the dictionary and replaced by a code. It is also possible to put common words such as "the," as well as character spaces, into the dictionary. The dictionary could have these entries:
o = "at"
§ = "the"
¢ = "space"
The compressed file would look like this:
§¢co¢so¢on¢§¢mo
The original 22-character phrase has been reduced to 15 characters.

PEG—LOW COMPRESSION 1.1MB

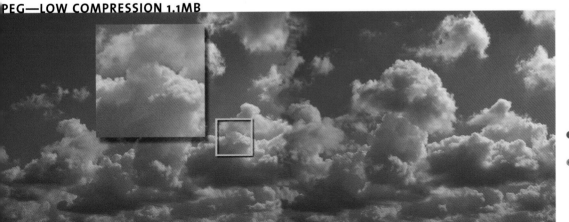

left A JPEG at a low compression does not produce any difference in quality from the original.

SEE ALSO

BIT DEPTH **58**

■ GIF compression

The GIF file format is commonly used on the worldwide web and in software applications. You can select different palettes depending on the destination of the file.

Converting files into a GIF (Graphics Interchange Format) format restricts the color space to a maximum of 8-bit color, based on your computer system's 8-bit Look-Up Table (LUT). The computer analyzes each pixel and then finds the closest match to it in the LUT.

Originally created by CompuServe for use on the Internet, this format has become the standard for web site imagery. GIF compresses by reducing color data and thus creates smaller file sizes. The GIF format is therefore a lossy compression system (see pp. 144–145) because it loses color that cannot be later recovered.

As with JPEG, different software manufacturers achieve different results from the conversion to GIF format. In the images on the right, you can see how these relate to each other.

Apple and Microsoft GIF files

Apple and Microsoft use slightly different LUTs when converting 24-bit images into 8-bit GIF files. However, Apple and Microsoft do share 216 of the 256-color range, and this is sometimes referred to as "Web color."

The best results, although not the fastest to load, is the Adaptive RGB palette, which analyzes the image as a whole and then selects the 256 most common colors used from the 24-bit, 16.7 million, color palette.

right The original 24-bit RGB image that has been used for conversion to different GIF formats.

-BIT MICROSOFT RGB

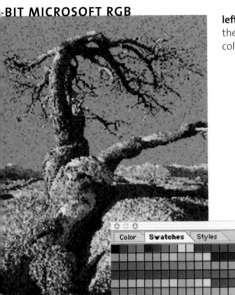

left This image uses the Windows 8-bit color palette.

8-BIT APPLE RGB

left This image uses the standard 8-bit color palette that is available on the Macintosh system.

-BIT WEB RGB

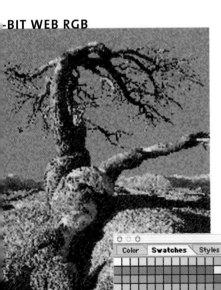

left This image uses the 8-bit color palette that is shared between the Mac and PC platforms.

ADAPTIVE RGB

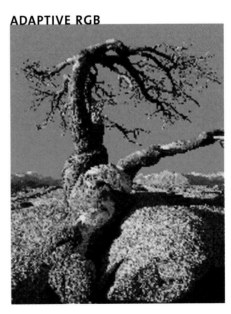

left This image uses the 256 most common colors used in the original image, which was generated from the 24-bit color palette.

GIF compression continued

CREATING GIFS AUTOMATICALLY

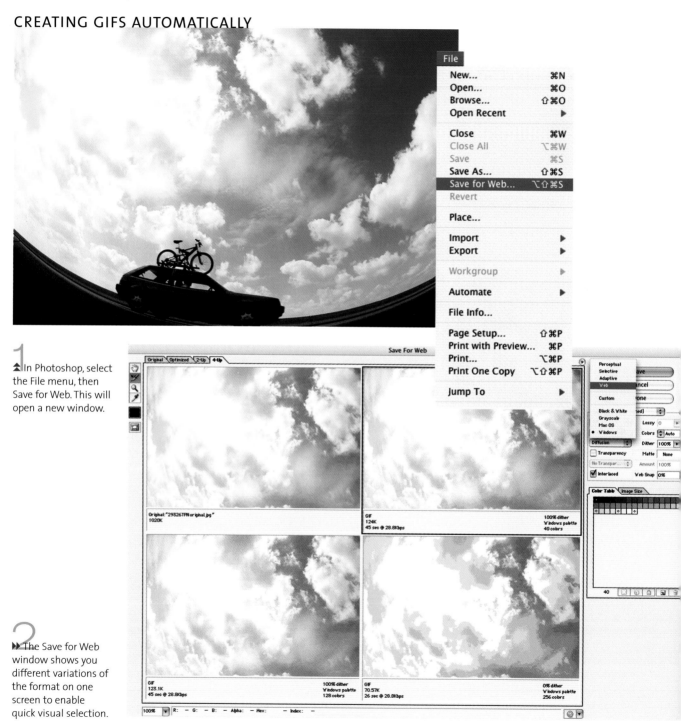

1 ▲In Photoshop, select the File menu, then Save for Web. This will open a new window.

2 ▶▶The Save for Web window shows you different variations of the format on one screen to enable quick visual selection.

CREATING GIFS MANUALLY

You can create GIFs manually by first changing the Mode from RGB Color to Indexed Color in the Image menu.

3 Once you select OK, the image will be reformatted into Indexed Color.

2 In this Indexed Color window, select Web from the Palette menu.

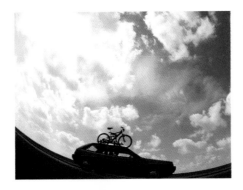

right This image uses the PC palette.

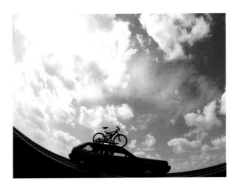

right This image uses the Mac palette.

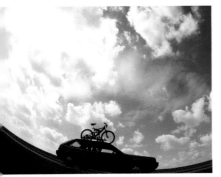

left This image uses the Adaptive RGB palette, which should produce a higher-quality image but uses more memory.

right This image uses the palette that is shared between the Mac and the PC platforms.

web-safe color palette

Decimal or binary numbers cannot be used for specifying 256 colors, as these take too long for a computer to process. Instead, a coding system called "hexadecimal" is used, using a base number of 16.

The first 10 digits, from zero to nine, are represented in numbers, and the remaining digits are in letter form, from A to F. The codes used for colors that are available on the Internet are given on this page, and opposite. These codes are installed into the operating system and can be entered into HTML code for web sites, or into Photoshop, using the Color Picker.

66FFFF	33FFFF	00FFFF			
66FFCC	33FFCC	00FFCC			
66FF99	33FF99	00FF99			
66FF66	33FF66	00FF66			
66FF33	33FF33	00FF33			
66FF00	33FF00	00FF00			
66CCFF	33CCFF	00CCFF	666666	336666	00666
66CCCC	33CCCC	00CCCC	666633	336633	006633
66CC99	33CC99	00CC99	666600	336600	00660
66CC66	33CC66	00CC66	6633FF	3333FF	0033FF
66CC33	33CC33	00CC33	6633CC	3333CC	0033CC
66CC00	33CC00	00CC00	663399	333399	003399
6699FF	3399FF	0099FF	663366	333366	003366
6699CC	3399CC	0099CC	663333	333333	003333
669999	339999	009999	663300	333300	003300
669966	339966	009966	6600FF	3300FF	0000FF
669933	339933	009933	6600CC	3300CC	0000CC
669900	339900	009900	660099	330099	00009
6666FF	3366FF	0066FF	660066	330066	00006
6666CC	3366CC	0066CC	660033	330033	000033
666699	336699	006699	660000	330000	00000

FFFFFF	CCFFFF	99FFFF	FF6666	CC6666	996666	
FFFFCC	CCFFCC	99FFCC	FF6633	CC6633	996633	
FFFF99	CCFF99	99FF99	FF6600	CC6600	996600	
FFFF66	CCFF66	99FF66	FF33FF	CC33FF	9933FF	
FFFF33	CCFF33	99FF33	FF33CC	CC33CC	9933CC	
FFFF00	CCFF00	99FF00	FF3399	CC3399	993399	
FFCCFF	CCCCFF	99CCFF	FF3366	CC3366	993366	
FFCCCC	CCCCCC	99CCCC	FF3333	CC3333	993333	
FFCC99	CCCC99	99CC99	FF3300	CC3300	993300	
FFCC66	CCCC66	99CC66	FF00FF	CC00FF	9900FF	
FFCC33	CCCC33	99CC33	FF00CC	CC00CC	9900CC	
FFCC00	CCCC00	99CC00	FF0099	CC0099	990099	
FF99FF	CC99FF	9999FF	FF0066	CC0066	990066	
FF99CC	CC99CC	9999CC	FF0033	CC0033	990033	
FF9999	CC9999	999999	FF0000	CC0000	990000	
FF9966	CC9966	999966				
FF9933	CC9933	999933				
FF9900	CC9900	999900				
FF66FF	CC66FF	9966FF				
FF66CC	CC66CC	9966CC				
FF6699	CC6699	996699				

SEE ALSO

BIT DEPTH 58
PANTONE COLOR 106

color management

Color management requires time and effort to set up correctly, but the results are worth the effort. This chapter introduces the principles of color management and demonstrates how all the information in the previous chapters comes together. The subjects on the following pages focus on how to operate an ICC color management system and how to measure and characterize the color gamuts of scanners, monitors, and printers, as well as create ICC Profiles.

color management systems

Math is difficult, even for a computer, so the fewer calculations it has to make, the faster it will work and the more predictable the results will be. Color management facilitates this.

Until the end of the 1980s, color control was in the hands of a few proprietary manufacturers such as Crosfield, Agfa, and Scitex, who produced the equipment used for high-quality color reproduction. These systems were expensive and difficult to use by modern-day standards and required the operators to have an extensive working knowledge of color science, reprographics, and the equipment, knowledge that was not always transferable among manufacturers. However, almost all effects that are now possible in Photoshop, or other applications, were possible at that time.

The early digital equipment in the 1970s and early 1980s only allowed you to input and then immediately output the data. All image manipulation had to be completed before the image was scanned, because there were no storage solutions, and you could not display the image on screen. The output was generally CMYK data, imaged straight on to film. Modern scanners are a different matter. You can generally transfer skills from one manufacturer's hardware and software to another quite easily, and without any extra training, even from low-end to high-end equipment. Modern scanners also

operate in many color spaces, rather tha solely RGB or CMYK, which allows you to wo using any familiar color space. Further, mar of the output features, such as screen typ and dot gain, are handled in the raster imag processor (RIP) when the file is output (se pp. 166–169).

At the beginning of the 1990s, with th advent of Postscript Level 2, separation were possible from the desktop compute and operators and designers expected t be able to scan an image at one site an output at another. This caused difficultie with proprietary systems owing to th

COMPLEX CALCULATIONS

right If a computer had to calculate all color spaces at once, it would cause a great increase in processing time.

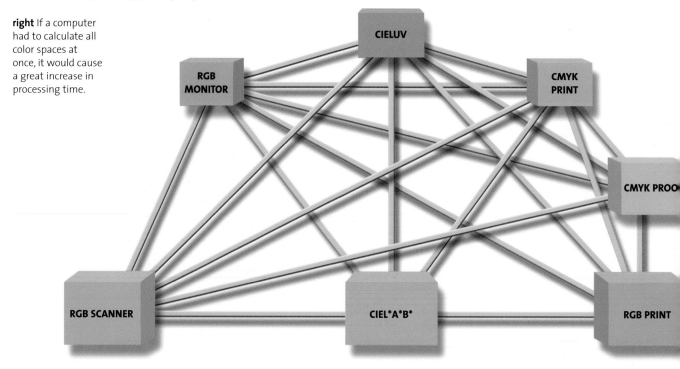

ransformations needed to convert color rom one space to another, or from one manufacturer to another. This complexity made it essential that the image's color pace should be independent to allow easy ransformations. These transformations lso have to be simple to allow the computer to process the data quickly and reliably. The illustrations at the bottom of these pages show a method of transformation that requires a large number of calculations compared to a simple method, using a central color space, which requires far fewer, increasing the processing speed.

transforming color systems

There are three places on modern computer systems where we need to control color. The first is the color gamut that the input device can capture, the next is the gamut that the display device can show, and the last is the gamut that is available in the final output.

We want to be able to capture and use as much color as possible, no matter what the device; color management systems allow us to do this.

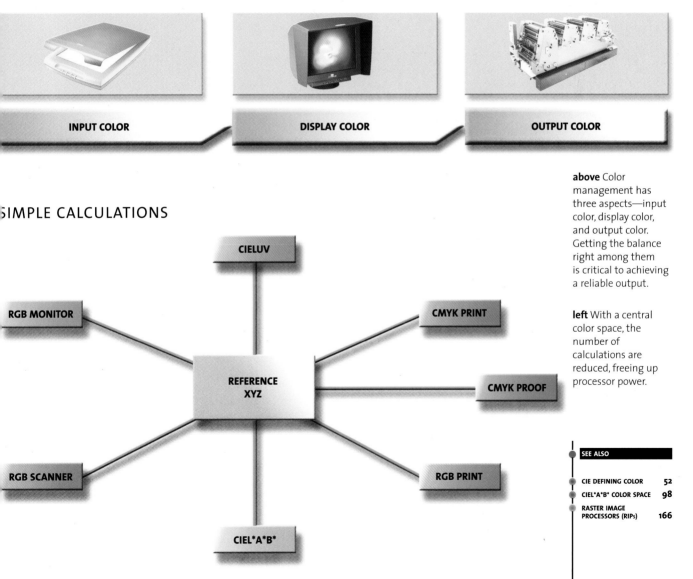

| INPUT COLOR | DISPLAY COLOR | OUTPUT COLOR |

above Color management has three aspects—input color, display color, and output color. Getting the balance right among them is critical to achieving a reliable output.

left With a central color space, the number of calculations are reduced, freeing up processor power.

SIMPLE CALCULATIONS

CIELUV

RGB MONITOR

CMYK PRINT

REFERENCE XYZ

CMYK PROOF

RGB SCANNER

RGB PRINT

CIEL*A*B*

open systems

Open systems enable third party developers to create their own, unique, solutions for controlling color. Creating a standard greatly increases the potential of color management.

Early scanners were only required to produce data that was to be printed, and was therefore exclusively in the CMYK color space. They had their own RGB to CMYK, or additive to subtractive, algorithms to convert color. These systems are called closed systems. Today, however, only a small percentage of images are produced for print only, and we require images in RGB for screen display.

To enable images to be viewed in RGB for screen display, systems are required that allow the easy transference of data from one device to another, keeping as much color as possible. These systems are called open systems.

The open system in your operating system (OS) that controls color is called the Color Management System (CMS). This allows color to be mapped from one system to another with open color spaces. The CMS

is controlled in the OS by the Color Management Framework Interface (CMFI). Color Management Modules (CMM) are the systems that perform the management operation and these slot into the CMFI. Your OS should have its own CMM to control color but you can buy other third party CMMs to add to your resources.

Among the first color management systems to be developed were those from Kodak and EFI (Electronics for Imaging). These use CIE color spaces as their method of colorimetry, which enables device-independent color to be used (see pp. 94–95). Other manufacturers now conform to this standard, including Adobe, Agfa, Apple, Sun, Microsoft, and most other major computer companies. In 1993, they formed a working group called the ICC (International Color

Consortium), whose aim was to produce method of profiling devices to enable seamless transfer, or conversion, of data.

gamut mapping

Yxy and/or CIEL*a*b* (see pp. 52–53 an 98–101) are at the center of your CMM where the data can be stored using the fu visual spectrum and transferred easily t other display or output devices. Each devic is characterized by having its gamut mea sured. As each device is different, it is impo tant to measure every scanner, monito printer, and substrate to get the best result These gamut maps are processed to creat reference files called "profiles."

It is not easy to convert from one gamu to another and the calculations are co trolled in the CMM. Each CMM may use

OPEN SYSTEM MODULES

right The color management architecture allows for third party developments to be added to it without any difficulties.

APPLICATION

GRAPHICS LIBRARY

COLOR MANAGEMENT FRAMEWORK INTERFACE

DEFAULT
COLOR MANAGEMENT MODULE

THIRD PARTY
COLOR MANAGEMENT MODULE

different algorithm to calculate these transformations, which is one reason why there are many different CMMs available.

ICC and tags

One of the main aims of the ICC was to create an open, vendor-neutral, cross-platform color management system architecture. This resulted in the development of the ICC profile specification.

Profiles are similar in construct to a TIFF (Tagged Image File Format) format. They are based on fields (tags, or meta data) of data, which can be used to define the image attributes of the profile. The basic set of tags is shown on the right. It is possible to add to this standard set of tags, thereby adding to the base level of performance, and these should be registered with the ICC to allow other vendors access to the information. This process is very useful, since maintaining the "openness" of the system benefits everyone.

BASIC INPUT PROFILE TAGS

TAG NAME	DESCRIPTION
ProfileDescriptionTag	Profile name information
RedColorantTag	XYZ values for the red colorant
GreenColorantTag	XYZ values for the green colorant
BlueColorantTag	XYZ values for the blue colorant
RedTRCTag	Tone reproduction curve for red color channel
GreenTRCTag	Tone reproduction curve for green color channel
BlueTRCTag	Tone reproduction curve for blue color channel
MediaWhitePointTag	XYZ values for media white

above Profiles are files that contain color and tonal information. The main tags that are used in the profile system for an input profile are shown above, demonstrating the XYZ and tonal values of the device.

#	Tag	Data	Size	Description
	Header		128	
1	'A2B0'	'mft2'	222772	Intent-0, 16-bit, device to PCS conve
2	'B2A0'	'mft2'	50740	Intent-0, 16-bit, PCS to device conve
3	'cprt'	'text'	71	Copyright ASCII Text String
4	'dmnd'	'desc'	110	Localized device manufacturer descri
5	'dmdd'	'desc'	143	Localized device model description st
6	'wtpt'	'XYZ '	20	Media white-point tristimulus
7	'desc'	'desc'	161	Localized description strings
8	'K013'	'ui32'	12	Unsigned 32-bit integers
9	'K019'	'desc'	161	Localized strings
10	'K030'	'ui32'	12	Unsigned 32-bit integers
11	'K031'	'text'	14	ASCII Text String
12	'K070'	'ui08'	10	Unsigned 8-bit integers
13	'K071'	'ui08'	10	Unsigned 8-bit integers

pslabpcs.pf

Kodak Company, All Rights

#	Tag	Data	Size	Description
	Header		128	
1	'A2B0'	'mft2'	222772	Intent-0, 16-bit, device to PCS conve
2	'B2A0'	'mft2'	50740	Intent-0, 16-bit, PCS to device conve
3	'cprt'	'text'	71	Copyright ASCII Text String
4	'dmnd'	'desc'	110	Localized device manufacturer descri
5	'dmdd'	'desc'	143	Localized device model description st
6	'wtpt'	'XYZ '	20	Media white-point tristimulus
7	'desc'	'desc'	161	Localized description strings
8	'K013'	'ui32'	12	Unsigned 32-bit integers
9	'K019'	'desc'	161	Localized strings
10	'K030'	'ui32'	12	Unsigned 32-bit integers
11	'K031'	'text'	14	ASCII Text String
12	'K070'	'ui08'	10	Unsigned 8-bit integers
13	'K071'	'ui08'	10	Unsigned 8-bit integers

IMAGING LIBRARY

THIRD PARTY
R MANAGEMENT MODULE

right If you open a profile, you can view all the data within it, and edit it. The ColorSync Utility in Mac OSX offers a good way to view profiles.

White X: 0.9643
Y: 1.0000
Z: 0.8251

SEE ALSO

CIE DEFINING COLOR	52
DEVICE-INDEPENDENT COLOR	94
CIEL*A*B* COLOR SPACE	98

setting up your Mac

Modern computers can place color information all over their systems. They are easy to set up but you need to keep track of where everything is and where to place your amendments.

The Mac comes with profiles built into the operating system (OS) for basic color management. These can be found in your System folder. Here, you will find the basic profiles in your system, including CMYK, RGB, CIEL*a*b*, XYZ, and sRGB.

If you add profiles to your system (these profiles will come with the installation disks that accompany scanners, monitors, and printers), put them in your User settings. You will find your installed profiles here.

selecting CMM and finding profile
In your System Preferences you will find ColorSync Hardware Control Panel. If you click on this, you can select your defau profiles and the CMM you wish to use Apple provides its own.

USING BUILT-IN PROFILES

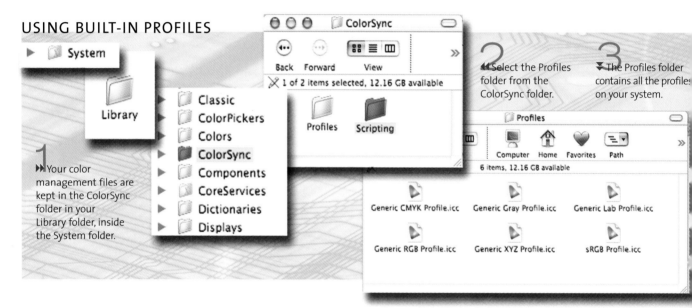

1 Your color management files are kept in the ColorSync folder in your Library folder, inside the System folder.

2 Select the Profiles folder from the ColorSync folder.

3 The Profiles folder contains all the profiles on your system.

ADDING PROFILES TO YOUR SYSTEM

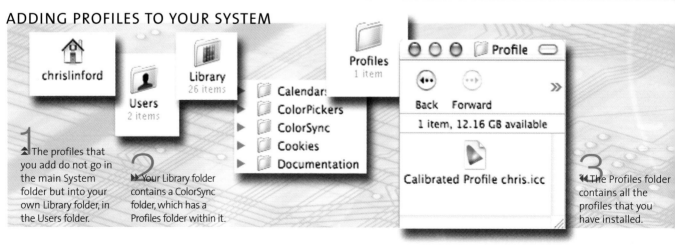

1 The profiles that you add do not go in the main System folder but into your own Library folder, in the Users folder.

2 Your Library folder contains a ColorSync folder, which has a Profiles folder within it.

3 The Profiles folder contains all the profiles that you have installed.

If you have multiple users on your machine, it is easy to lose profiles. If this happens, you can search for them with ColorSync Utility. This is found in the Applications folder in the Utilities directory. The software will show you all the profiles in your computer and where they can be found. This allows you to send any profiles with your work to other people.

Apple also enables you to create your own monitor profile with the Display Control Panel found in your System Preferences. You can choose an existing one or create a new one by selecting Calibrate. Do this every few months. A new ICC profile will be created for you.

right The profile facilities on the Mac give excellent control of profiles.

FINDING PROFILES ON YOUR SYSTEM

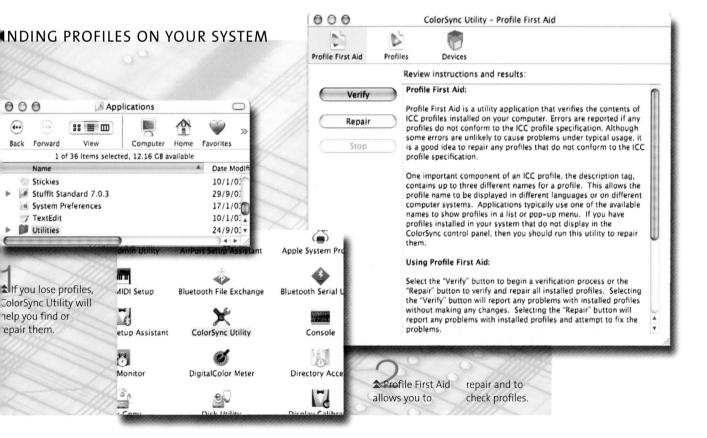

1 If you lose profiles, ColorSync Utility will help you find or repair them.

2 Profile First Aid allows you to repair and to check profiles.

ColorSync Utility – Profile First Aid

Review instructions and results:

Profile First Aid:

Profile First Aid is a utility application that verifies the contents of ICC profiles installed on your computer. Errors are reported if any profiles do not conform to the ICC profile specification. Although some errors are unlikely to cause problems under typical usage, it is a good idea to repair any profiles that do not conform to the ICC profile specification.

One important component of an ICC profile, the description tag, contains up to three different names for a profile. This allows the profile name to be displayed in different languages or on different computer systems. Applications typically use one of the available names to show profiles in a list or pop-up menu. If you have profiles installed in your system that do not display in the ColorSync control panel, then you should run this utility to repair them.

Using Profile First Aid:

Select the "Verify" button to begin a verification process or the "Repair" button to verify and repair all installed profiles. Selecting the "Verify" button will report any problems with installed profiles without making any changes. Selecting the "Repair" button will report any problems with installed profiles and attempt to fix the problems.

setting up your PC

Setting up a PC is harder than a Mac but can be done in most PC operating systems. Profiles need to be installed on a PC, rather than just put in the system.

PCs that use a Microsoft operating system (OS) (Windows 95 or later) have software built into them that allows you to use color management systems and profiles based on ICC guidelines. This system is called the Image Color Management (ICM) and is found in the Windows Application Programming Interface (API) (see step 3, opposite). This maps color gamuts from device to device. The API itself can be found in the Monitor Control Panels in the OS.

1 Open the Windows Control Panel.

INSTALLING PROFILES ON YOUR PC

2 You can access printer information by selecting the Printers and Faxes icon in the Control Panel window, then Printing Preferences.

4 ◀◀ Monitor Profiles can be accessed by selecting the Display icon in the Control Panel window.

DOWNLOADABLE PROFILE SOFTWARE

It likely that on a PC you will use third party software to regulate your color management system. There are many different types available, ranging in price from free to thousands of dollars.

■ setting up Photoshop

In addition to setting up your computer, you often need to set up each application independently. The following pages show how to set up Photoshop for Mac and PC.

It is important to set up color management protocols in each piece of software that you use. Probably the most important place is within Photoshop, because the profiles can be embedded into the file using sRGB file formats. Any profiles that you have installed in your OS are available in the Color Management resources within your software, although you may need to "tell" them where they are (see p. 158–161).

The Color Management resources Photoshop are found in the Color Settings preferences of Photoshop. We have see this before in Chapter 3 and the principle are the same.

USING COLOR MANAGEMENT RESOURCES IN PHOTOSHOP

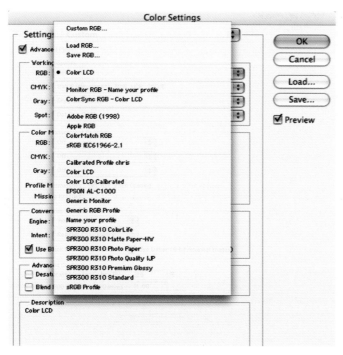

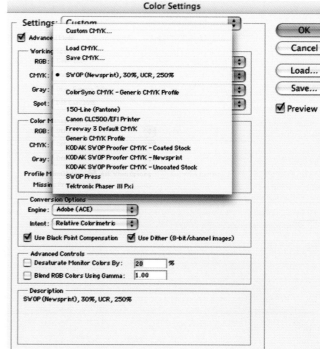

2 Set up your CMYK settings to optimize the output. Here, you specify all the characteristics of the printing device— the ink type, paper specification, dot gain, and UCR and GCR (see pp. 174–177). Generally, this information needs to come from your printer; otherwise the standard settings that come with your computer will suffice.

1 Select Color Settings from the Edit menu. Then set up how you wish to view the file in the RGB menu in Working Spaces. If you have created your own monitor profile, you can load it here, or you can use presets such as sRGB IEC61966-2.1, which is a default profile for PC monitors, scanners, and low-end printers.

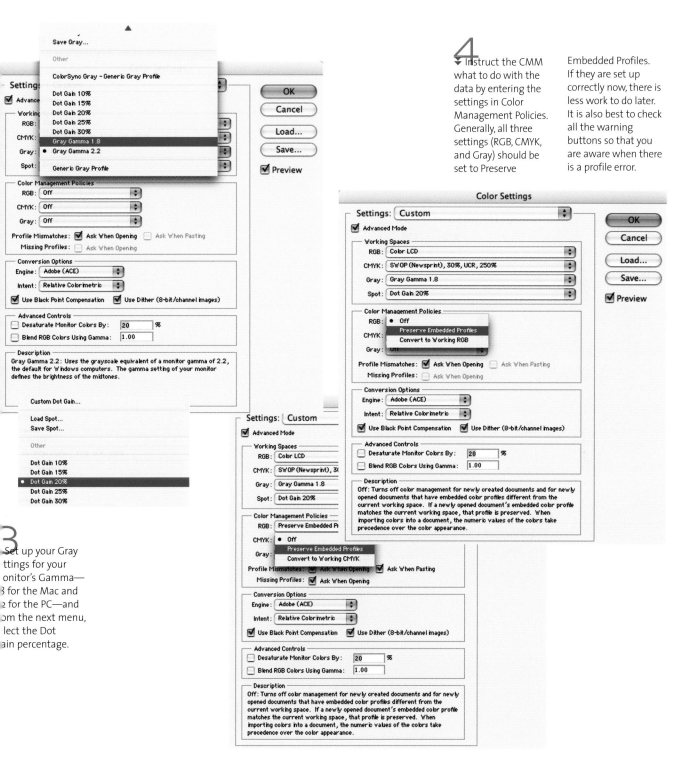

4 Instruct the CMM what to do with the data by entering the settings in Color Management Policies. Generally, all three settings (RGB, CMYK, and Gray) should be set to Preserve Embedded Profiles. If they are set up correctly now, there is less work to do later. It is also best to check all the warning buttons so that you are aware when there is a profile error.

3 Set up your Gray settings for your monitor's Gamma—1.8 for the Mac and 2.2 for the PC—and from the next menu, select the Dot Gain percentage.

■ setting up Photoshop continued

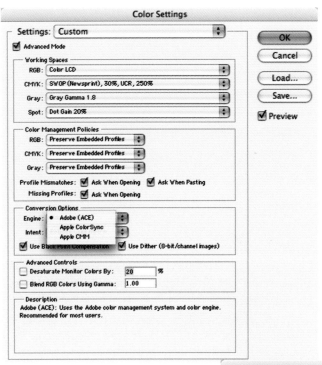

5 The Conversion Options specify the CMM that you wish to use. In Photoshop, it is considered best to use the Adobe (ACE) engine. However, if you have other Color Management Modules, select these here.

6 The Intent section allows you to specify how you want to work on the data. Once you have chosen your preferences, select Save. This enables you to preserve your settings for other files.

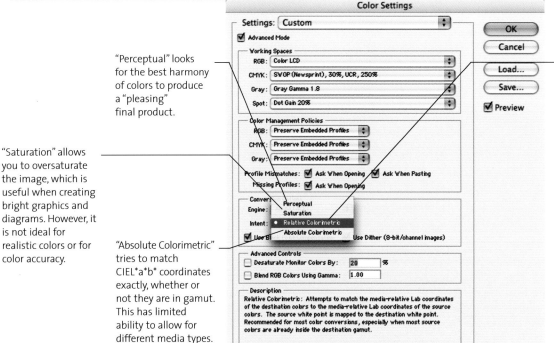

"Perceptual" looks for the best harmony of colors to produce a "pleasing" final product.

"Saturation" allows you to oversaturate the image, which is useful when creating bright graphics and diagrams. However, it is not ideal for realistic colors or for color accuracy.

"Absolute Colorimetric" tries to match CIEL*a*b* coordinates exactly, whether or not they are in gamut. This has limited ability to allow for different media types.

"Relative Colorimetric" is generally the preferred setting for most purposes. It maps the input CIEL*a*b* profile to the destination CIEL*a*b* profile, taking into account the media's white point to allow better transformations.

mbedding and working with profiles

o embed these settings into your file, ou will need to keep the file in RGB color pace. When you save the file, click on the mbedded Profile button. The window ill tell you which profiles you are going o attach.

Further, it is often necessary to change rofiles (see below). This is easily managed y going to the Image menu then Mode, hen Assign Profile. This will change your GB profile. If you want to change the output profile, select Convert to Profile.

You can use profiles to show you what colors are out of the gamut of your output device. To see this, go to the View menu and then select Gamut Warning. Out-of-gamut colors will be blocked out. If there are only a few of these, there is probably not much to worry about, but if the image is covered, more work is needed.

The Proof Setup menu allows you to simulate what the image will look like when it is output. If you select Custom, you can load all the settings you have available in Photoshop.

USING PROFILES IN MAC OSX

1. Go to the Image menu, select Mode, then Assign Profile or Convert to Profile.

2. To see which colors are out-of-gamut, go to the View menu, then select Gamut Warning.

3. To see what the output image will look like, go to the View menu, then Proof Setup. Select your working space.

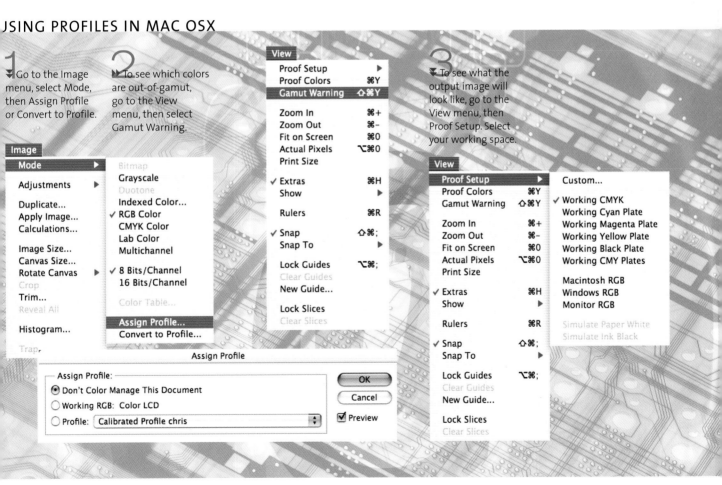

■ raster image processors (RIPs)

The heart of your printing system is the Raster Image Processor (RIP), which calculates you
image transformations and resolution when you send a file to print.

All Postscript printers require a processor to interpret the Postscript code that is sent to it. These processors are called Raster Image Processors and they convert all the data into the format required for that device. Simple black-and-white laser printers have these inside the printer, and inkjets can use a software RIP from the host computer that sent the data. High-end printers often require their own computer to control them with proprietary software.

The role of the RIP is to process data and hold it until the printer needs it. High-end printers are very expensive pieces of equipment and need to be kept running to return the investment. It is for this reason that the RIP can queue files and the RIP operator can prioritize them.

It is also possible to hold the RIPed file on the computer until you require it again for output. This can increase efficiency with data that is often required for output.

There are two parts to RIP software—the input, and the output (imaging). Th RIP can perform both tasks at the sam time and can also be monitored.

what does the RIP do?

One role of the RIP is to color separate th data. The RIP is responsible for the colo control of the final image and either rur the Color Management System or feec directly off it.

right This EFI RIP offers the latest in sophistication for digital printers. EFI is one of the leaders in color technology, based on a PC platform.

COLOR MANAGEMENT SYSTEM

CONVERSION FROM RGB TO CMY

The RIP provides a number of services dependent on the type of file. The easiest is a rasterized CMYK file, which does not require any further processing.

RGB RASTER FILE

RGB VECTOR FILE

CMYK VECTOR FILE

CMYK RASTER FILE

First the RIP converts the RGB data into CMY using the profile data. This is done via the Look-Up Table (LUT) in the CMS. If the data is already in CMYK, this process is bypassed and the data is sent straight to the rasterizer, which turns the data into pixels. If the file is not CMYK, it is processed through the UCR or GCR algorithms (see pp. 174–177) to generate the black.

The RIP's next job is to rasterize all the Postscript data, so the pixels match the matrix of the resolution of the printer; a 3,200 dpi printer will therefore create 3,200 dpi, which are either black or white. These are used to create the halftone dot.

right Mac computers are not normally used as RIPs because they do not process algorithms as well as PCs. However, they can still do the job.

RIP WORKFLOW

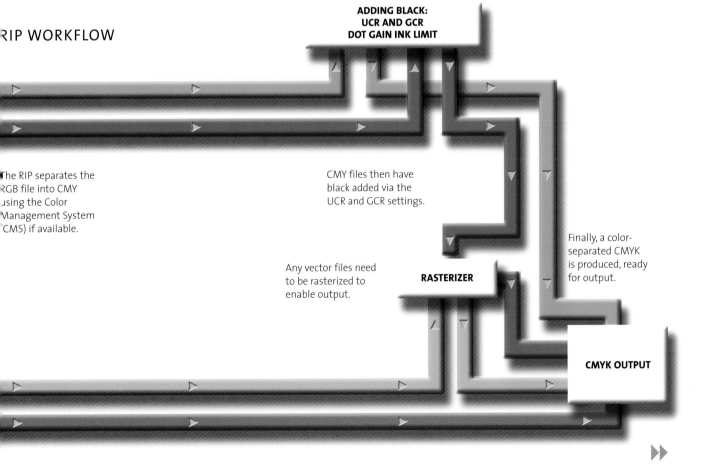

ADDING BLACK:
UCR AND GCR
DOT GAIN INK LIMIT

The RIP separates the RGB file into CMY using the Color Management System (CMS) if available.

CMY files then have black added via the UCR and GCR settings.

Any vector files need to be rasterized to enable output.

RASTERIZER

Finally, a color-separated CMYK is produced, ready for output.

CMYK OUTPUT

■ raster image processors (RIPs) continued

Rasterized images (those that are already pixelized), pass through the processor and are separated into the resolution of the printer. Vector or Postscript files, such as those from Illustrator or Freehand, have to be pixelized into the resolution of the printer. The RIP takes longer to process vector files than raster ones.

PDF RIPs

Modern Postscript Level 3 RIPs can separate high-resolution PDF (Portable Document Format) files. These files have good compres-sion, allowing for easy storage and trans-portation, and because they are based on Postscript, deliver fewer errors and faster pro-cessing. These RIPs often have their own Pre-flight software that allows all files to be auto-matically vetted for errors so that they are found earlier and less RIP time is wasted.

right RIPs often have a workflow window where you can find out what it is doing.

USING EFI RIP SOFTWARE

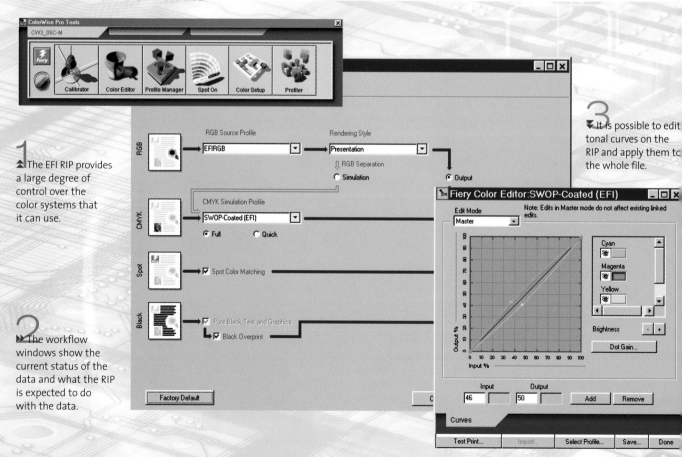

1 ▲ The EFI RIP provides a large degree of control over the color systems that it can use.

2 ▶▶ The workflow windows show the current status of the data and what the RIP is expected to do with the data.

3 ▼ It is possible to edit tonal curves on the RIP and apply them to the whole file.

USING AGFA RIP SOFTWARE

1 Agfa's RIP software is Windows-based and has an imaging window and an output window.

2 The RIP Tuner allows you to make changes to the RIP set-up.

5 The EFI RIP will show a preview of the file if required, although you cannot work over it.

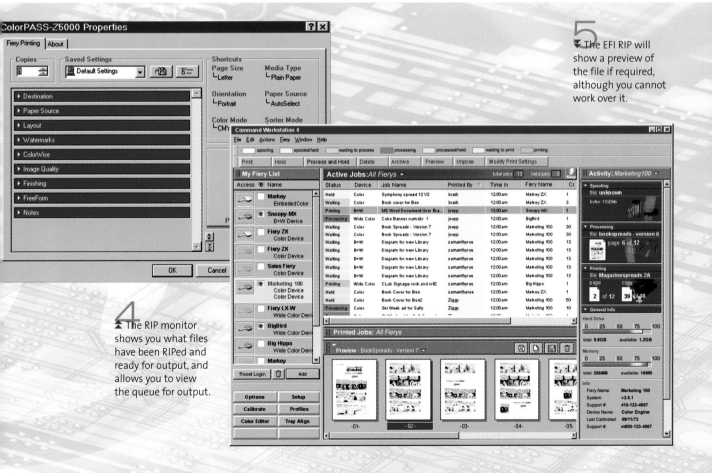

4 The RIP monitor shows you what files have been RIPed and ready for output, and allows you to view the queue for output.

the profile workflow

Controlling the workflow of a file sent to print is important in getting the most from your system. RIPs need to work with Color Management Systems to be effective and efficient.

Working with profiles can be problematic. When you have limited equipment, such as a printer, a scanner, and a digital camera, it is easy to maintain control over the process. The more equipment you use, the greater the complexity.

Modern design work, whether for print, the Internet, or broadcast, goes through a large number of designers and developers, all of whom can be using their own profiles to control their color. To a large extent, the input side of profile management is easy if you use sRGB, where the profile is embedded into the image. However, if this is not used, then the profiles need to be sent to all parties to install in their operating systems.

Output profiles cause the greatest number of problems. Many printers do not have profiles for their presses, and some could not even tell you which press your job will be printed on. This causes problems optimizing the output. There are many standard settings, or "wizards," that can help in this situation when you cannot get any information from the printer. Bear in mind that the print minder can also make changes by controlling the ink on the press.

where are profiles applied?

Because profile information is required in many software applications, it is often difficult to know which one is being used at any one time. For example, is the CMS in the

DIGITAL FILE PROFILE WORKFLOW

below This is the starting point, from where you send the file from your desktop to the printer.

below The RIP first interprets the Postscript and runs it through the Color Management System. The system then converts the files from RGB to CMY.

Proofing presses are inkjets and can use the same profiles as the final printer.

below and right When the process is complete, the files are output to their final destination(s).

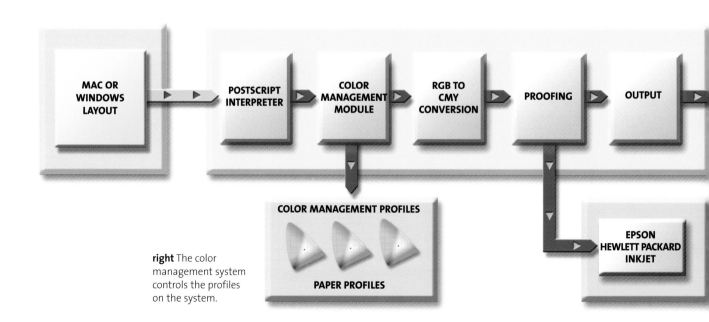

MAC OR WINDOWS LAYOUT → POSTSCRIPT INTERPRETER → COLOR MANAGEMENT MODULE → RGB TO CMY CONVERSION → PROOFING → OUTPUT →

COLOR MANAGEMENT PROFILES

PAPER PROFILES

EPSON HEWLETT PACKARD INKJET

right The color management system controls the profiles on the system.

DTP software overriding the information in the image file, or are many different systems working together, or against each other? It is often difficult to identify this in any workflow and the only way to do it is by trial and error. The critical area is specifying the requirements on the final output device or RIP. Getting this information correct is often all that matters. The best advice is to ensure that the profile information in each application is the same. Many high-end DTP software packages now have profile-checking software as well as Preflight systems that provide alerts when errors occur.

PROFILE TYPES

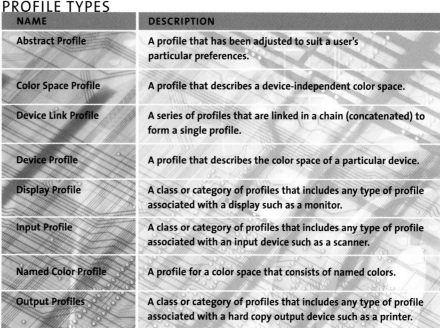

NAME	DESCRIPTION
Abstract Profile	A profile that has been adjusted to suit a user's particular preferences.
Color Space Profile	A profile that describes a device-independent color space.
Device Link Profile	A series of profiles that are linked in a chain (concatenated) to form a single profile.
Device Profile	A profile that describes the color space of a particular device.
Display Profile	A class or category of profiles that includes any type of profile associated with a display such as a monitor.
Input Profile	A class or category of profiles that includes any type of profile associated with an input device such as a scanner.
Named Color Profile	A profile for a color space that consists of named colors.
Output Profiles	A class or category of profiles that includes any type of profile associated with a hard copy output device such as a printer.

IRIS PROOFING PRESS

FILM OUTPUT

PRESS

COMPUTER TO PLATE

RIPED PS RIPED PDF TIFF / IT-P1

above There are different types of profiles, and each has its own function.

right Profile-checking and pre-flight software are available from a variety of sources to check your work before it prints, saving both time and money.

color separation

There are two ways to separate a file for color printing—AM (halftone) and FM (stochastic) screening. Halftones are usually used in high-end printing and stochastic on inkjets.

Generally, all files sent for printing need to be separated into four colors: cyan, magenta, yellow, and black (CMYK). It is possible to create color separations in many places, so use the best solution available, whether it is on the RIP, image software, or scanner.

The computer's mathematical algorithm first translates the RGB file into CMY and then adds black (K) to increase the tonal range, using GCR or UCR (see pp. 174–177). What happens after the separation is important to the image quality on the print.

Printing presses need a halftone dot to enable color or tonal reproduction. The modern way of generating these is on Computer-To-Plate (CTP) imaging systems, which image directly from a RIP onto the plate that is to be used on the press.

To optimize the color of the press there are several settings that need to be calculated, all of which can be stored in a profile. One of the most important is "dot gain." Dot gain occurs when ink touches paper and is absorbed and spreads, making the dot bigger on the final print than anticipated. Most papers have a standard characteristic for dot gain and this can be entered into the Color Management System.

However, care is needed when getting this information from paper vendors. In the U.S. dot gain is measured on the 50 percent dot whereas in Europe it is measured on 40 percent and 80 percent dots, so check first Photoshop uses the U.S. version.

AM and FM screening

There are two methods of placing the halftone dots on the paper. The traditional method is AM screening, which produces the normal halftone system. Here the dots are laid at specific angles, so as to avoid moiré patterns on the printed page (see

above Heidelberg's CTP system has enabled a reduction in production time and an increase in image quality.

SCREEN ANGLES

below Each halftone dot needs to be printed at a different angle to avoid moiré patterns on the final print. When this is correct you can sometimes see "rosettes" on the image, where all the dot angles come together.

CYAN
105 DEGREES

YELLOW
90 DEGREES

MAGENTA
75 DEGREES

BLACK
45 DEGREES

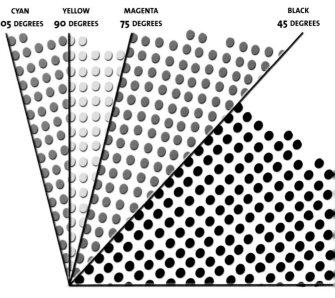

pp. 110–111). This system is tried and trusted by printers and its strength is that it can produce depth in a flat image. However, texture detail can sometimes be lost.

The alternative to this is FM (or stochastic) screening, which is also used with HiFi color (see pp. 92–93). This is very similar to the inkjet's method of dithering (see pp. 112–113). This system only places color where it is needed and can use finer dots than the AM system. The FM system can show greater texture detail but is weaker on flat colors. Printers have yet to find much commercial demand for FM screening.

DOT GAIN

right When ink hits the paper it spreads. This is called dot gain and you need to calculate it so that your images do not use up too much ink and therefore look too dark. The image on the right is a 50 percent tint, but the image on the far right shows what the print will look like when the ink hits the paper.

PERFECT 50 PERCENT DOT SCREEN

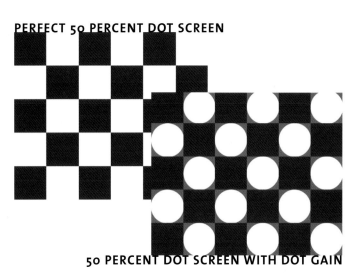

50 PERCENT DOT SCREEN WITH DOT GAIN

AM SCREENED IMAGE

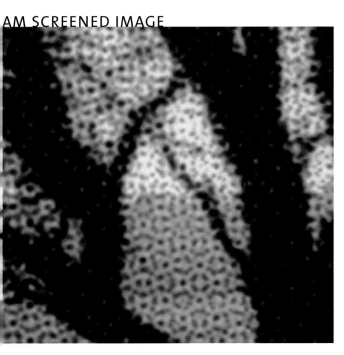

above An enlargement of a halftoned image printed with AM screening. You can clearly see some of the screen angle.

FM SCREENED IMAGE

above The same image using stochastic screening, which gives a smoother, more continuous tone.

■ UCR and GCR

Using Under Color Removal (UCR) or Gray Chroma Removal (GCR) to generate the black (K) component of the CMYK separation can help optimize the cost of printing.

How a printer generates the black (K) component of the CMYK separation is very important. Not only is the black used to add tonal value to the final image, it can also be used to reduce the cost of the printing process. Black ink is a lot cheaper than colored ink and therefore the more black you use, the cheaper the final print cost. Under Color Removal (UCR) and Gray Chroma Removal (GCR) are used to facilitate this.

Before setting the UCR and GCR specification in your software packages, you need to set what the ink limit is on the press. If you print with 100 percent of each of the four CMYK colors (reaching the 400 percent limit), the ink will dry slowly. This will mean the press will run slowly, increasing the print cost. Most litho printing presses use a 300 percent ink limit. It is important to specify this in your software packages because it has a direct impact on the separation and the generation of the black channel.

UCR

UCR creates the black plate by looking for dark colors and replacing the cyan, magenta, and yellow components with black ink. When you print using 100 percent cyan, magenta, and yellow it is possible to replace this with a single 100 percent black ink. The black replaces the "under color" (the combination of CMY), and reduces the ink to only 100 percent, enabling faster printing and reduced ink cost. However, small amounts of the CMY colors are retained to add density to the black. UCR can be set up in Photoshop in the Color Settings (see below).

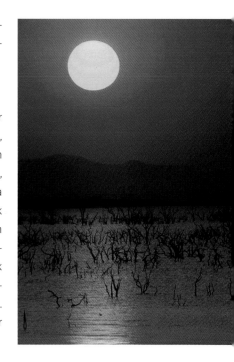

above The original image used for the tests illustrated on the right.

MAKING A UCR SEPARATION

1 You can access the UCR setting in the Color Settings window in Photoshop by selecting Custom CMYK from the CMYK menu in Working Spaces.

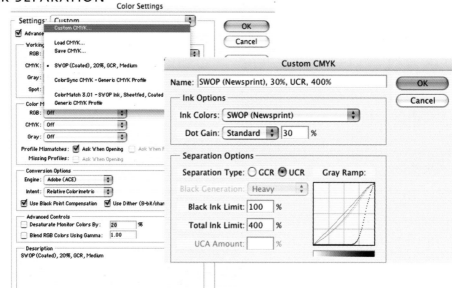

2 You need to know the ink limit that you want the press to run on. A 400 percent limit means printing with 100 percent of each of the four CMYK colors. The UCR system then calculates the appropriate settings.

UCR 300 PERCENT

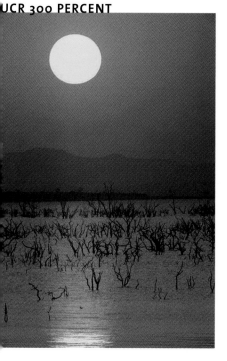

UCR 400 PERCENT

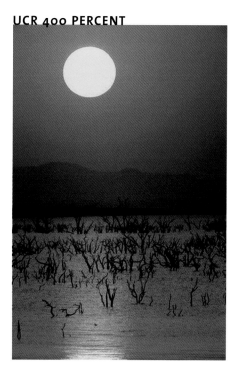

left and right Both images look very similar to the original, but they are printed using a 300 or 400 percent ink limit. UCR removes the expensive CMY colors while leaving the image perceptually the same. Generally, a 300 percent ink limit is best for most printing types.

left and right The plates on the left show lower levels of color on all of the CMY plates compared to the plates on the right. The K plate on the left uses more black ink than the K plate on the right, due to the UCR setting.

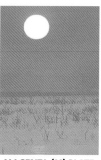

CYAN (C) PLATE　　**MAGENTA (M) PLATE**　　　　　　**CYAN (C) PLATE**　　**MAGENTA (M) PLATE**

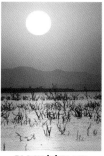

YELLOW (Y) PLATE　　**BLACK (K) PLATE**　　　　　　**YELLOW (Y) PLATE**　　**BLACK (K) PLATE**

■ UCR and GCR continued

GCR

GCR (Gray Chroma Removal, sometimes called Gray Composite Removal) takes UCR a step further and is normally the preferred system in color separation. This looks for gray colors in an image and replaces them with tints of black ink.

This system allows you to control how much black you wish to use. The setting for this can either by calibrated by the printer or come from user trial and error.

MAKING A GCR SEPARATION

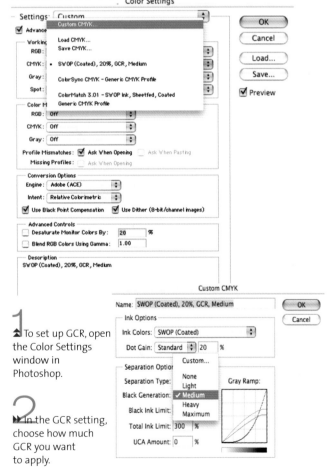

1 ▲ To set up GCR, open the Color Settings window in Photoshop.

2 ▲ In the GCR setting, choose how much GCR you want to apply.

GCR HEAVY

left This image uses "heavy" GCR settings.

left There is very little color in the CMY channels. The black (K) plate carries most of the ink density.

CYAN (C) PLATE

MAGENTA (M) PLATE

YELLOW (Y) PLATE

BLACK (K) PLATE

CR LIGHT

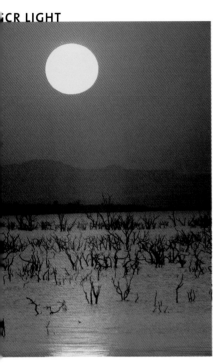

left The image has been separated using "light" GCR settings.

left The three color channels contain a lot more information than on the GCR Heavy example (opposite). In addition, there is less black ink used on this file than on the GCR Heavy example.

CYAN (C) PLATE **MAGENTA (M) PLATE**

YELLOW (Y) PLATE **BLACK (K) PLATE**

GCR NONE

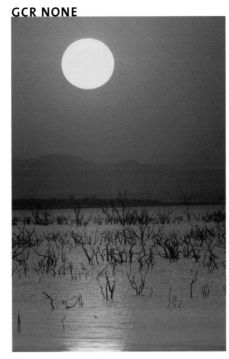

left This image uses no GCR and no black plate. The colors are generated entirely from the CMY colors.

left There is a lot of information in the three CMY color channels, as they try to create a black color.

CYAN (C) PLATE **MAGENTA (M) PLATE**

YELLOW (Y) PLATE **BLACK (K) PLATE**

■ profile creation equipment

To create profiles you need to use color measuring devices. There are three types of device, one for each profile type—input, display (monitor), and output.

You cannot create all profiles with the software that comes in your operating system (OS), unless you are using a Mac, which can make monitor profiles in the OS (see pp. 182–183). To create profiles for input, display, and output devices you will need to purchase different software and hardware for each.

Input profiles can be created solely within your computer with special software. You will need to purchase an IT8 target (see below) for each film type (Kodak, Agfa, or Fuji) that you scan, and the software measures the results accordingly.

To create monitor and output profiles, you need a spectrophotometer or colorimeter. This device scientifically measures color, which is then interpreted by the software that creates the profile. The spectrophotometers use D56 and D65 light settings to standardize the viewing conditions (see pp.

26–27) and, because of their sophistication, are expensive at many thousands of dollars each. Spectrophotometers have their own software to measure color, which is then passed to the software that creates the profile. Most spectrophotometers measure in all available color spaces.

On monitor spectrophotometers or colorimeters, the sensor, which is attached to the monitor's screen with suction pads, "reads" the color emitted from the monitor.

Monitor spectrophotometers are used measure transmissive materials and a therefore preferred for additive color me surement (see pp. 20–21).

The spectrophotometers used to crea output profiles are different from monite spectrophotometers, as they measure ligh reflected from a substrate; they therefo measure subtractive colors (see pp. 20–21).

The data generated can be placed int software such as Photoshop.

below LaCie colorimeters are used to measure screen color.

right This is an input IT8 target from Kodak. IT8s measure "pure" color from the chromaticity section and then measure lighter and darker shades of each.

IT8 TARGETS

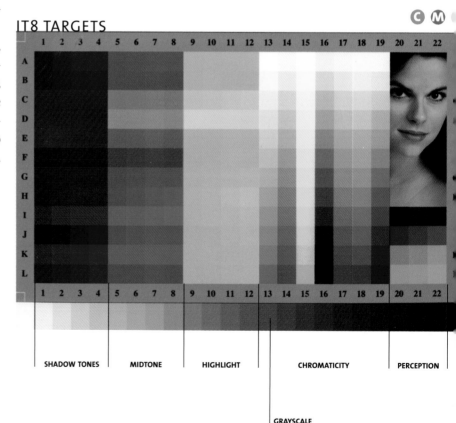

SHADOW TONES MIDTONE HIGHLIGHT CHROMATICITY PERCEPTION

GRAYSCALE

MUNSELL TEST CHART

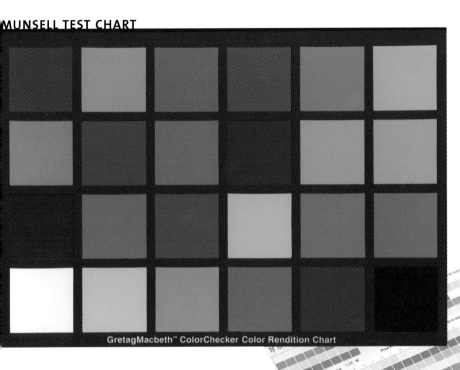

GretagMacbeth™ ColorChecker Color Rendition Chart

left The GretagMacbeth Munsell test chart is commonly used in digital photography to create input profiles and to control the image.

above Output charts used for creating output profiles are the most complex form of chart because they have the most swatches.

4 X 5 EVALUATION TARGET (KODAK)

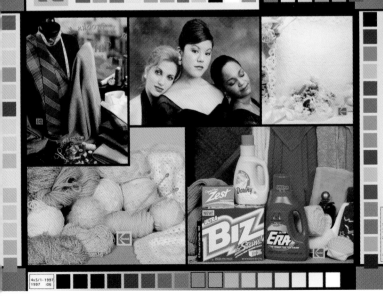

COLOR EVALUATION TARGET TRANSMISSIVE

left This test chart is used for perceptual evaluation and basic measurements of the output device.

■ creating input and output profiles

The tests used to create different profiles change from profile type to profile type. Display profiles (monitors) are the easiest to create. Output profiles (printers) are the most difficult

To create an input profile, you need an input IT8 target. Kodak, Agfa, and Fuji—the three major film manufacturers—produce the most common formats, and are most commonly used by professional photographers. Each IT8 target set comes with a printed IT8 target on the manufacturer's photographic paper and another on their 35 mm and 4 x 5 in transparency film. Each manufacturer uses the same set of colors in the main section of the target, but the right-hand section changes. Caucasian flesh

colors are the hardest to achieve, and each manufacturer uses the right-hand bar to help with this. Agfa produces a series of flesh-colored patches, while Kodak uses a photograph for perceptual interpretation (see the IT8 target, pp. 178–179).

IT8 targets are created to a standard specification of what the XYZ value is of each patch (see pp. 52–53). Due to the variable nature of color in analog photography it is not always possible to match the original exactly, no matter how precise the

manufacture. The variance of the test target from the original is provided on a computer disk that accompanies the targets. I is important to use the right disk for each target to be assessed.

To create a profile, you need to scan the target and open it into the software that is to be used to create the profile. Most software used to make profiles is very user friendly. It generally follows a step-by-step procedure, guiding the user through the application in simple steps.

CREATING THE INPUT PROFILE

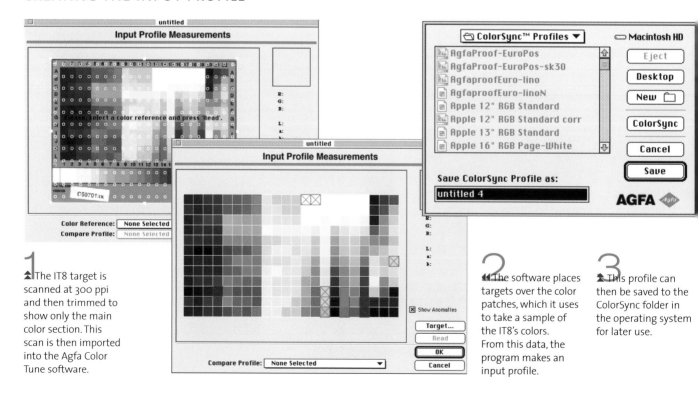

1 ▲ The IT8 target is scanned at 300 ppi and then trimmed to show only the main color section. This scan is then imported into the Agfa Color Tune software.

2 ◀◀ The software places targets over the color patches, which it uses to take a sample of the IT8's colors. From this data, the program makes an input profile.

3 ▲ This profile can then be saved to the ColorSync folder in the operating system for later use.

CREATING THE OUTPUT PROFILE

1 To make an output profile you need an output IT8.7/3 target. This is a digital file used to measure your printer's color gamut. A variety of output targets are available and you will need a spectrophotometer to measure the color of the final print.

ColorTune Profile — AGFA

input — New... / Open...
monitor — New... / Open...
output — New... / Open...

ColorSync™ Profiles ▼ — Macintosh HD

- AgfaProof-EuroPos
- AgfaProof-EuroPos-sk30
- AgfaproofEuro-lino
- AgfaproofEuro-linoN
- Apple 12" RGB Standard
- Apple 12" RGB Standard corr
- Apple 13" RGB Standard
- Apple 16" RGB Page-White

Eject / Desktop / New / ColorSync / Cancel / Save

Save ColorSync Profile as: untitled 4

AGFA

3 This profile can then be saved to the ColorSync folder in the operating system for later use. After the profile has been created, output the IT8.7/3 target again to assess if there has been an improvement.

AgfaProof-EuroPos

Output Profile Gamut

Compare Profile: None Selected

2 You will need to print the IT8.7/3 file as best you can on the required printer. This may be using "standard" settings for each inkset and paper, or custom-made ones created by trial and error. The target is then measured on the spectrophotometer. Each patch's data is entered into the profile-making software and this is used to create the final output profile.

untitled 7 — ...ut Profile Measurements

C: / M: / Y: / K: / L: / a: / b:

☒ Show Anomalies

Target... / Read / OK / Cancel

4 Profiles will need to be made for every combination of printer, substrate, and ink type.

SEE ALSO

TYPES OF INK 42
CIE DEFINING COLOR 52
CMYK MODEL 70

creating monitor profiles on a Mac

One of the benefits of the Mac computer platform is its ability to create monitor profiles within its operating system. This function is not yet available on PCs.

In Mac's OSX, it is possible to create monitor profiles using the operating system's own software (see illustrations below). To ensure that the profile is optimized, first make sure that the monitor is properly calibrated, using the correct gamma and display type.

Greater control can be gained by using a spectrophotometer, which is suitable for measuring screen color. The light-sensitive sensor, which is used to measure the light emitted from the monitor, uses a suction pad to attach itself to the monitor.

The pad is attached to a specified area of the monitor. The spectrophotometer then measures the colors displayed. The data is then entered into the profile-making software, which is then installed into the operating system.

CREATING MONITOR PROFILES IN OSX

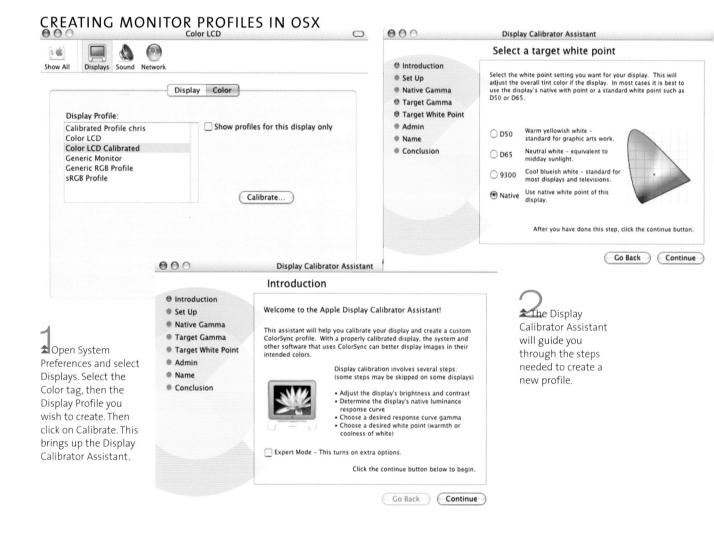

1
⤒Open System Preferences and select Displays. Select the Color tag, then the Display Profile you wish to create. Then click on Calibrate. This brings up the Display Calibrator Assistant.

2
⤒The Display Calibrator Assistant will guide you through the steps needed to create a new profile.

MILLIONS OF COLORS

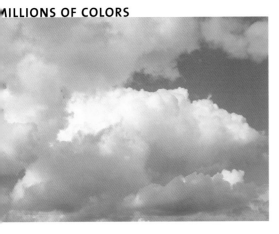

THOUSANDS OF COLORS

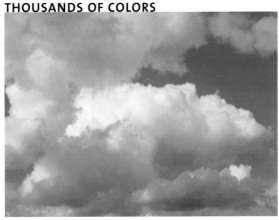

far left and left The image on the far left is made up of 16.7 million colors. The one on the left only uses 67,000 colors. Ensure that you are using millions of colors when creating a monitor profile.

USING APPLE COLORSYNC UTILITY

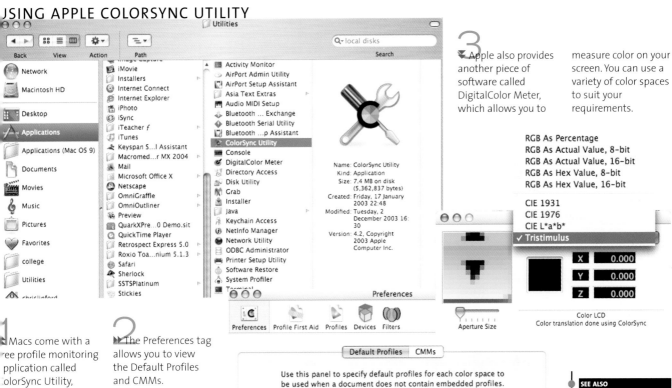

1 Macs come with a free profile monitoring application called ColorSync Utility, which is found in the Utility folder in the OSX Applications folder. This allows you to view, find, and repair profiles on your computer or network.

2 The Preferences tag allows you to view the Default Profiles and CMMs.

3 Apple also provides another piece of software called DigitalColor Meter, which allows you to measure color on your screen. You can use a variety of color spaces to suit your requirements.

RGB As Percentage
RGB As Actual Value, 8-bit
RGB As Actual Value, 16-bit
RGB As Hex Value, 8-bit
RGB As Hex Value, 16-bit

CIE 1931
CIE 1976
CIE L*a*b*
✓ Tristimulus

X	0.000
Y	0.000
Z	0.000

Color LCD
Color translation done using ColorSync

Aperture Size

Use this panel to specify default profiles for each color space to be used when a document does not contain embedded profiles.

RGB Default: Color LCD

CMYK Default: Generic CMYK Profile

Gray Default: Generic Gray Profile

■ glossary

A

ACE (Adobe Color Engine) Adobe's Color Management Module (CMM).

Additive color Color created from light using red, green, and blue (RGB).

AM screening A printing method that produces the normal halftone system, where ink dots are laid at specific angles.

B

Bit The smallest unit of data used on a computer system.

Bit depth The number of bits used to create a color.

Bitmap The simplest type of computer-generated graphic. Uses black and white only.

above Bitmap, see pp. 58–61.

Blue (B) The third primary color used in additive color.

Brightness The luminance of a color; also referred to as Lightness.

Byte A sequence of bits, usually eight, used as a unit by a computer.

C

Cast Incorrect color bias to one hue.

CCD (Charged Coupled Device) The element that converts light to energy in scanners and digital cameras.

Chromaticity The amount of color saturation.

CIE (Commission Internationale de l'Eclairage) The organization that created the first full spectrum color space.

CIEL*a*b* Lab color, a uniform color space that measures the whole visual spectrum. Created by the Commission Internationale de l'Eclairage.

Colorimeter A device used to measure color for hardware calibration purposes. Similar to spectrophotometer.

CMFI (Color Management Framework Interface) The place in software where third party CMMs slot together.

ColorSync Apple's Color Management System, built into their operating system.

below The color wheel, see pp. 24–25.

Complementary colors Colors that appear on opposite sides of the color wheel and clash. This clash can be used to great effect.

Compression The method of reducing the file sizes of digital images.

CMYK Cyan (C), magenta (M), yellow (Y), and black (K), used in printing.

CMM (Color Management Module) The software on your operating system that controls the interaction of Color Management Systems.

CMS (Color Management System) Software that controls color in a computer's operating system.

Color separation The conversion of files from additive color (RGB) to subtractive color (CMYK).

Color space A system in which color can be defined.

Color wheel A system used to view complementary and harmonious colors.

CRT (Cathode Ray Tube) The most common way of generating color on a computer monitor.

CTP (Computer-to-Plate) Modern system in which a digital file can be used to create plates for a printing press, with no need for an intermediate film stage.

Curves A system used to control and harmonize tonal value in images. Similar to Levels.

D

D56 Standard light measurement, determined by a measurement of direct sunlight at a temperate latitude.

D65 Standard light measurement, determined by a measurement of direct sunlight at a northerly latitude.

Depth Adding or subtracting blue to send elements of an image into the background or foreground.

Device-dependent color A color gamut that is restricted by process.

Device-independent color A color gamut that is not restricted by process.

Dichromat A sight deficiency in which a person cannot see one primary color.

Dot gain The spread of ink on paper during printing.

dpi (dots per inch) A system used to define the resolution of an imaging device such as a printer.

Drum scanner A pre-CCD scanner that uses Photomultiplier Tubes (PMTs).

E

Eurostandard An inkset used in printing to suit European color tastes.

F

Flatbed scanner A scanner that uses CCD technology.

FM screening A printing method that uses six or more colors, with an irregular dot pattern. Similar to HiFi color.

G

Gamma The measurement of light emitted from a computer monitor.

Gamut The range of colors available within any system of specifying or creating color.

GCR (Gray Chroma Removal) A process that replaces equal amounts of cyan, magenta, and yellow with a similar black tint.

GIF (Graphics Interchange Format) A file format that uses indexed color to create an image, commonly used on the Internet.

above Creating color depth, see pp. 40–41.

▶▶

■ glossary continued

H

Halftone The dot created during color separation in high-end printing.

Harmonious colors Colors that are close together on the color wheel.

Hexadecimal coding A system used to specify indexed color, where each color is given an individual code.

HiFi color Printing that uses six or more colors; similar to FM screening.

HSB (Hue, Saturation, Brightness) A color space found in Photoshop.

below Halftone dots, see pp. 110–111.

I

ICC (International Color Consortium) The organization that sets color standards.

ICM (Image Color Management) Microsoft's Color Management System, built into the Microsoft operating system.

Indexed color 8-bit colors, using a fixed palette.

Inkjet Usually, a low-cost printing device.

Iris A high-end inkjet device used to create color proofs.

Inkset A predetermined range of inks used by printing presses.

Ishihara's Charts A method of testing for color blindness.

IT8 targets Reference charts used to create Color Management Profiles.

J

JPEG (Joint Photographer's Expert Group) A "lossy" digital file compression system.

L

LCD (Liquid Crystal Display) A type of screen used to display color in some computer monitors

Levels A system used to control and harmonize tonal value in images. Similar to Curves.

Lightness The luminance of a color; also called Brightness.

Lossless compression A compression system where data is not lost when a file is compressed, for example LZW compression.

Lossy compression A compression system where some file data is lost when a file is compressed, for example, JPEG.

lpcm (lines per centimeter) The metric version of lpi (lines per inch).

lpi (lines per inch) A system used to measure the resolution of a halftone print.

uminance The degree to which light is mitted or reflected.

ZW (Lempel-Ziv and Welch) A lossless igital file compression system.

M

Monitor The computer display.

Monochromat A sight deficiency in which a person is totally color blind and can therefore see only shades of one color (monotone).

Munsell A color space used in photography.

N

Natural color Combinations of harmonious and complementary colors as they would appear in plants and animals in the environment.

O

Open systems Computer data that many applications can access.

Operating system (OS) Software that controls your computer.

OSX the latest operating system from Apple.

P

Pantone A set of standard ink colors, each of which is identified by a number.

left Munsell color tree, see pp. 102–103.

Panther Apple's OS10.3.

PCD (Photo CD) A system developed by Kodak to digitize analog photographs. Uses Kodak's YCC color space.

PDF (Portable Document Format) A method of creating an easily transferable file using the open architecture of Postscript.

Photoshop Photo manipulation software from Adobe.

Pixel The smallest element on a computer screen.

Plasma screen A new type of display used in monitors.

Platform RGB RGB color that changes if the file is opened on another type of computer.

PMT (Photomultiplier Tube) A device for converting light to energy, as used on drum scanners.

Postscript A computer language developed to enable any computer to describe an image to any printer, regardless of manufacturer.

ppi (pixels per inch) A system used to define the resolution of a digital image.

■ glossary continued

Pre-flight A process that tests the output characteristics of an image prior to printing.

Pre-press Any work that takes place before a file is printed.

Primary color A color that cannot be created by mixing any other two colors together.

Profiles The files that operate the Color Management software.

Q

QuarkXPress Desktop publishing software.

R

Resolution The number of pixels used in a digital image.

RGB Red, green, and blue; the primary colors found in additive colors.

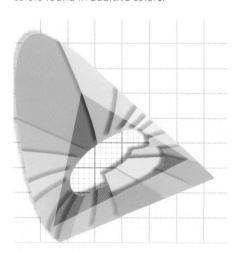

above sRGB color gamut, see pp. 64–65.

RIP (Raster Image Processor) The system used to create halftone dots in printing.

S

Saturation The amount, or intensity, of a color.

Secondary color A color created by mixing together any two primary colors.

Spectrophotometer A device used to measure color for hardware calibration purposes. Similar to a colorimeter.

sRGB A system that embeds RGB data into a file so that it does not change when opened on different computer systems.

Stochastic screening A system of printing designed to give high print quality. Also called FM screening.

Subtractive color Color reflected from pigment, such as inks on a substrate.

SWOT An inkset used in printing to suit American color tastes.

T

TIFF (Tagged Image File Format) A common file format used for images for printing.

Toyo An inkset used in printing to suit Asian color tastes.

Trichromat A person who can see the full color range (i.e., with normal color vision).

U

UCR (Under Color Removal) A system that detects instances of 100 percent cyan, magenta, and yellow and replaces them with black to cut ink and printing costs, and ink drying time.

USM (Un-Sharp Mask) A sharpening tool used on digital devices to increase the definition of an image; common on PMT scanners.

V

Vector A mathematical system used to create resolution-independent computer images.

W

Web-safe colors Indexed colors shared by the Apple and Microsoft operating systems.

Windows The operating system on PCs. There are several types.

X

XYZ The first color space developed by CIE

Y

YCC The color space used in Kodak's Photo CD system.

Yxy A color space used to define chromaticity

index

■ index continued

■ picture credits

Every effort has been made to contact the copyright holders for all the images in this book.

Axis Publishing Ltd. apologize for any omission, which, if drawn to our attention, will be corrected on a reprint.

Adobe: 40 bottom, 41 bottom left and right, 44–45, 54–55, 64 middle and right, 66, 68–69 (screen grabs), 70–71 (screen grabs), 96–97, 98–99 bottom (screen grabs), 104–105 bottom (screen grabs), 106, 107 bottom (screen grabs), 114 right (three screen grabs), 115, 132–133 (screen grabs), 134–135 (screen grabs), 136–137 (screen grabs), 142–143 (screen grabs), 144–145 (screen grabs), 146–147 (screen grabs), 148–149 (screen grabs), 161 bottom, 162–163, 164–165, 174 bottom (screen grabs), 176 bottom left (screen grabs)

Images courtesy of Agfa, 2004: 126–127, 169 top, 180–81

Apple Computers, Inc.: 61 bottom, 62–63 bottom, 63 top, 94 top, 112–113 bottom (screen grabs), 114 left (two screen grabs), 140 left and right, 141 bottom, 157 bottom right (screen grabs), 158–159, 182–183 (screen grabs)

Axis Publishing Ltd.: 1, 2–3, 4–5, 6–7, 8–9, 10–11 bottom, 11 top right, 15 far right (four images), 18–19, 20–21, 22–23, 24–25, 27 bottom (all images), 28, 30–31, 35 top, 36–37, 42–43 top, 48–49, 50, 52 bottom left, 57 top right, 58, 59 bottom right, 60 far left, 64 far left, 67, 73–91, 93 middle left and right, 95, 99 top, 100–101, 102–103, 106 right top and bottom, 110–111, 120 left and top right, 121 bottom right, 131 top, 145 middle, 150–151, 152–153, 154 bottom, 155 bottom, 156–157 bottom, 166–167 bottom, 170–171 bottom, 172 bottom right, 173 top right

CIE: 52 right

Colour Confidence: 179 middle

EFI: 166 left, 167 top right, 168 top, 168–169 bottom

Enfocus Software NV: 171 right

Epson: 92 top left and right

Mary Evans Picture Library: 10 top

Extensis: 140 middle

GretagMacbeth: 179 top

Heidelberger Druckmaschinen AG: 27 top, 92–93 bottom, 93 top, 113 (printer image), 119, 155 top right, 172 left

The images on pages 178 right and 179 bottom are the copyright of the Eastman Kodak Company and are reproduced with permission.

Konica Minolta: 128 second from left

LaCie: 56 left, 62 top, 141 top right, 155 middle, 178 left

Chris Linford: 108–109, 122 top and bottom right, 123 top and bottom left, 124–125 bottom, 133 top right (four images), 134 top left and right, 135 top left and right, 136–137 (all photographic images)

Screen shots reprinted by permission from Microsoft Corporation: 61 top, 160, 161 top

Nikon: 120 bottom right, 128 (far left and far right), 130

Pantone, Inc.: 94 bottom left. COLORVISION® and other ColorVision Inc. trademarks are the property of ColorVision Inc. PANTONE® and other Pantone, Inc. trademarks are the property of Pantone, Inc.

Pentax: 128 second from right

Reprinted with permission of Quark, Inc. and its affiliates: 46–47, 72, 107 top (screen grabs)

Sinar: 131 (bottom), 138–139

Sony: 57 top and bottom left

Umax: 122 far left (three images), 123 right, 125 top right, 155 top left

John Woodcock/Axis Publishing Ltd.: 12, 56 right, 57 bottom right, 118, 121 top right

All other copyrights to their respective companies.